TUSCANY

EVERGREEN is an imprint of Benedikt Taschen Verlag GmbH

© for this edition: 1999 Benedikt Taschen Verlag GmbH
Hohenzollernring 53, D–50672 Köln
© 1999 Editions du Chêne – Hachette Livre – La Toscane
Under the direction of Michel Buntz – Hoa Qui Photographic Agency
Text: Jean Taverne
Photographs: Wojtek Buss/Hoa Qui
(except: page 16 top Giulio Veggi-White Star,
page 102 J.P.H. Ruiz and page 103 Bruno Morandi.)
Layout: Roger Donadini
Map and illustrations: Jean-Michel Kirsch
Editor: Corinne Fossey
Cover design: Angelika Taschen, Cologne
Translated by Simon Knight
In association with First Edition Translations Ltd, Cambridge
Realisation of the English edition by First Edition Translations Ltd, Cambridge

Printed in Italy
ISBN 3-8228-7066-8

TUSCANY

Text JEAN TAVERNE
Photographs WOJTEK BUSS

EVERGREEN

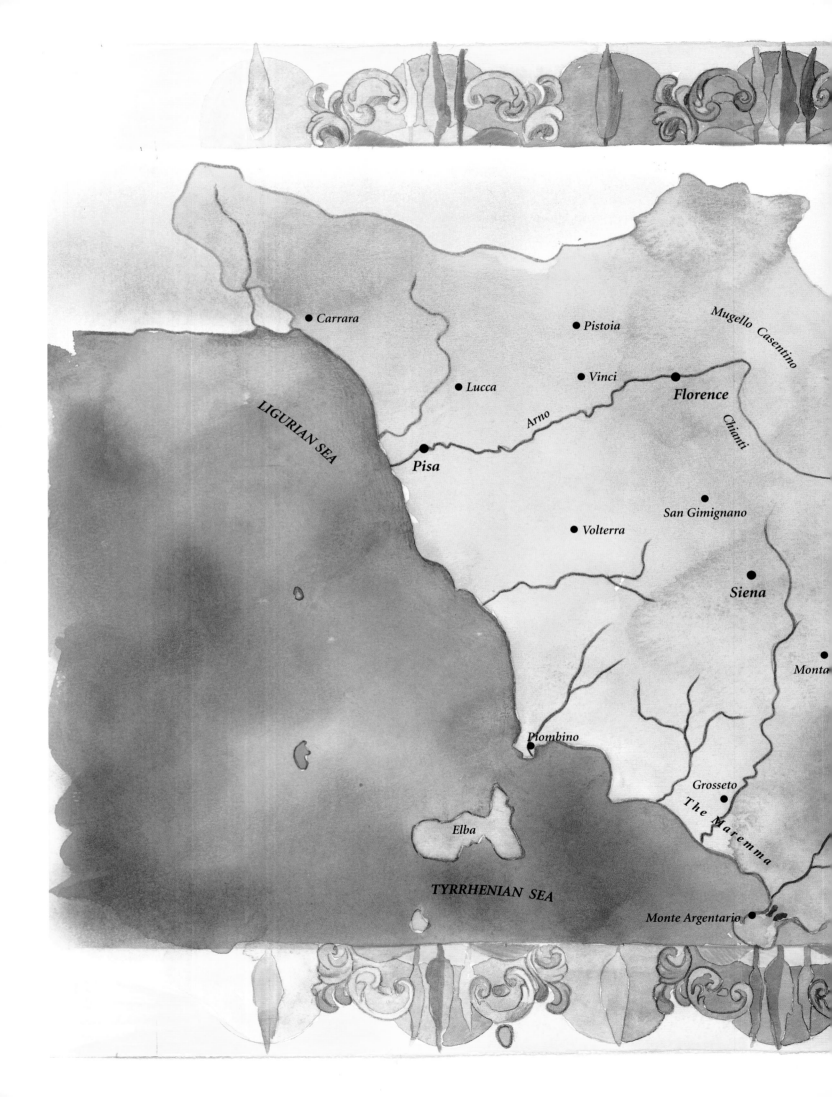

● *Arezzo*

● *Cortona*

● *Montepulciano*

Florence is associated in the English mind with art and culture, but also with political intrigue. One of her most famous sons was, after all, Machiavelli, and for centuries the Medici family needed to deploy all the dark and subtle arts of his Renaissance Prince in order to obtain, and remain, in power. Interestingly, the word *fiorentino* has no such sinister overtones in Italian: in character the Florentines are regarded as independent, proud and freedom-loving. By what strange association of ideas did the English arrive at another of the dictionary entries for Florentine: "a kind of biscuit packed with nuts, glacé cherries, and other preserved fruit, coated on one side with chocolate"?

For generations, Tuscany has had a bewitching effect on wealthy northern Europeans, art lovers or not. Prospectors scour the countryside in search of properties that wealthy British or Germans will pay a fortune to convert into bijou holiday homes. Americans think nothing of crossing the Atlantic for a three-week annual visit. In "Chiantishire", they invite one another for drinks, throw parties, try out Italian recipes (not always successfully), complain of the unregulated development that threatens the countryside and the depredations of tourism, exchange tips on local craftsmen who will do a good job for cash, and frequent the local café to rub shoulders with the natives. Such is life.

Tuscany has it all: swelling landscapes, lovingly cultivated countryside, the beauty of its hilltop towns, an artistic heritage that extends to even the remotest village; centuries-old *palazzi* with "ground floors like prisons and upper storeys like lace", as one observer saw them; scattered farms each in an oasis of green, old monasteries nestling in quiet valleys, villages perched, eyrie-like, on spurs of rock; the gentle hills painted by Fra Angelico and sublime views stretching away to shimmering horizons. But what is most admirable, and could not be bought for any price, is the lesson in civilisation which for more than a century it gave to the world.

It was here that, for the first time in modern history, an ambitious mercantile class, rooted in popular culture, overthrew and supplanted the aristocracy. There was nothing very saintly about

them, as Dante had foreseen. They simply changed the rules of the age-old game, and made use of the common people and the "intellectuals" to bolster their new Republic. Like many others, the Medici acquired their wealth from the trade in wool, linen, and alum, and later from banking. By good fortune, their "dynasty" was founded by two men of exceptional temperament and intelligence, Giovanni di Bicci and his son Cosimo the Elder. Cosimo, though exiled, overcame his enemies by skilled political manoeuvring and judicious use of his wealth, and established a dominant position as financier, entrepreneur, patron of the arts, and statesman.

What we call the Renaissance could not have happened without them. It was a revolution in thought comparable with that of Copernicus in astronomy. The Church, though so strong in the secular sphere, was powerless to prevent an amazing liberation that made Man – with a capital M – the measure of all things. In every field, the Byzantine obscurantism of traditional belief was smashed to smithereens. Painters and sculptors continued to depict religious subject matter, but with a renewed affirmation of the dignity of human nature.

It is difficult to measure our debt to them. Despite the excesses from which no revolution is exempt, our humanistic heritage, our pride as free-thinking human beings, is rooted in the Tuscany of the fifteenth century, whose masterpieces are but the visible signs of an intellectual tidal wave.

But let us not get too serious. The photographs in this book pay homage to a key region of Italy, which, despite the sarcastic jokes of bankers from Frankfurt and other points north, demonstrates a creative vitality sorely lacking in most of Europe. People think they know Tuscany when they have visited Florence or Siena, San Gimignano or Lucca, the Chianti region or Arezzo. But what do they know of its festivals, its way of life, its cookery and its deeply rooted traditions? What do they know of its secluded houses, the cultivation of vine and olive, which have nourished it for centuries, or the backbreaking agricultural labour, stone by stone,

Following pages:
Like a group of sculpted figures appearing from nowhere, this clump of cypresses epitomises the mystery of the Tuscan countryside.

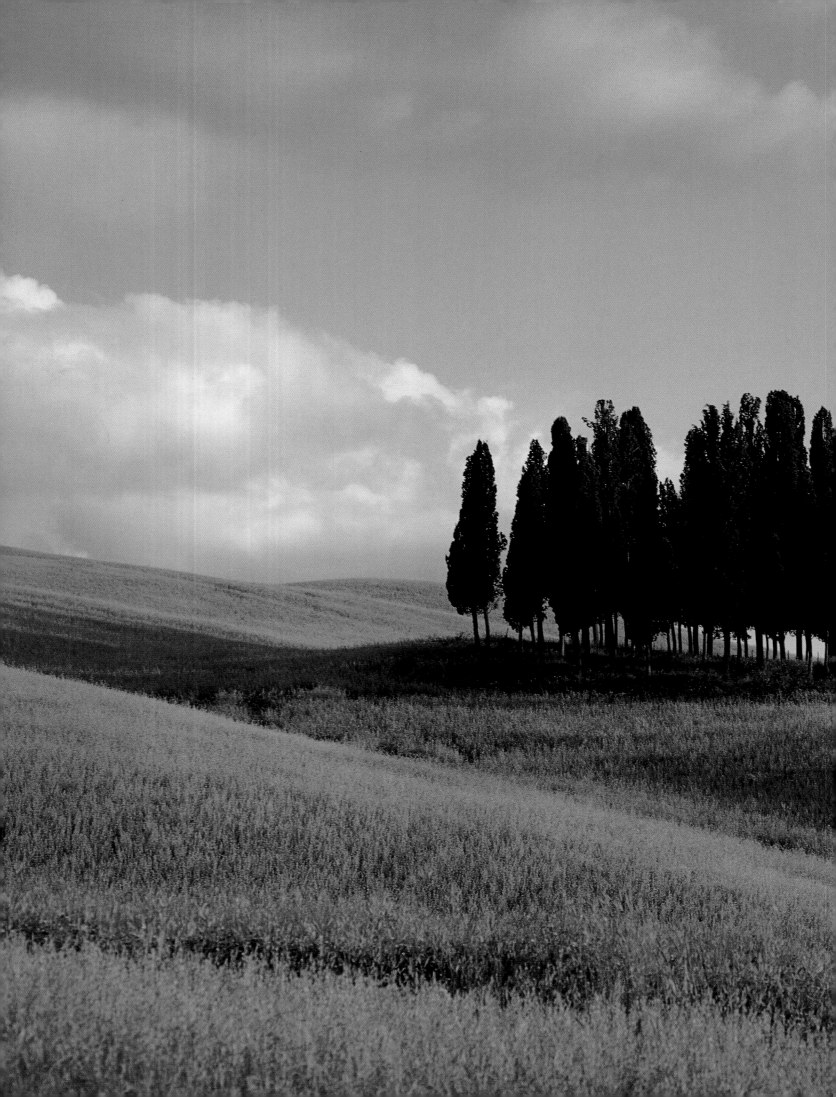

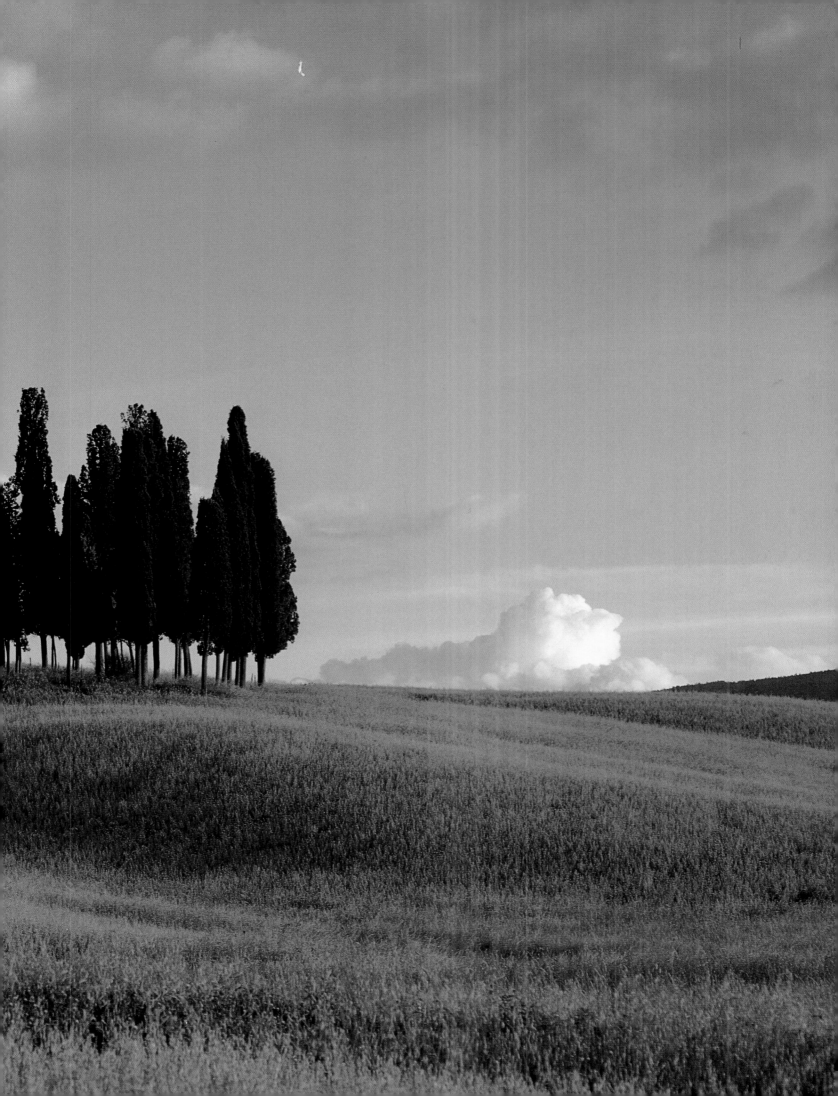

year by year, required to terrace its hills and its mountainsides? Forget all your arty nonsense! Tuscany is anything but the sweet and sugary heritage site to which it is often reduced in the tourist literature. It is hard, secretive and jealous; of a haughty, honeyed beauty augmented by the effects of light. Here, as in all parts of the Mediterranean, it is light that determines everything. Whether the greens of the olives and cypresses, or the old rose of its farmhouse walls, come to life, sparkle, or take on a tragic, funereal hue, all depends on the quality of the light. Take a look at the Sienese countryside in Simone Martini's famous fresco of Guidoriccio da Fogliano: it is earthy, ochreous, sinister, bristling with fortifications and pointed stakes. Take a walk through Florence's labyrinthine streets, where your footsteps sound like a funeral knell on the massive paving stones. Observe her blind walls, built of enormous blocks of razor-sharp stone. Contemplate her towers, which have served as store-rooms, keeps, and prisons.

This daughter of light draws the eye to the eternal beauties of her countryside, which sings only in the sunlight, especially in the early morning and evening. Baked and bare by early summer, at midday it shimmers in the withering heat, or sets rigid in the glacial light of winter.

In his Italian journal, Stendhal tells how, after an intensive day's sightseeing, he was suddenly struck by a strange malaise on visiting the church of Santa Croce in Florence, where he had gone to study Giotto's frescoes. The doctors diagnosed what we would now describe as an overdose of cultural excitement. A department at the hospital of Santa Maria Novella now devotes serious study to this "Stendhal syndrome", which affects over-sensitive visitors. The fact is that, under an often austere exterior, Tuscany is seductive and insinuating. She can be brilliant, caressing, gentle to the point of voluptuousness and more beguiling than Eve herself. She steals the unwary heart but, when all is said and done, she is what we make of her. Everyone has his or her mental image of Tuscany. This is ours.

Siena stands like a sentinel at a crossroads. In the foreground, far below, is part of the Campo, the famous scallop-shaped square; beyond, the roofs around the Duomo form a complex tapestry.

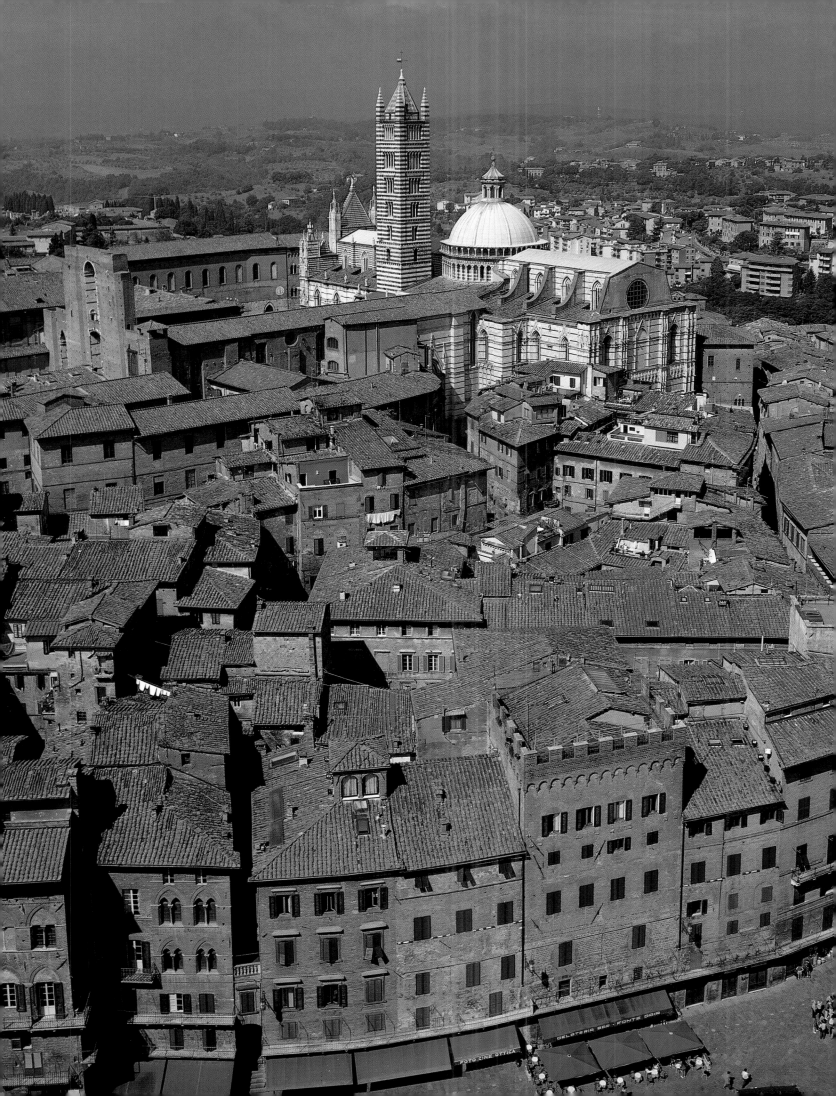

PISA, LUCCA, PISTOIA:
the triumph of marble

Built of marble, the Leaning Tower of Pisa deviates 2.26 m (7 ft 5 in) from the perpendicular. It began to tilt dangerously in 1183, when the third level was being built, and the work was interrupted for ninety years. Closed to the public since 1990, girded with iron and counterbalanced at the base by enormous weights, it continues to list by approximately seven millimetres every ten years. Given the instability of the ground on which it stands, some experts fear that it may fall in the next 100 to 150 years.

It is easy to forget that Tuscany is not just Florence and Siena. It cannot be reduced to a landscape in which cypresses framing red-brick farmhouses rise like candle-wicks in the burning heat. Nor is it merely the adopted country of nineteenth-century English aristocrats and wealthy Germans, who once creamed off all the former duchy's patrician estates and rustic villas, Italian gardens, and abandoned country dwellings. It is true, of course, that we are indebted to them for the resurrection, or at least the safeguarding, of an exceptional cultural heritage.

It is also easy to forget that Tuscany is a mountainous region: the Apuan Alps, with their snow-covered summits, look down from a great height on a sea whipped up by winter storms. Shelley and Byron loved to come and contemplate this sea from the wild pine woods which fixed its then-deserted beaches. For Shelley, it became his last resting place, when his body was washed up on the shore between Pisa and Leghorn, after the shipwreck of his cutter. In the 1920s, the cultured classes of Europe would congregate on these shores. Puccini had a charming villa built on the banks of Lake

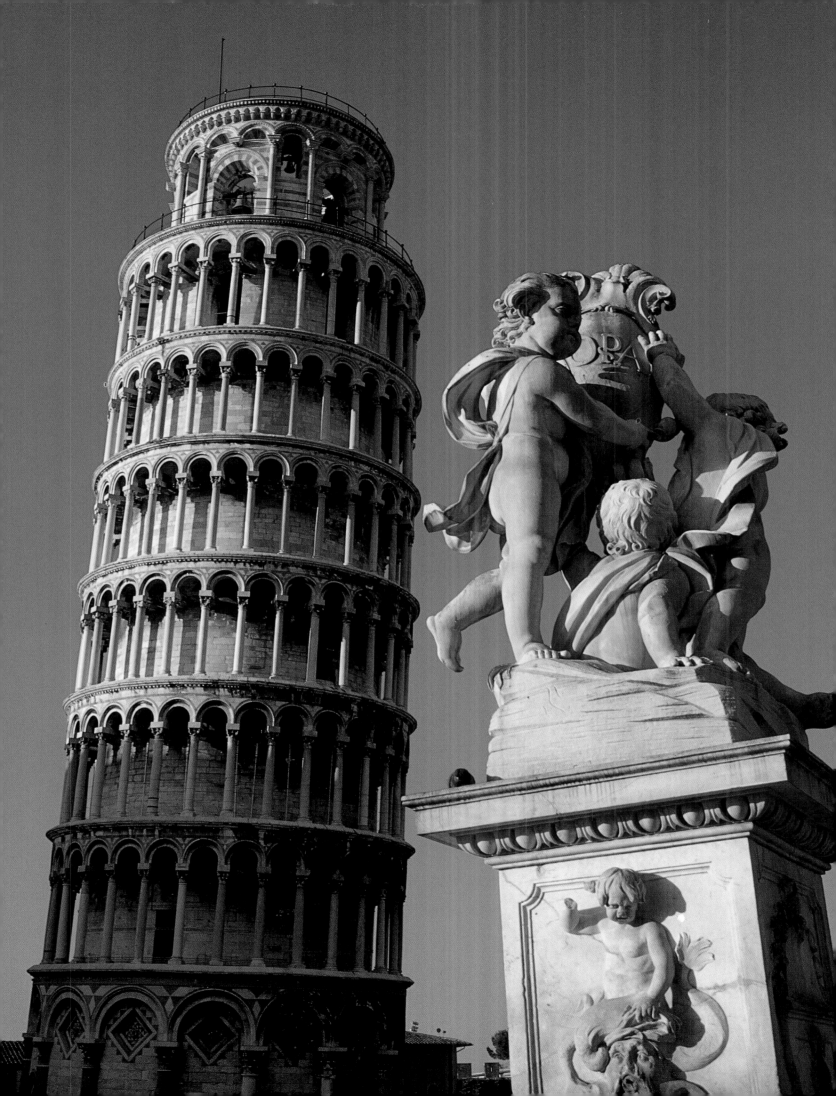

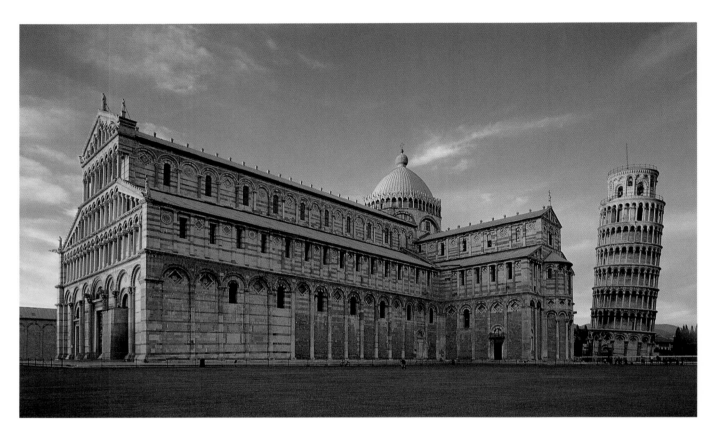

Light and airy, despite being 100 m (328 ft) in length, Pisa's cathedral, begun in 1063, is also remarkably unified, although it took two centuries to finish. The Carrara marble façade, with superimposed registers of columns, set the pattern for the Romano-Pisan style which spread to the rest of Tuscany and beyond.

Massaciuccoli, where he is buried, and present-day visitors are moved to discover his writing desk and private furniture, bathed in a soft light. Rilke, Thomas Mann, D'Annunzio, and their friends used to meet in Viareggio, and in a short space of time the town acquired the Art Nouveau and oriental-style buildings which now give it its exotic character.

This part of Tuscany, which has long looked to the open sea, is still a point of entry for travellers coming by air, rail and road. And it is a spectacular way to arrive, because the first place you come to is also one of the region's greatest attractions: Pisa.

It is pointless to describe the sparkling charms of Pisa, the sepia of its walls, the animation of its *passeggiata* under the arcades of the Borgo Stretto, or the delightfully provincial atmosphere of the market in the Via San Martino. All the newcomers have eyes for is the Leaning Tower, whose fame and image have reached every corner of the world. Never mind the town itself – the *palazzi*,

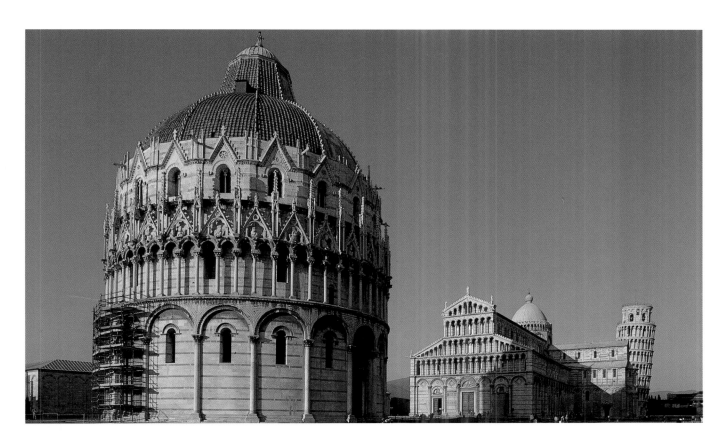

medieval towers, and Romanesque architectural treasures beside the languid Arno. Where is the tower, la tour, la torre pendente? – Straight on, tout droit, sempre diritto…

The fascination of this tower lies not in the elegance of its six registers of classical column, rising one upon the other like a turban, nor in its immaculate white marble. What matters is its defect. A tower is supposed to stand upright, perfectly vertical. Pisa's tower has never stood straight, and appears to maintain a precarious balance. It was already tilting eight centuries ago, possibly due to the instability of the water table, and it continues to lean a fraction more each year, despite the enormous counterweights intended, if not to right it, at least to prevent its fall. As it is, the angle of inclination is reckoned to be increasing by seven millimetres a decade.

Here it is then, served up on a tray on the strangely isolated Campo dei Miracoli, floating like a mirage with the cathedral and baptistery, all clothed in the whitest, most sparkling marble imaginable, under

Piazza dei Miracoli, Pisa. A long shot of the baptistery, the cathedral and its campanile, the famous Leaning Tower. The buildings are laid out alongside a vast cemetery, not visible in this photograph. This complex was one of the most ambitious building programmes of the entire Middle Ages. The slender columns of the Duomo's oriental-looking cupola create delicate light effects.

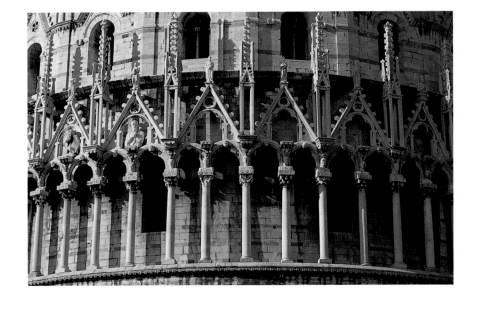

*P*art of the baptistery's elegant arcading. Most of the statues carved for this building by Nicola Pisano and his son Giovanni can be seen in the nearby Museo dell'Opera del Duomo.
Below:
Mosaic dedicated to the Blessed Virgin Mary.

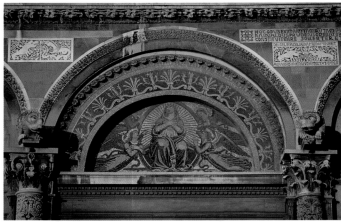
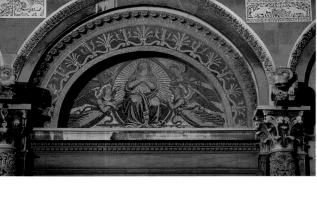

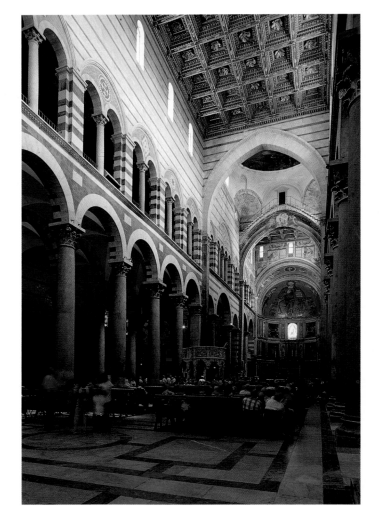

Interior of the Duomo, Pisa. Its nave and four side-aisles create subtle chiaroscuro effects. In spite of the coffered ceiling, the brightly lit upper part of the central nave gives lightness to the whole and draws the eye towards the apse.
Facing page:
The Duomo, Pisa. Coloured stone decoration inlaid in the marble. Some of the designs are purely geometrical; others are based on animal shapes.

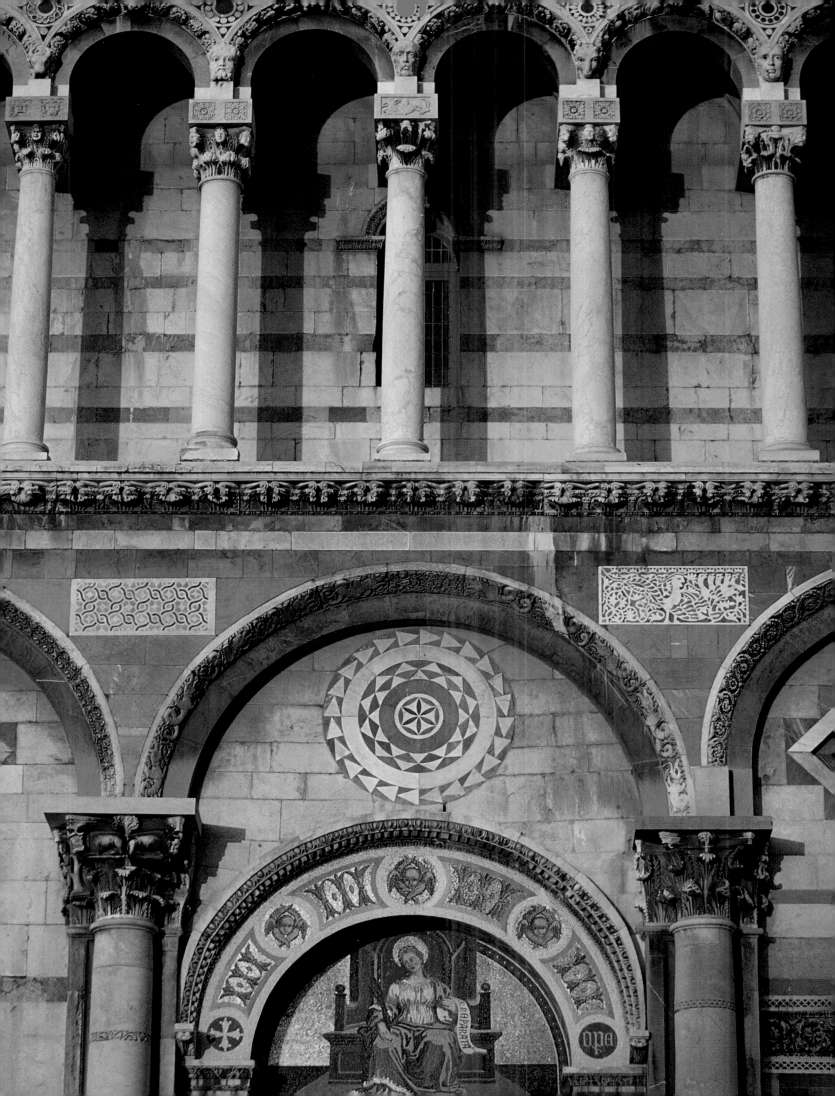

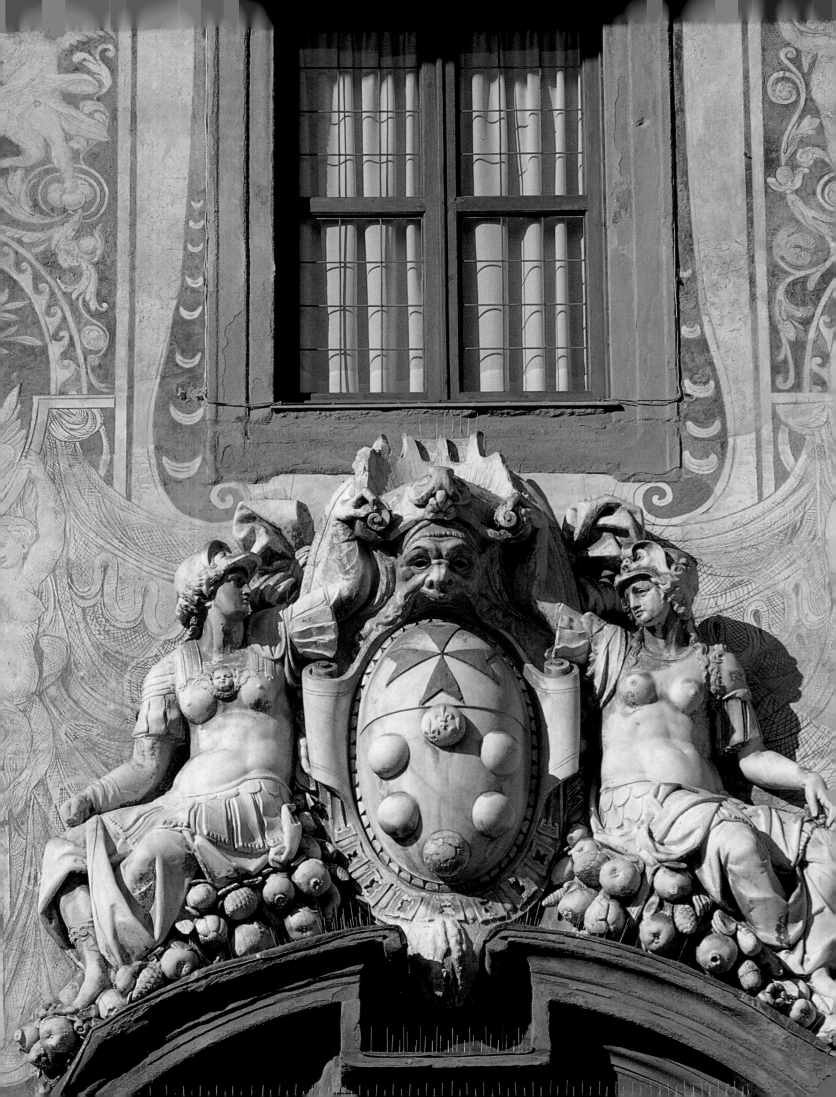

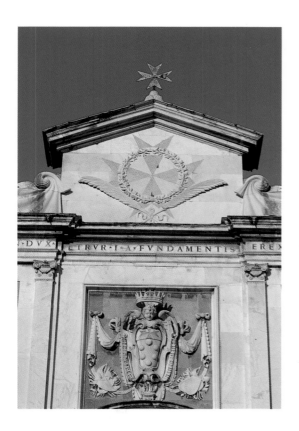

*P*revious pages:
As a reminder that it was an important maritime republic, twice a year Pisa organises regattas and an extremely popular jousting match in Renaissance costume. The north and south districts of the town do battle on the River Arno, the city's link with the open sea.

Facing page:
The façade of Pisa's Palazzo dei Cavalieri is entirely decorated with sgraffito work, created by incising a layer of fresh plaster to reveal the darker under-layer of stucco. This palazzo was built in the mid-seventeenth century by the Knights of Saint Stephen, an order founded by Cosimo I de' Medici on the lines of the Knights of Malta. Note the Medici arms and the Maltese cross. This humiliating episode is now forgotten. The young, busy town is a pleasant place to live.

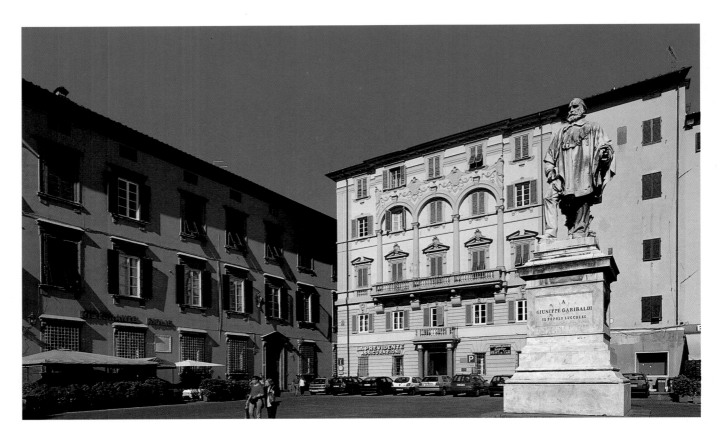

Lucca. Every Italian town must have a statue of Garibaldi, honouring the republican who, in the nineteeth century, swallowed his principles and served the monarchy to bring about his great patriotic dream of a united Italy.
Facing page:
Lucca's Piazza del Anfiteatro, which follows the oval outline of the ancient Roman arena, is totally unspoilt. The entrances to the piazza are exactly where the gladiators would once have entered.

a metallic blue sky. Apart from tourist interlopers, no one ever crosses this vast treeless expanse of grass, burnt brown in summer, which leads only to an enclosed, marble-walled cemetery: the Campo Santo. The soil, or at least part of it, is said to have been brought from Golgotha, the hill outside Jerusalem. This miraculous earth, transported by a fleet of galleys in the 1200s, is supposed to mummify the skeletons of the dead, whose flesh melts away overnight… A few pigeons and turtle doves coo under the long funereal arcades which form a kind of cloister.

In the age of satellites and space stations, we remain overawed as we contemplate, by moonlight, this extraordinary esplanade, and how astounded the merchants of the Middle Ages must have been when, arriving from the Adriatic or the Levant, they discovered here the symbols of Pisa's economic might, rivalling that of Genoa and Venice. There can have been nothing to compare with this amazing monumental complex, the first large-scale use of marble, torn from

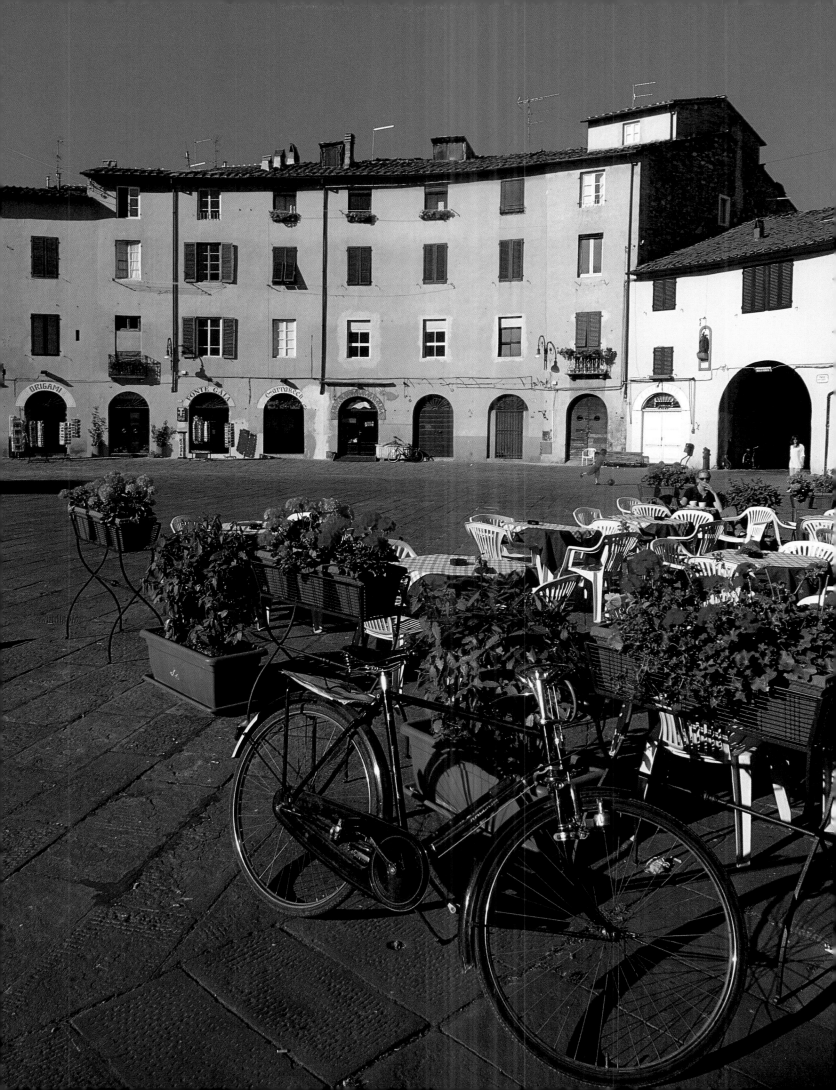

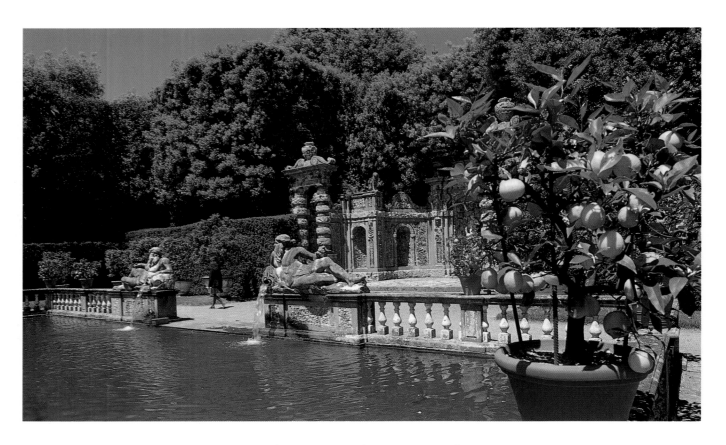

Symbol of eternal springtime, the lemon tree in its pot is a standard feature of an Italian garden – one of the "trees bearing golden apples" in the garden of the Hesperides, guarded by the nymphs of the West.

the quarries of Carrara, not far away in the mountains. If you have time to spare, this is the opportunity to discover a little-known part of Tuscany, whose name – the Lunigiana, or country of the moon – stimulates the imagination. This timeless region, its attractive hilltop villages dominated by the feudal fortresses of the Malaspina family, derived its odd name from the little Roman port of Luni, now silted up, through which for centuries the blocks of marble brought down from the quarries were shipped to their final destination. Moon harbour: no name could better suggest the almost unreal, translucid whiteness of this material, which could almost have come from another planet.

It was the Pisans, then, who cleared the hillsides and began reworking the abandoned seams. The raw marble was brought down in bullock carts, then transferred to bulging-hulled boats. Later, when it became fashionable, the stone was transhipped to flat-bottomed lighters which could negotiate the waterways of the

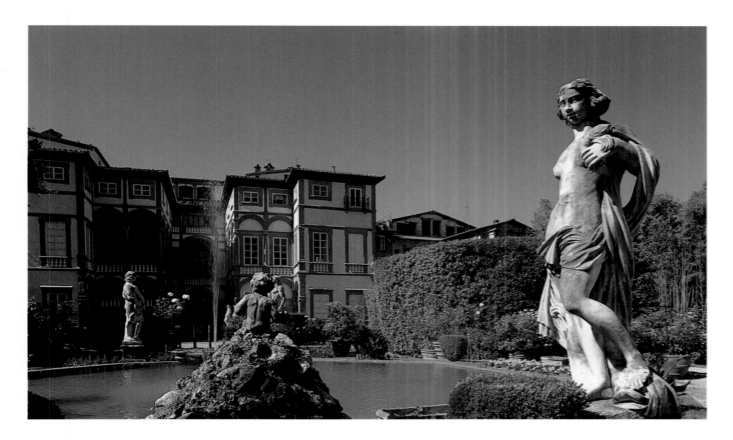

interior. Nicola Pisano, famous for the pulpit that stands in Pisa's baptistery, dynamic founder of a line of brilliant Tuscan sculptors, came to reconnoitre here and select the best blocks of marble. Many have followed him to these remote mountains, in particular Michelangelo, who on several occasions stayed in a house opposite Carrara's handsome Duomo – itself faced with marble, as one would naturally expect.

The town and region still have many marble works. And there are other remote mountain ranges, such as the Garfagnana, covered in dense woods of chestnut with clearings where sheep graze. The River Serchio, flanked by small medieval towns with an old-fashioned charm and crossed by humped-back bridges, makes its precipitous way down to Lucca, a sleeping beauty sheltering behind her pink ramparts in one of the richest and most fertile plains you will find anywhere. In Italy, you have to get used to the sudden apparition of ghosts from a prestigious and monumental past,

The balconies of Palazzo Pfanner in Lucca, open to the fresh scents of the garden. An example of the happy marriage between the arts of sculpture and gardening.

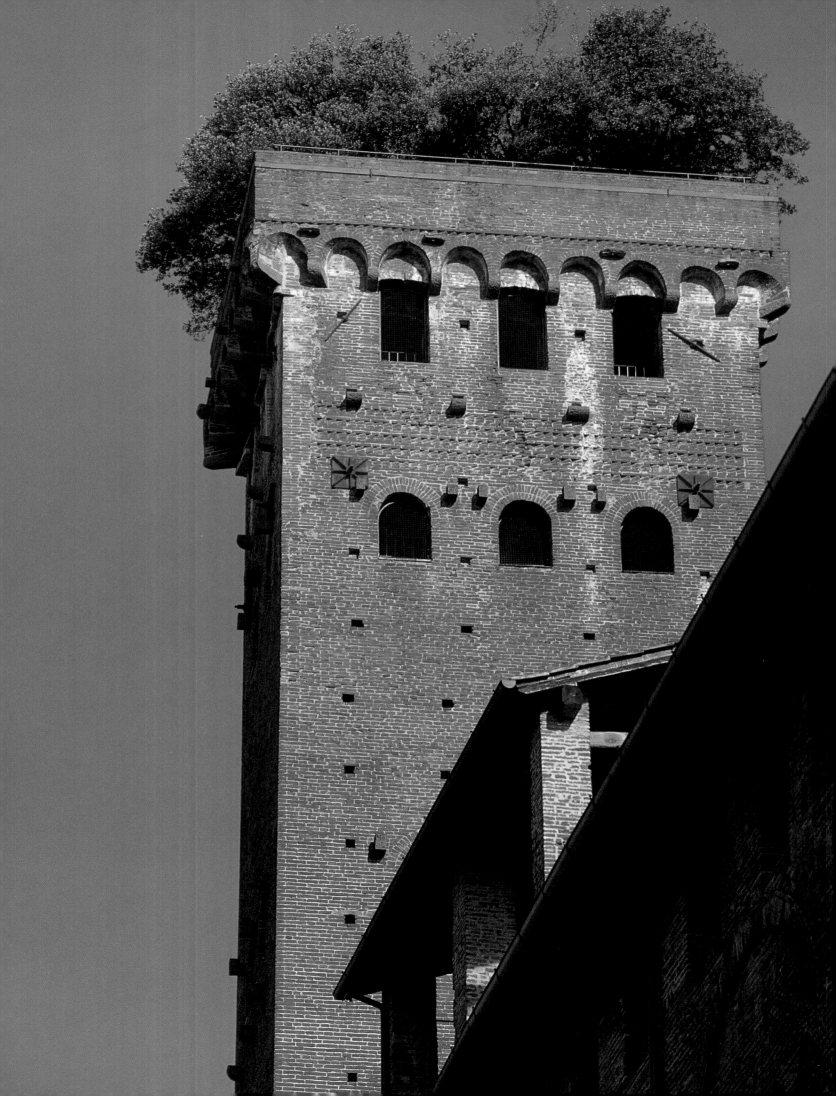

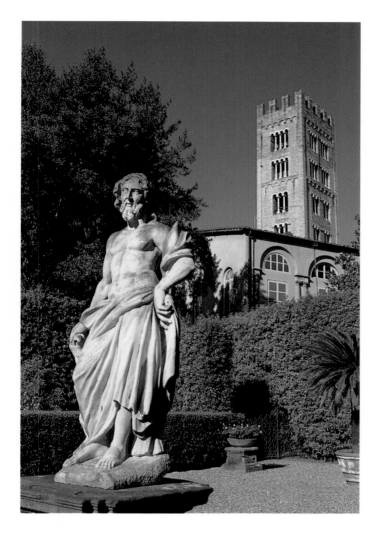

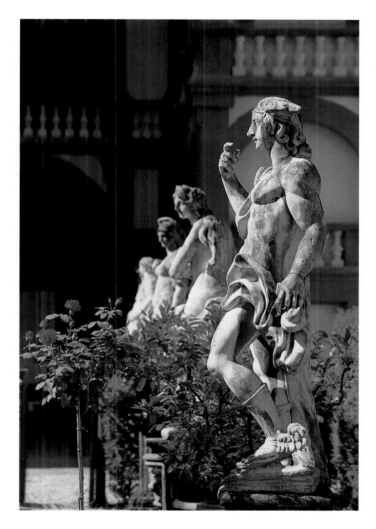

which turn out to be very much alive. Here in Tuscany, often with far greater panache than elsewhere, small states established themselves and developed and, maybe for only a generation or two, made a great impact on the world. Just outside Pisa, the town of San Piero a Grado, once lapped by the waves stands dream-like in strange solitude, reminding us that it once carried on a busy trade with the Levant and Africa. Every Tuscan town, even the most humble, has at one time or another experienced a golden age. How else can one explain the presence of sumptuous palaces in sleepy little towns, fabulous squares, massive churches, town planning of a nobility that is truly stunning?

Here, for example, is Lucca, so bellicose under the rule of its feudal lords (Castruccio Castracani who rose to power in the early

A whole Baroque population of classical gods and goddesses inhabits the French-style garden of Palazzo Pfanner, not far from the church of San Frediano, whose campanile can be seen in the background.
Facing page:
The tall brick tower of Palazzo Guinici, in Lucca, sprouts the traditional crown of holm oak.
Following pages:
Facing the fertile plain of the Serchio, Lucca turns its back on the chestnut-clad Garfagnana massif to the north. These are the foothills of the Apennine mountain chain, some of whose summits rise to over 2,000 m (6,560 ft).

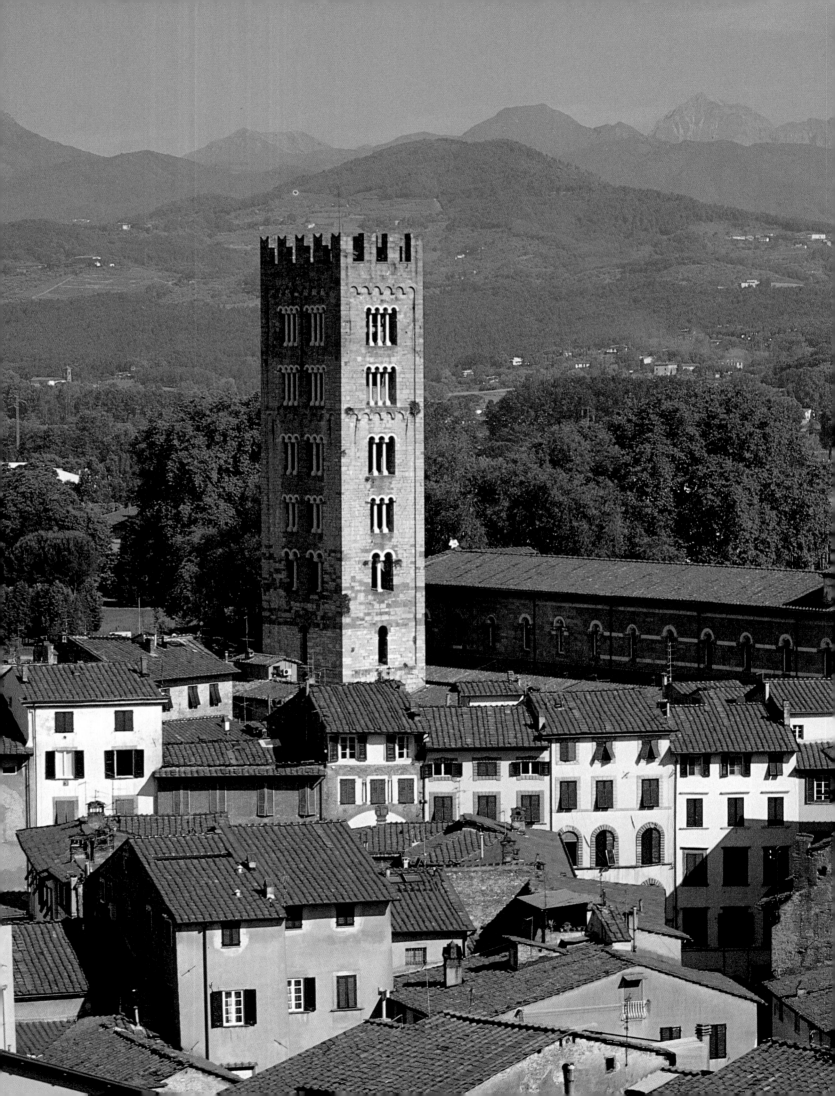

Details of the church of San Michele in Foro, Lucca. Atop the richly-decorated pediment, Saint Michael crushing the dragon is framed by a pair of trumpet-blowing angels.
Below:
Scenes from the Roman bestiary; the idea of lust and debauchery attaches to many subjects inherited from classical antiquity, in this case the mermaid, the centaur, and the coupling of wild animals.

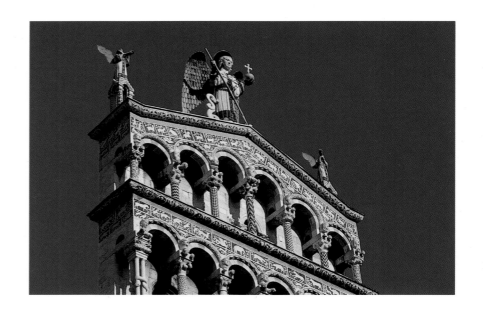

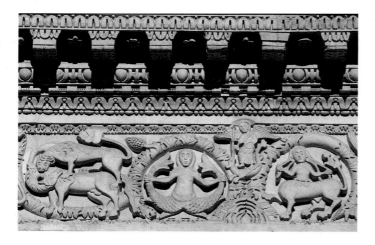

A difficult scene to interpret: a lion fighting a serpent, both of them upheld by a figure apparently crushed by destiny. The lion has traditionally been taken to represent Christ and the serpent Knowledge. But they may be two complementary dragon figures.
Facing page:
Façade and campanile of San Michele in Foro (thirteenth century). An unusual example of the Romano-Pisan style, with the superimposed arcades supported by columns decorated in an extremely varied manner. The second arcade is open to the sky, as is the light and airy two-stage pediment. Note the statue of Virgin and Child at the corner of the building.

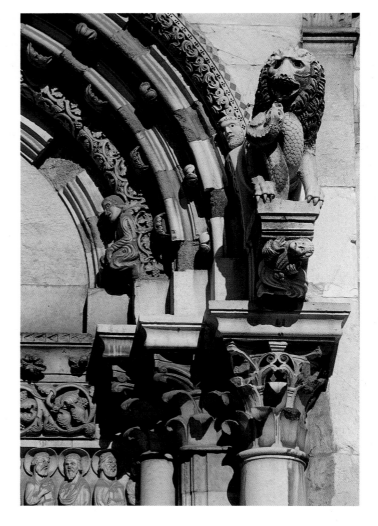

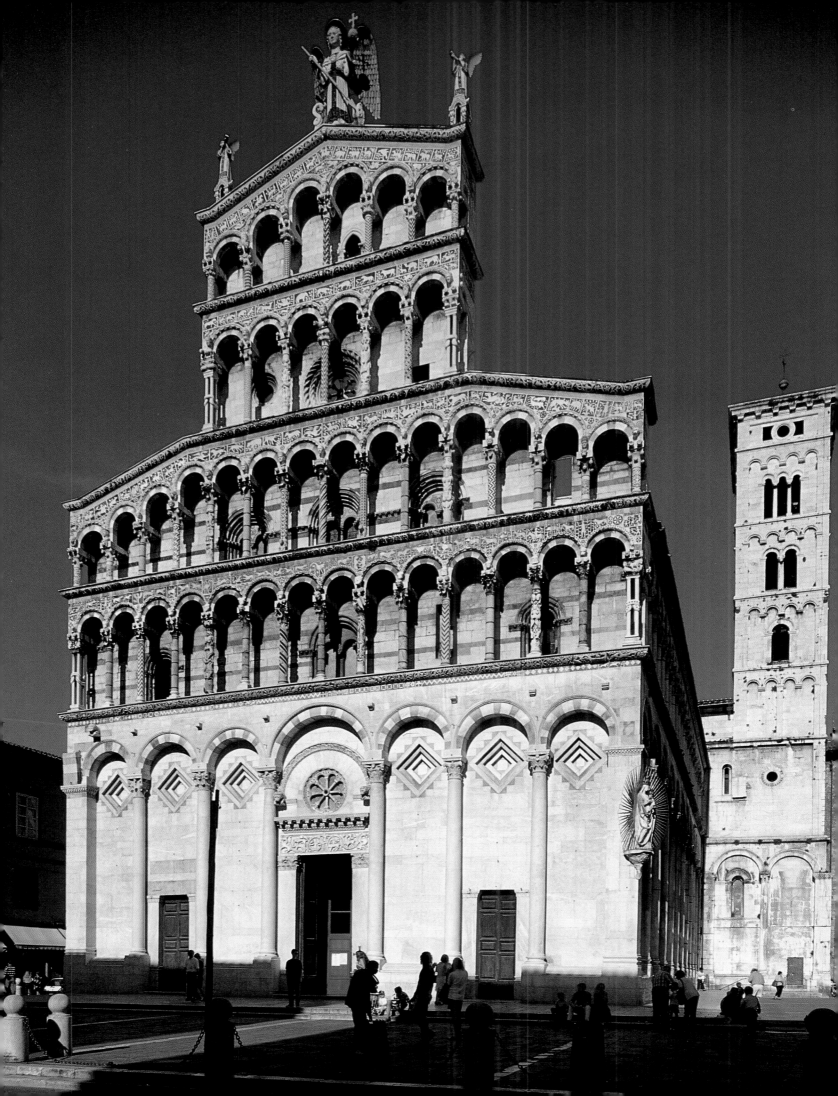

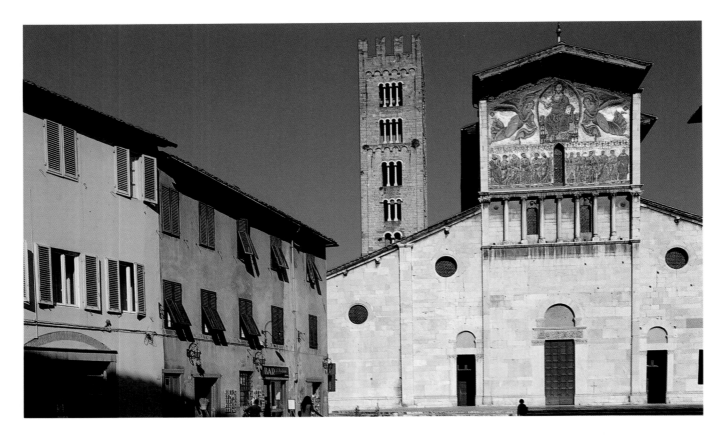

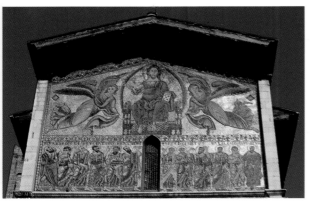

Saint Frediano is said to have saved Lucca from flooding by the Serchio, an impetuous mountain torrent. The church dedicated to him is one of the most beautiful in the town, built between 1112 and 1148. The only decorative feature of the otherwise bare façade is a Romano-Byzantine mosaic – a graceful depiction of the Ascension of Christ, watched by the stupefied apostles. Crowned with swallow-tail battlements, the campanile is a model of elegance.

fourteenth century was greatly admired by Machiavelli). The town remained a hub of the silk trade for several centuries. Passing through here just before the Great War, Suarès has left us an amusing account of his visit to the descendant of another tyrant, Paolo Guinici, who governed the city in the fifteenth century (his residence is open to visitors). Having shown him his fabulous collection of paintings, including works by Rembrandt, Murillo, and Andrea del Sarto, gloried in his family history, and bemoaned the decadence of modern times, the marquis suddenly asked Suarès, without the least trace of shame: "Would you by any chance know an American to whom I could sell it all?"

Lucca has no intention of knocking down its cultural heritage to the highest bidder like that disillusioned old aristocrat, instead it seems almost oblivious of it. For a long time, the city lived with its boots and armour on, fighting against Pisa and Florence. Now, for many years, it has been wandering around in its slippers amid the same

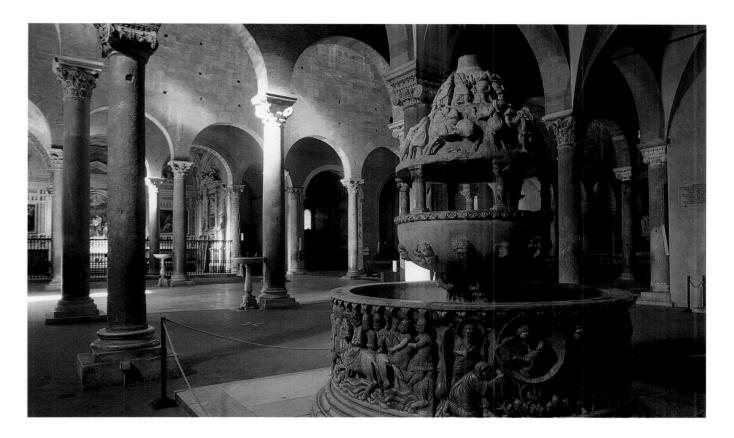

heroic stage sets. The only remaining function of its dungeons, ramparts, and fortified palaces is to bear witness to the past, like the tall brick tower of the Guinici, one of the last in Italy to continue the old custom of having a tuft of holm oak crown its summit. That is just how Lucca is: not in the least proud, completely pacifist, but with a toe always planted firmly in the past. Just one night at your hotel or *pensione* and you feel entirely at home. From a window, you suddenly hear some bars from La Bohème, a reminder that Puccini was from Lucca. He took his first steps not a stone's throw from here, in an apartment overlooking a little square.

Then, suddenly, you emerge into an oval piazza totally enclosed by sober, working-class homes: Piazza di Mercato, adhering to the ground plan of the old Roman amphitheatre. The off-season is the time to come and indulge your emotions here among the flocks of swishing pigeons. There are no pretensions: sheets, night-shirts and other intimate items hang simply but theatrically above the shops

The interior of San Frediano. The magnificent thirteenth-century baptismal fonts are by Matteo Civitali. The scenes on the larger basin are of Moses showing the Tablets of the Law, and The Crossing of the Red Sea. His companions are dressed like medieval knights.

In every Tuscan town, the careful observer will find dozens of interesting decorative features, like this Baroque stucco medallion of Abundance on the Villa Mansi, near Lucca, or these distinctive door knockers.

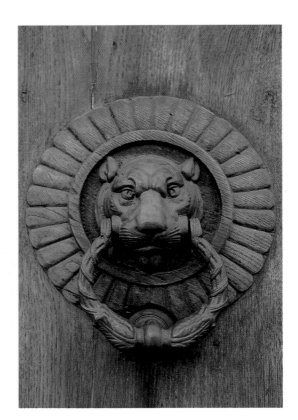

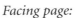

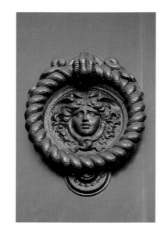

Facing page:
Set in an English-style garden, the height of fashion in the nineteenth century, the Villa Mansi, near Lucca (open to visitors) is one of the region's finest examples of a patrician country retreat. Designed for his own family by Paolo Cenani, a cleric and dilettante architect, it was later acquired by the Mansi, who had made a fortune in the silk business, a great speciality of Lucca. In the nineteenth century, the grand central salon was decorated with brilliant trompe l'oeil frescoes by Stefano Tofanelli.

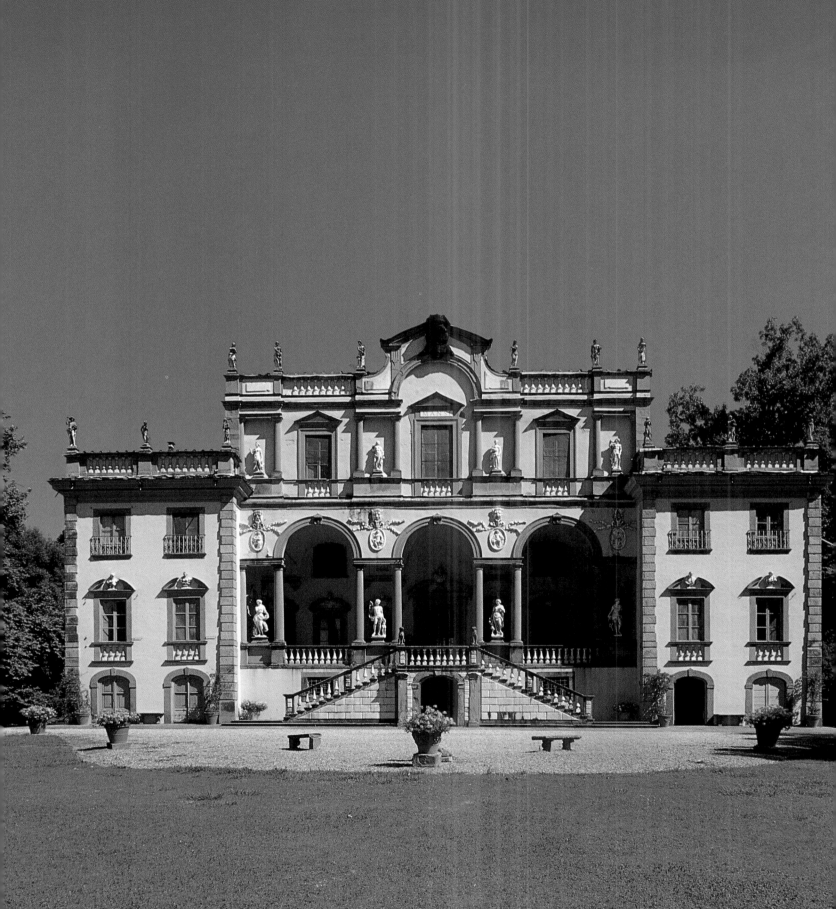

*K*nown throughout the world for the purity of its white marble,
the stylish little town of Carrara still has a number of sculptors' workshops.
Facing page: from a distance they look like great snow slides. There are still many marble quarries
hidden away in the Apuan Alps (in this case Bedizzano). Most of the marble they produce is used for flooring.

• Carrara •

Carrara is a flourishing little town near Massa, high above the Bay of Genoa. Marble quarrying has never really stopped there, though there have been two periods of intense activity: classical antiquity, when this hard rock with its incomparable white grain was first discovered; and the thirteenth to sixteenth centuries, when sculptors competed for the best blocks, and Carrara marble was used for hundreds of commissions throughout Italy. As a result of the fashion for coloured marbles during the Baroque period, Italian clients looked elsewhere for their raw materials. Finally, the French and British reopened many of the quarries. A railway was built at the end of the nineteenth century to link the quarries to the nearby ports. Current reserves are reckoned to be 60 billion cubic metres (78 billion cubic yards).

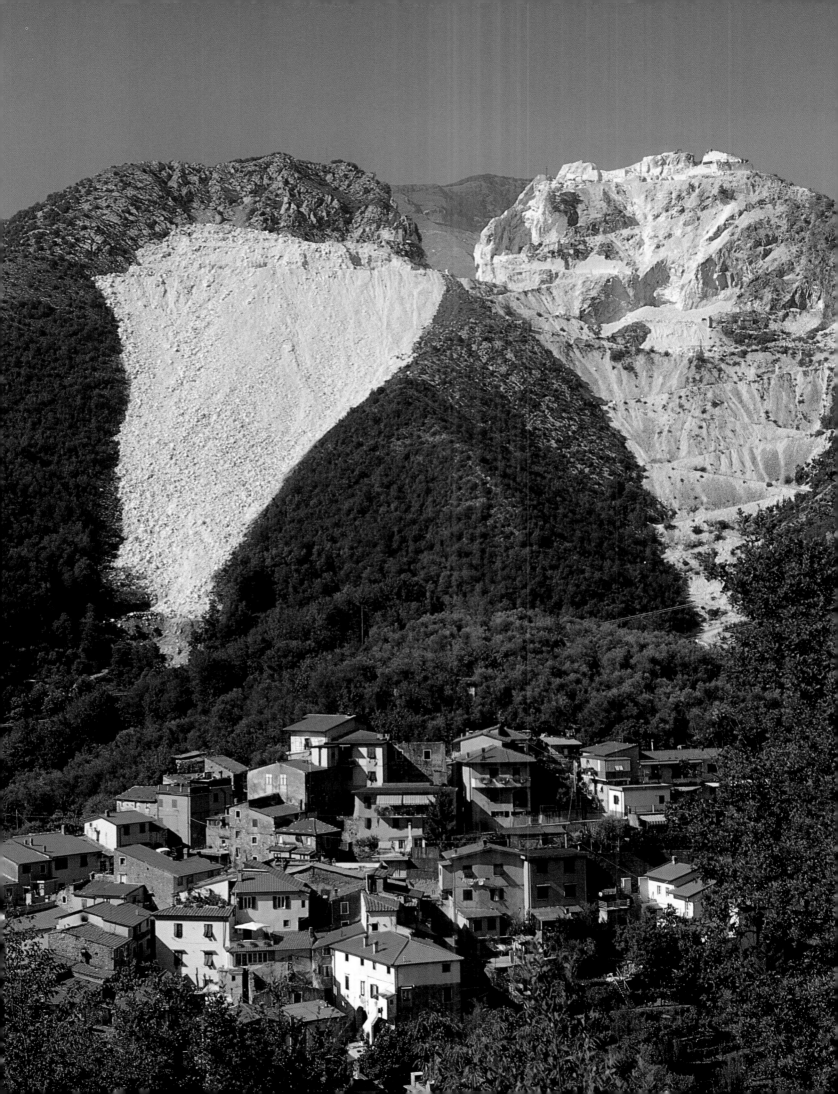

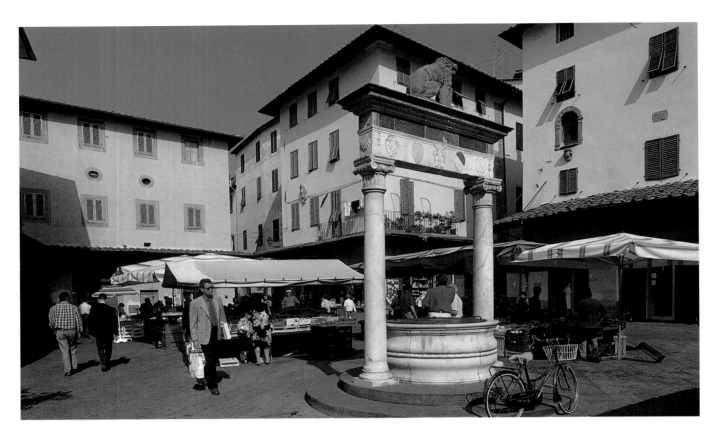

Restored to its medieval splendour, with tiled canopies and old stone counters, the intimate Piazza della Sala and its neighbouring streets form the most pleasant part of historical Pistoia. A fruit and vegetable market is held here every day. In the centre of the square stands the Lion Fountain (Pozzo del Leone). Facing page:
San Zeno, Pistoia's Romano-Pisan style cathedral with its three superimposed arcades dates from the twelfth century. The portico was added somewhat later and in 1505 was decorated with glazed terracotta tiles by Andrea della Robbia. Note the handsome green and white marble banding.

on the ground floor. Then we find ourselves back in narrow streets hemmed in by massive buildings, eventually coming out onto the ramparts with their rows of dishevelled plane trees. From this vantage point, there is a superb view of the surrounding mountains, their summits white with snow in winter.

History can be brutally cruel. By comparison with Lucca, now adorably provincial in character, Pistoia has become a desert to chill the blood. We watched a caravan of tourists, in search of the 628 figures in the Duomo's chapel of San Giacomo, cross the vast central square. Here one of the most noble complexes of monuments on earth – churches, baptistery, campanile, *palazzi* – seems struck by paralysis. Life, or what remains of it, has withdrawn into the city's silent dwellings. Blood courses through its veins only twice a week, when the clothes market takes place, and in summer during the blues festival and the picturesque jousting matches (Giostre dell'Orso) – a medieval festival during which twelve horsemen

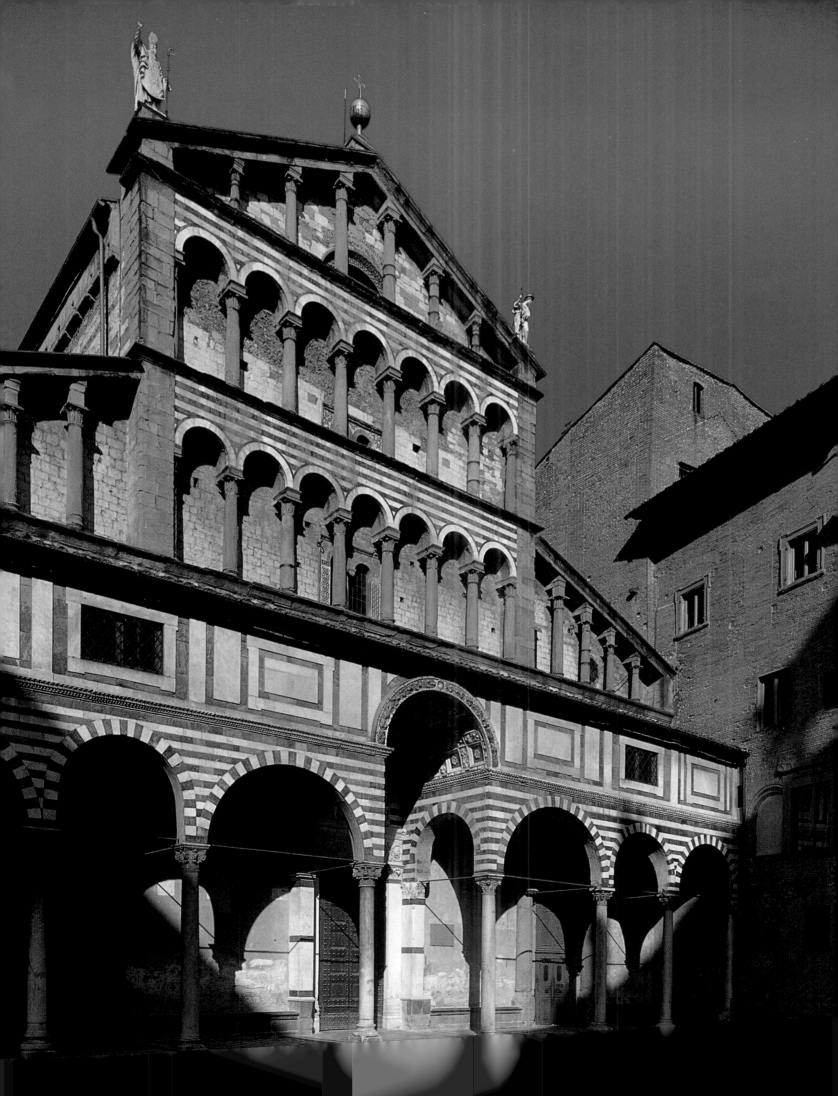

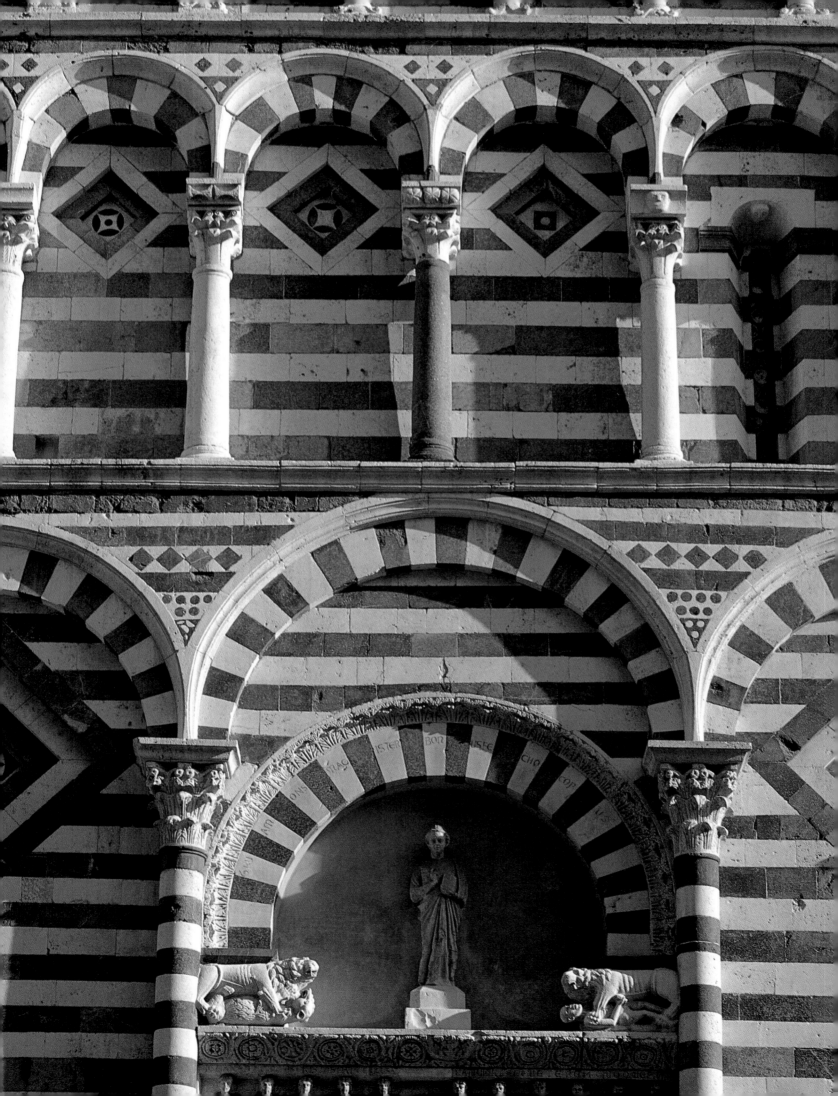

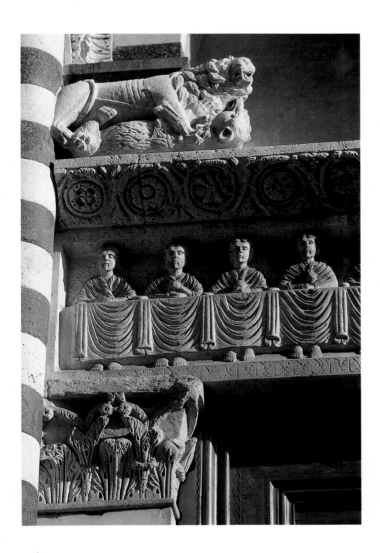

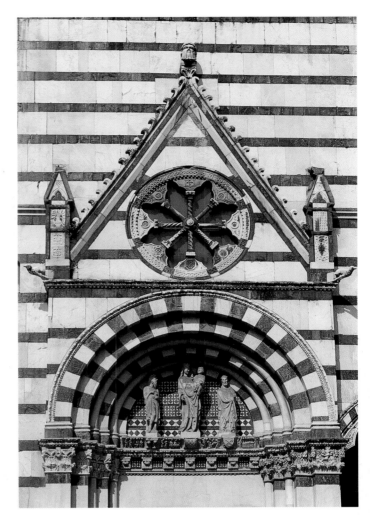

(three from each quarter of the town) have to tilt at figures of bears. For a few brief hours, the heart of Pistoia is again alive with colours, finery, and crowds.

Since Florence swallowed it up in the fourteenth century, Pistoia has been like someone wearing an oversize garment. Its residual life can be found each morning in the Via Stracceria and on the friendly little Piazza Sala, in the centre of which stands the Pozzo del Leone, the lion's well. Since it was restored, the daily fruit and vegetable market has recovered something of its medieval flavour. The tiled canopies and stone stalls cock a snook at the architectural pomp nearby. And the passing tourist easily falls in love with this convivial little square, which is perhaps unique in Italy.

The church of San Giovanni, dedicated to Saint John the Evangelist, was known as 'Fuorcivitas' because it was outside the city walls when work began in the twelfth century. This graceful side door with its double arch and alternating green and white marble is decorated across the lintel with a finely carved Last Supper. Note the individualised faces of the apostles and the modelling of the table cloth. In the tympanum of another doorway, we find a superbly executed Virgin and Child, set against a sophisticated mosaic of coloured marbles.

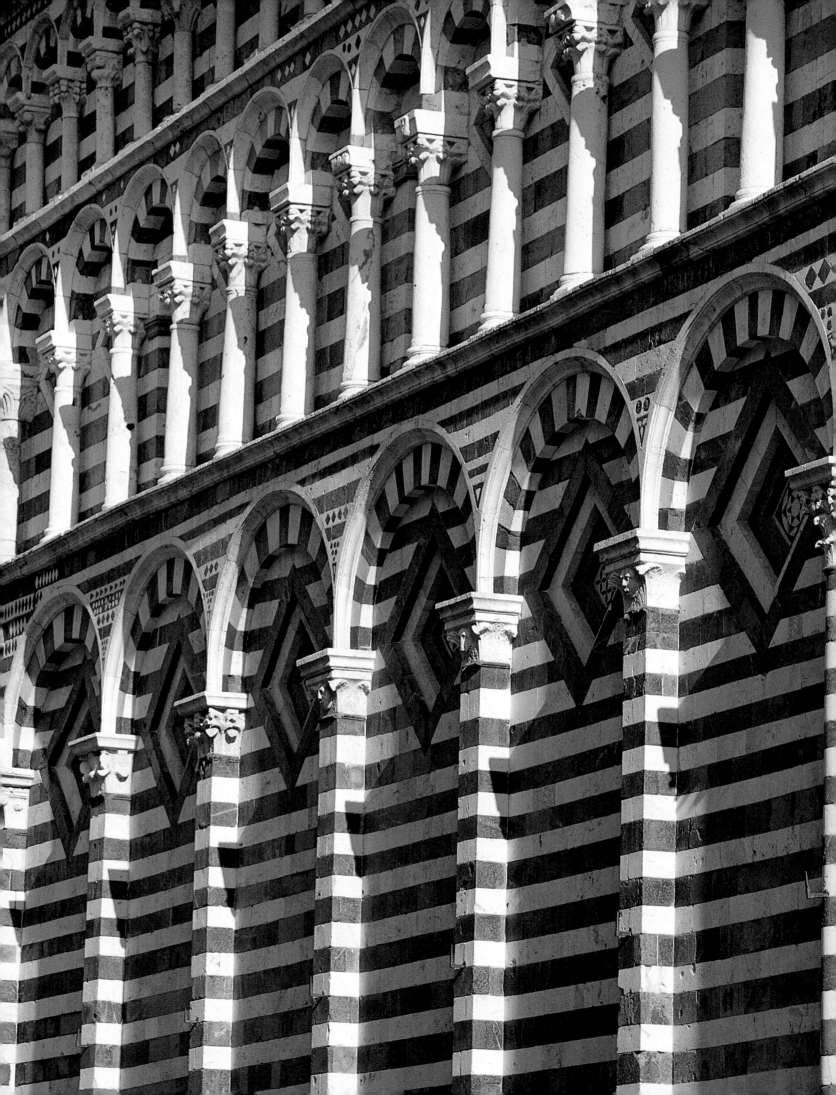

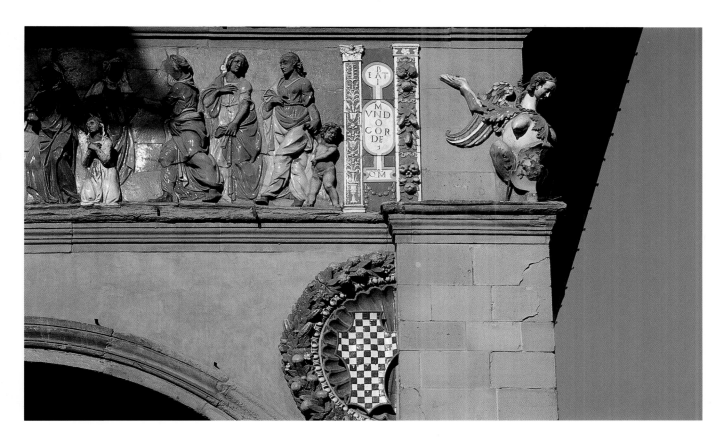

But it is time to leave the towns and discover a little-known area of Tuscany, taking the road from Pistoia to Vinci. It gradually climbs into the forest and enters a green, silent world of villages clinging to the slopes of distant hills, terraced gardens, and isolated farms. The road zigzags, climbs, and finally descends in a series of hairpins offering stunning views over the vineyards of Vinci, which produce a good fragrant wine.

The magnificent olive groves surrounding the much-altered farm in the hamlet of Anchiano where Leonardo was born must be centuries old. Instead of the black asphalt of the narrow, winding road, you can imagine the white dirt track on which he played as a child. This delightful spot is three kilometres (2 miles) north of the busy little town of Vinci, where a museum has been created in the castle. Here, as at the Clos Lucé in Touraine, where Leonardo spent the last years of his life as a "guest" of Francis I, there are models of his inventions, based on his sketches and diagrams.

The Ospedale del Ceppo, in Pistoia, was founded by a wealthy pious family at the end of the thirteenth century. It played a vital role during the plague epidemic of 1348, which ravaged the whole of Italy and particularly Tuscany. A loggia was erected in the sixteenth century and decorated with lively glazed terracotta friezes representing Works of Mercy (visiting the sick, prisoners, etc.). Facing page:
A magnificent example of the rhythmic effects that can be achieved with horizontal bands of green and white marble, and vertical semi-columns. The inlaid lozenges, which are repeated on the three unequally spaced registers, lend added grace to the whole. Note the wonderful light effects.

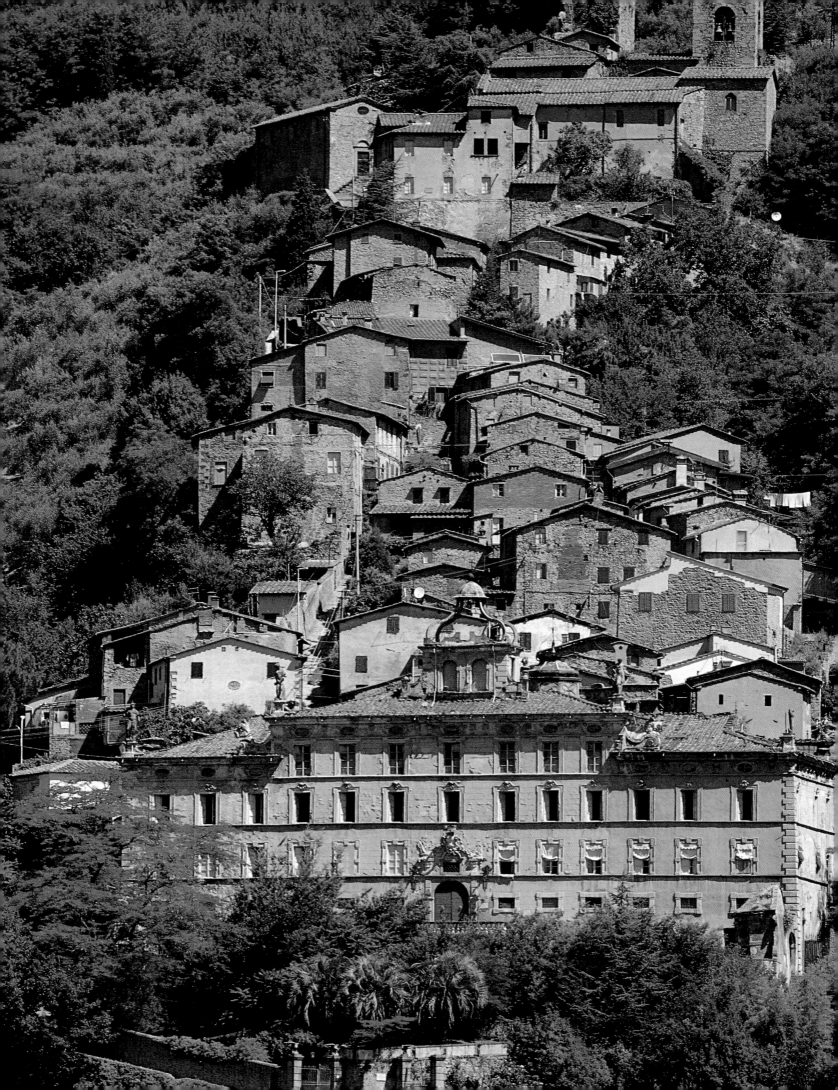

Pinocchio Park is devoted to the famous puppet whose nose grew longer every time he told a lie. Facing page: The interesting little town of Collodi, near Lucca. The houses seem to nestle against the Villa Garzoni, whose monumental façade is shown here. Owing to lack of space, the Italian garden with its theatrical flights of steps was laid out on the steepest part of the hill.

• Pinocchio •

Pinocchio, the young imp whose falsehoods made his nose grow longer, was invented in 1880 by the journalist Carlo Lorenzini. Lorenzini wrote under the pseudonym of Collodi, the name of his mother's native village, just a few miles from Lucca. The surrealistic and often violent adventures of the cheeky, disobedient little puppet enthused young Italian readers of the *Giornale per i bambini*. Having become an international hero and, much later, the star of a film directed by Luigi Comencini, Pinocchio now has his own theme park in the village of Collodi itself. Sculpted scenes remind young and old alike of the misadventures of the wooden puppet, which have entertained several generations. Collodi, alias Lorenzini, is buried in Florence, in the pretty little cemetery of San Miniato al Monte.

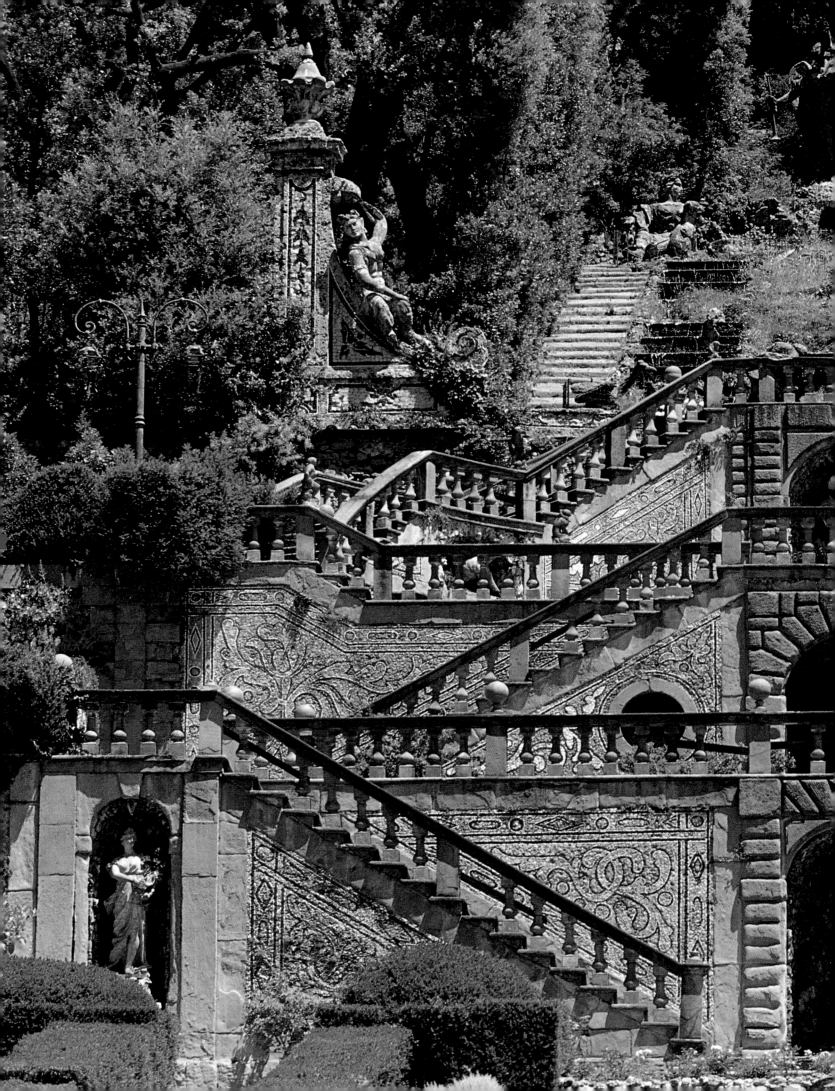

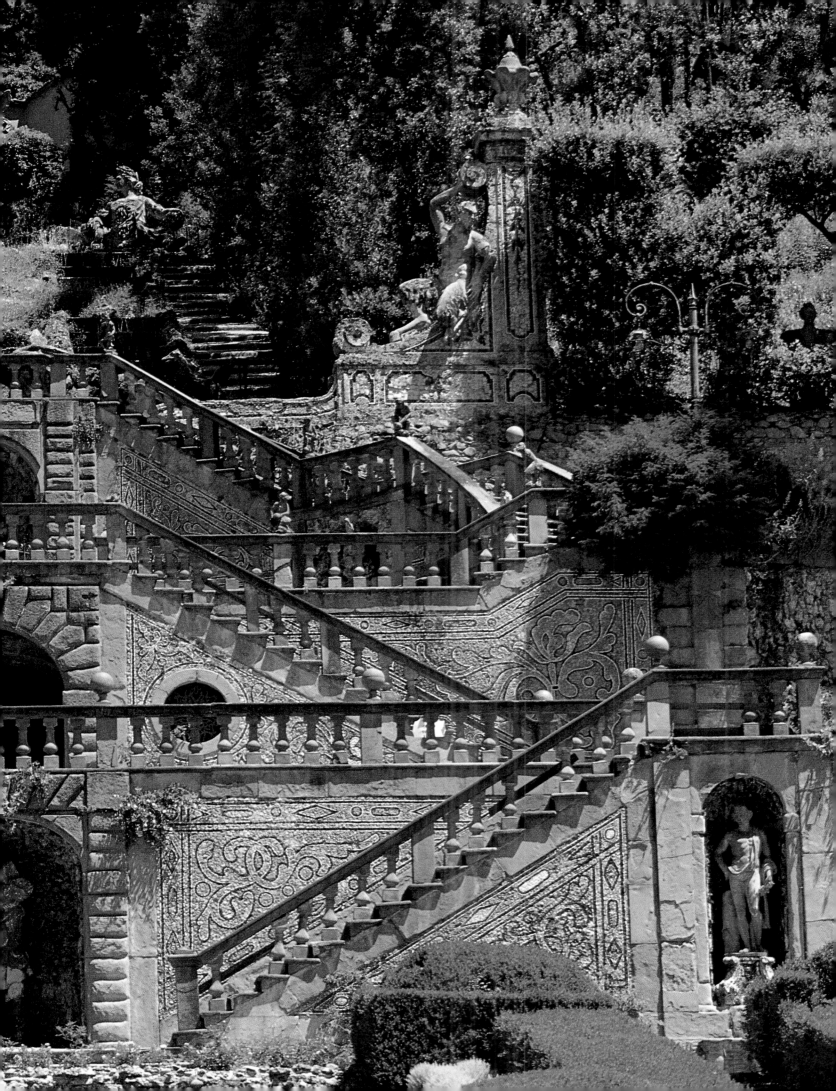

Leonardo da Vinci was born on an isolated farm in the hamlet of Anchiano, reached by delightful minor roads winding among olive groves. From this unspoilt vantage point, there is a fine view of Vinci.

Facing page:

Set among olive groves and vineyards – the delicious Carmignano wine has the fragrance of violets – Vinci's castle houses a museum featuring fifty or so models built from Leonardo's sketches. Fertile though Leonardo's imagination must have been, the drawing of a bicycle was added to his notebooks by some clever impostor in the nineteenth century. Another nearby museum – the Museo Ideale Leonardo da Vinci – also provides much food for thought.

We know that he had an encyclopaedic mind, but the sheer breadth of his knowledge and intuitions is a revelation. His ideas included a steam canon (the water was passed over red-hot coals, turning into steam whose concentrated force propelled the projectile), a tank, and a multi-barreled machine gun. He conceived the principle of the hygrometer (wax was placed on one scale of a balance, on the other cotton wool, which gained weight as it absorbed humidity from the air and activated a pointer to indicate the degree of humidity on a graduated scale). His banking indicator is now used in aviation; and his paddle boat became reality two centuries after his death.

Leonardo was a contemporary of Copernicus, Michelangelo, Luther, and Raphael. In 1492, Columbus discovered the New World; in 1498, Vasco da Gama opened the route to the Indies. In 1495, Leonardo painted his celebrated Last Supper, and in 1504 the Mona Lisa – the same year that Michelangelo began work on the Sistine Chapel. What a time to be alive!

Furtive glances
AT FLORENCE

Florence surrounded by hills. In the foreground, the dome of the cathedral, Brunelleschi's technical tour de force, built between 1420 and 1436 and still a source of admiration for architects. Sixty metres (197 feet) above the ground at the base, spanning 42 metres (138 feet), it was built without the benefit of scaffolding or wooden centring. It had to be an ultra-light structure because the walls of the octagon on which the dome rests were rather fragile. Brunelleschi's solution was a double shell and a revolutionary technique for anchoring the stonework, to divert part of the thrust horizontally and upwards.

Seven o'clock in the morning. Michael is singing as he waters the pots of azaleas in the hotel courtyard. He calls out to Pepino upstairs, who calls Antonio in the kitchen to find out if breakfast is ready. No? They had better hurry up, then, the first guests are about to come downstairs. All of this is at the top of their voices, with the sound reverberating from one wall to another. Not much chance of a lie-in…

Outside, the sun is warming the old walls of the Borgo Pinto, one of those anonymous streets in the old city centre lined with venerable dwellings, through whose carriage entrances you get a glimpse of delightful gardens. The blackened stone suddenly takes on a honeyed colour, the dust dances in the sunbeams. It is the hour of the street cleaners, policemen towing away illegally parked cars, and the sugary smell of early-morning confectionary.

In Piazza della Repubblica, the heart of modern Florence, a scattering of customers enlivens the terrace of the Café Paszkowski, edged with potted palms, its salmon-pink tablecloths cheered by the sparkling sunshine (in the evening, sip your aperitif on the other side of the square, at the renowned Giubbe establishment). From

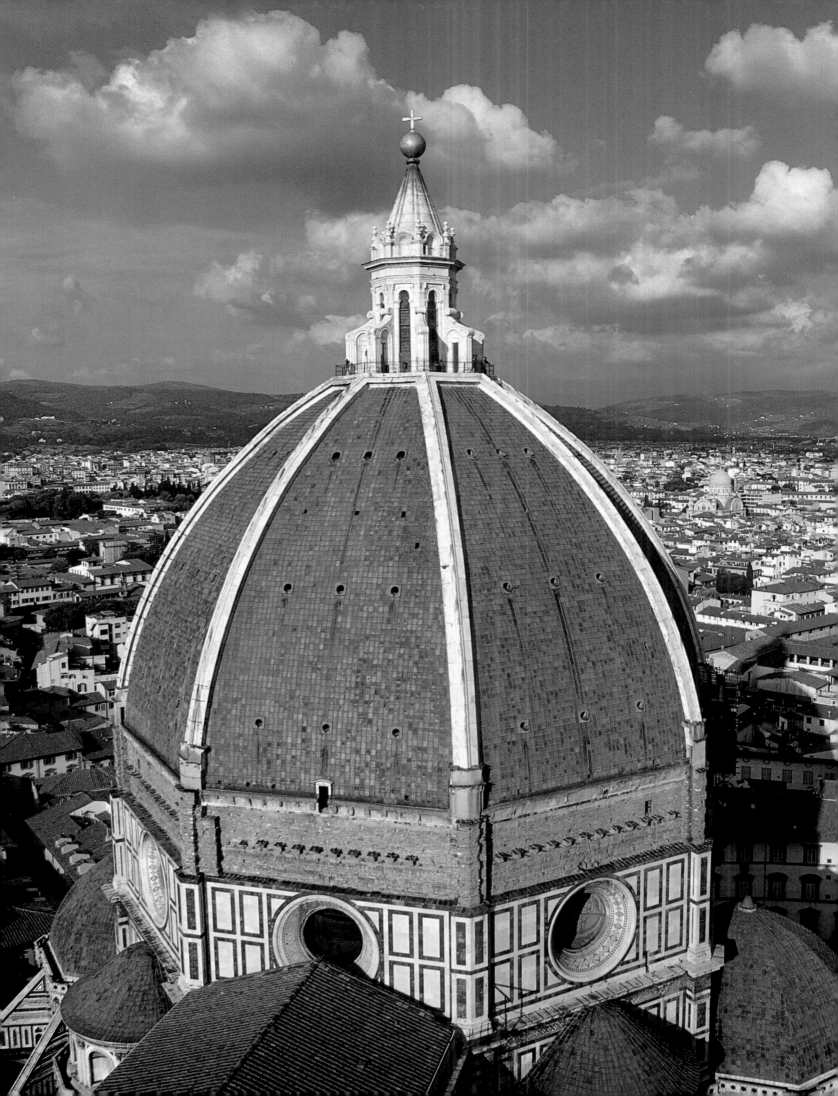

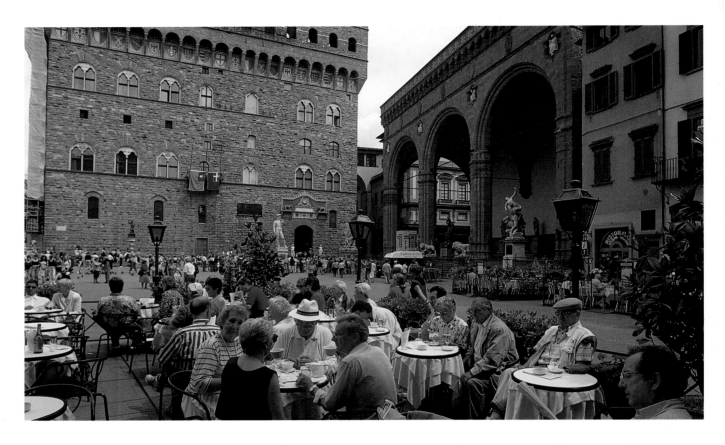

The Piazza della Signoria in summertime, looking towards the Palazzo Vecchio.
On the right is the Loggia dei Lanzi, with copies of Giambologna's Rape of the Sabines and Cellini's Perseus.
Facing page:
The church of Santa Croce (façade dating from the nineteenth century) is Florence's pantheon, containing among others the tombs of Michelangelo, Machiavelli, Galileo, and Rossini.
Note how the jumble of roofs has lent itself to the creation of terraces, conservatories and balconies.

this strategic point, there are lateral views of the towered houses that greeted Dante every morning and, beyond the pompous late nineteenth-century arcades, the proudest and most lugubrious residence in Florence, the Palazzo Strozzi, now owned by a bank.

Slanting sunbeams lend softness to the stone. Fountains murmur gently. From the belvedere of Piazzale Michelangelo, still deserted at this hour, a few lovers of beauty look down on Florence as she sprawls comfortably in the pearly morning light. The air is pleasant, almost cool. The tourist hoards are still showering or eating their bread and jam in hotel dining rooms.

Let us go and sit in Piazza della Signoria, on the terrace of the Café Rivoire, with a cup of its celebrated hot chocolate. Not even Hollywood in all its glory could invent so amazing a setting. The Ghibelline houses that stood here in the Middle Ages were razed by the victorious Guelf faction, and the losers were forbidden to rebuild on the ruins. Hence this magnificent, strangely shaped

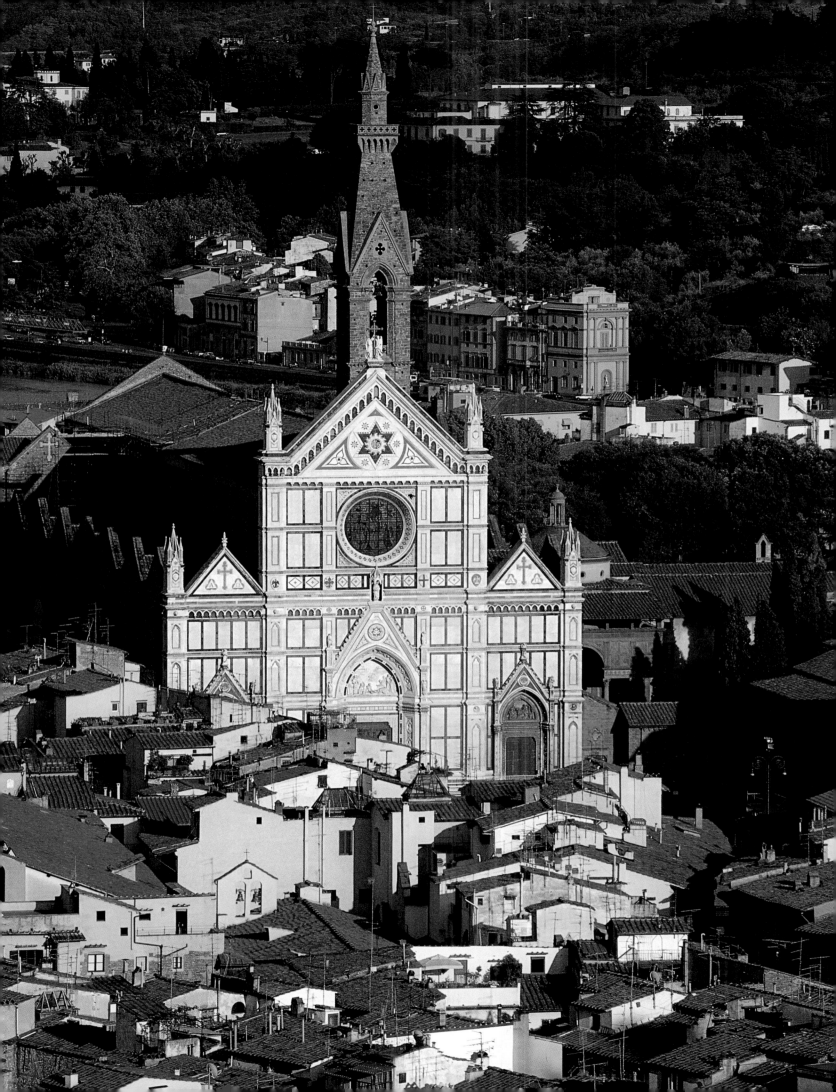

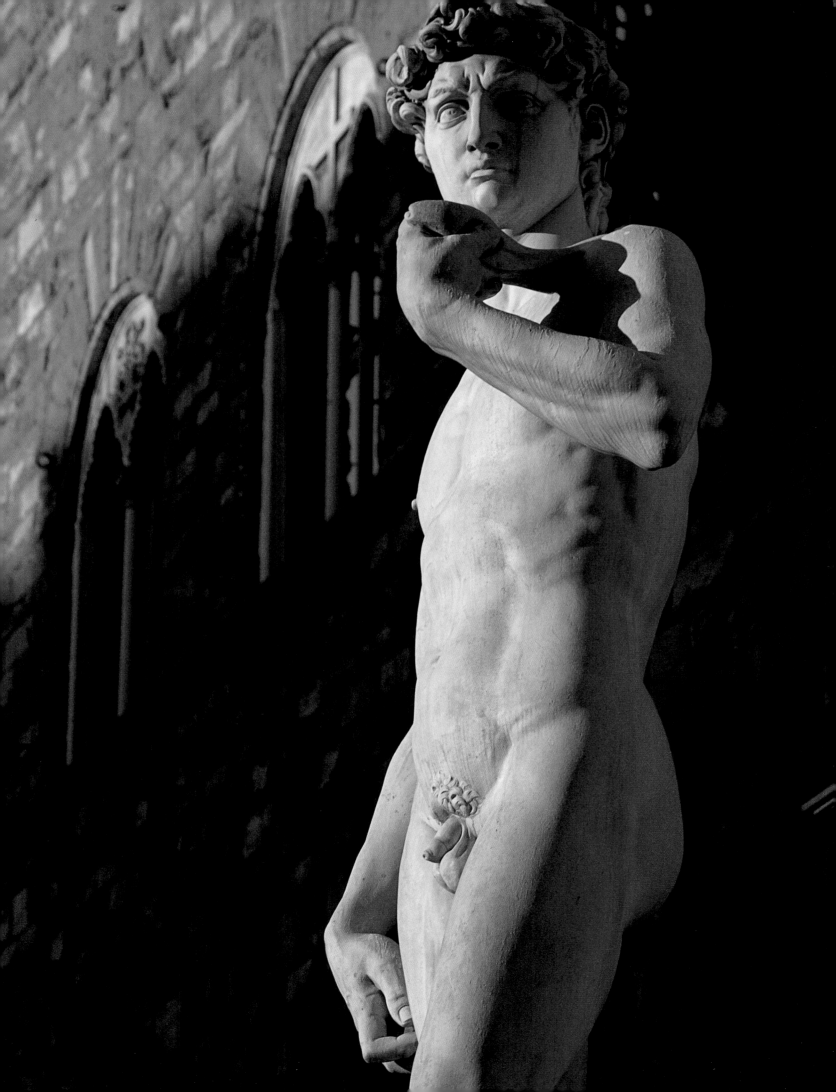

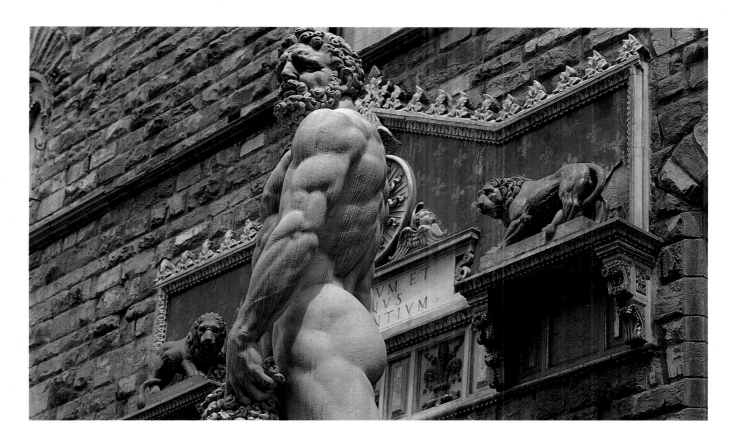

square, surrounded by massive buildings and soberly adorned by a fountain of Neptune with ravishing water nymphs and the elegant Loggia dei Lanzi sheltering copies of Cellini's Perseus and Giambologna's Rape of the Sabines.

The enormous, surly, and fascinating Palazzo Vecchio seems to have been pushed back into a corner of the drawing room, like an oversized piece of furniture. Here the very stones cry out. At the top of the alberghettino tower (literally, the little hotel!) is the dark cell where the martyred Savonarola spent his last days before being burnt to death as a reward for his strivings to bring morality and virtue to Florence. From the windows of the forbidding *palazzo* peep the ghosts of those hanged for their part in the failed plot against Lorenzo the Magnificent. Behind a plate-glass window, Marino Marini's striking bronze horse looks placidly down on the spectacle from the upper floor of the Galleria d'Arte Moderna. Somewhere, a group of clarinettists is playing a morning serenade.

On one side of the entrance to the Palazzo Vecchio stands Michelangelo's David (1501, the original is in the Accademia), sculpted from a single block of marble when he was thirty. Bandinelli's Hercules, opposite, seems pale by comparison, despite his Charles Atlas physique.

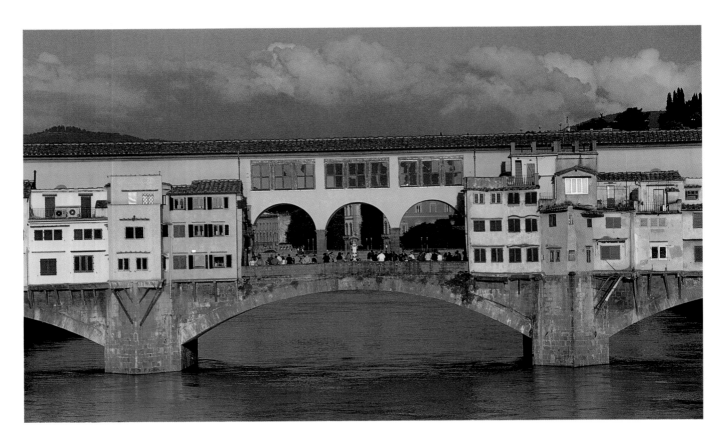

All Florence's bridges were destroyed in 1944, except for the Ponte Vecchio, built in 1345. In the warm evening light, it is a place to meet friends or simply admire Florence. Closed to traffic, the bridge is famous for its goldsmiths' workshops. They have replaced the butchers, who once threw their offal into the Arno.

People say that Florence is hamstrung by its past, and that is true. Its destiny is too much for it to cope with. It is not just a question of assuming responsibility for its visual splendour and world-famous museums. Florence itself is a masterpiece, wrought by a brilliant company of architects, sculptors, and painters who, especially in the fifteenth century, made the city a beacon for the entire Western world. It was one of those fortunate times when art brought about a revolution in thinking in a prevailing climate of economic liberalism. At the Uffizi museum, the sensitive visitor can follow the slow emergence of a new concept of Man and his place in the universe. This revolutionary process took place then in a context of carefully coded religious subjects – Annunciations, Virgins and Child, biblical scenes... And yet, from Duccio and Giotto to Masaccio and Michelangelo, you can follow a scarlet thread which leads from an almost disembodied representation of the human figure to the triumph of expression, life, and movement.

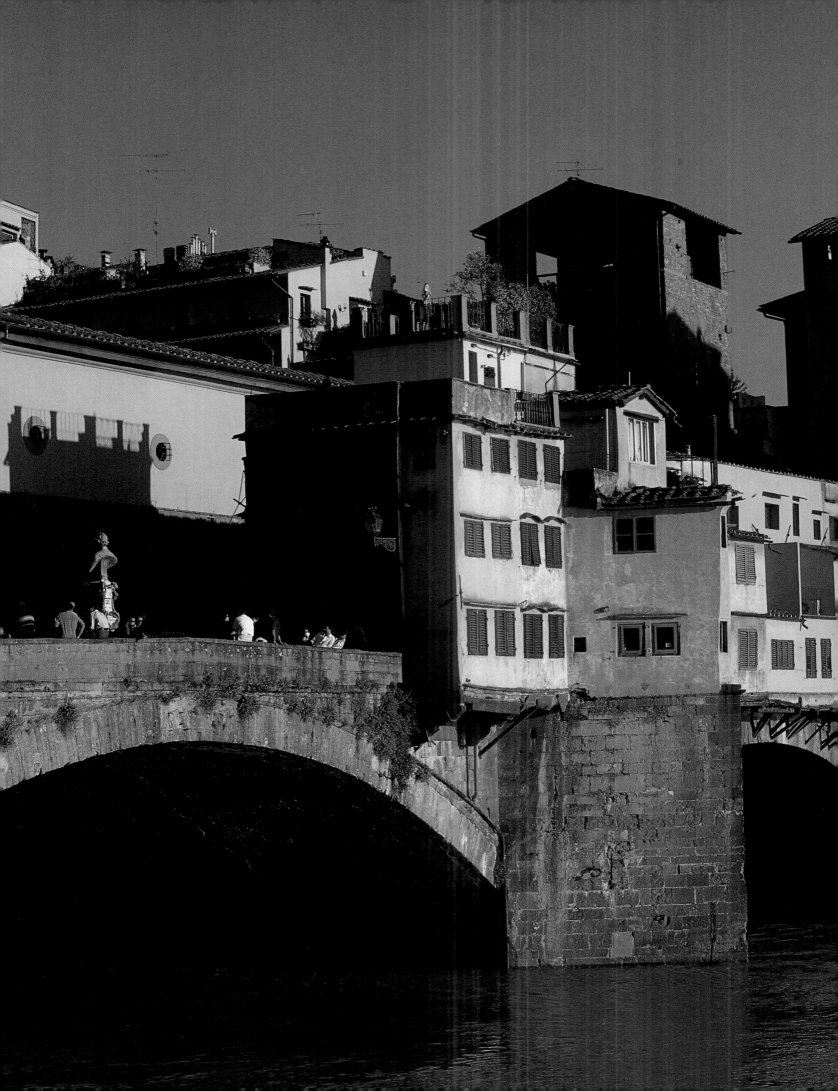

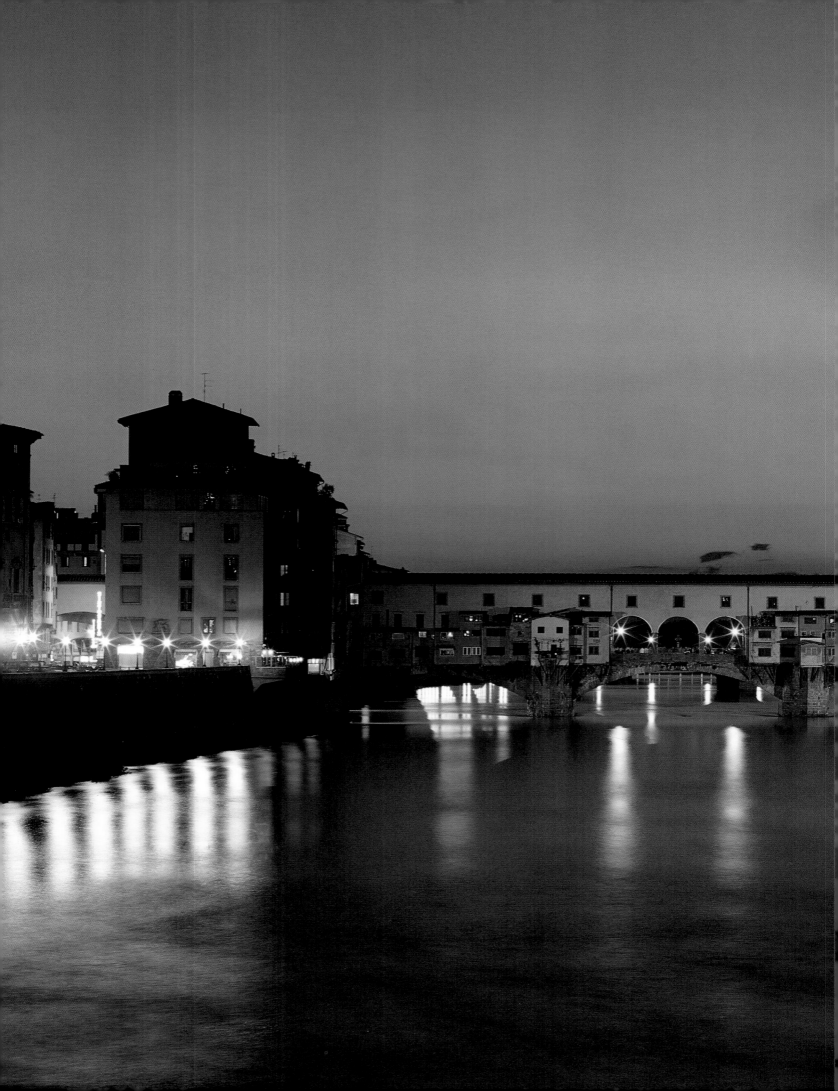

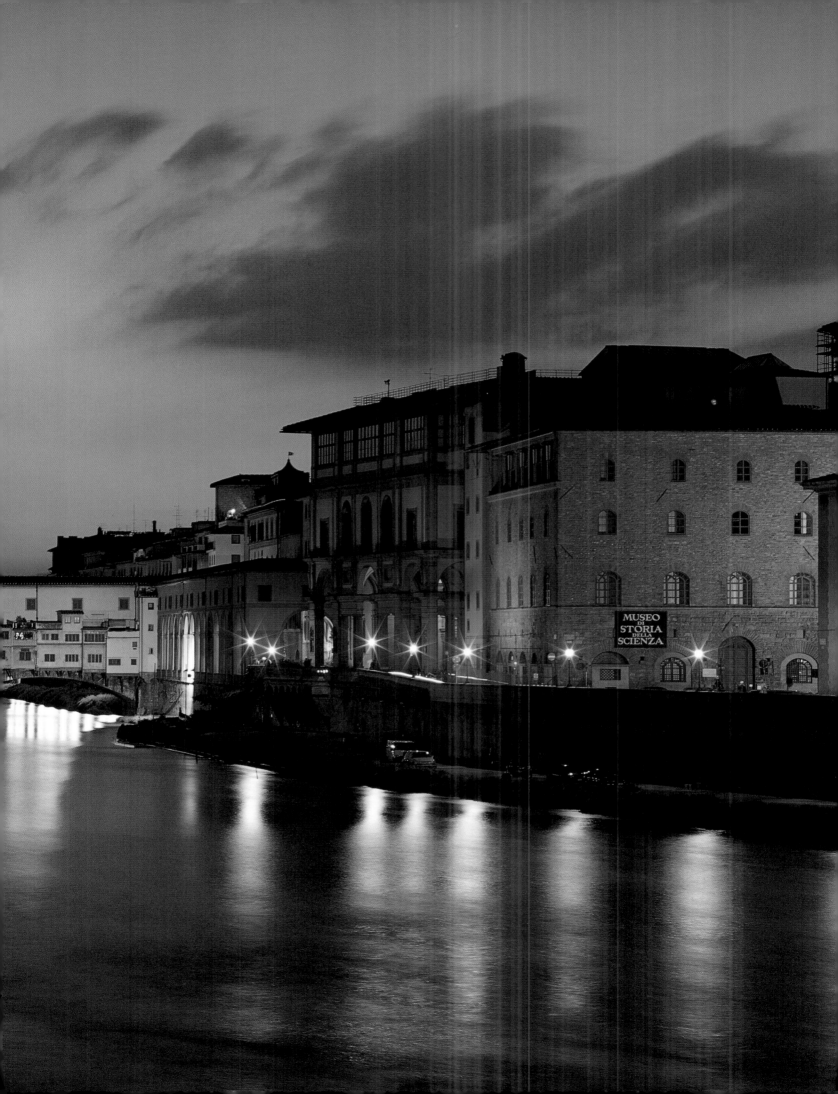

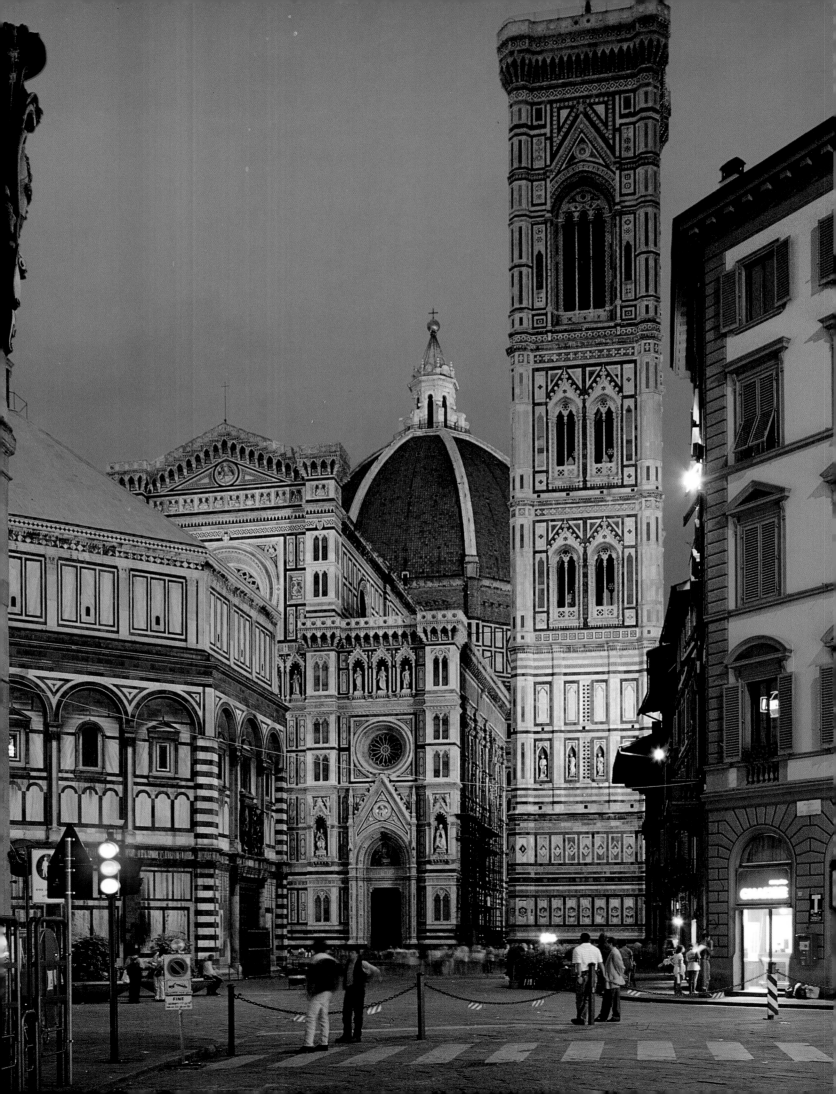

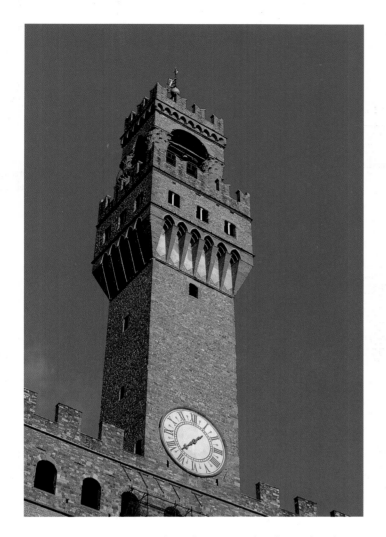

The pity is that art has become the bait for business-orientated tourism. The only solution is to go against the flow. In the pocket-handkerchief sized district of Santa Croce, try visiting Michelangelo's house (Casa Buonarroti), which shows the flip-side of his genius. Then wander round to Brunelleschi's pleasant cloister, one of the most charming oases in Florence. A little further on, you can enjoy the intimate atmosphere of Palazzo Horne, attractively furnished and hung with some fine paintings. Cross the Arno and lose yourself among the sumptuous jumble of paintings, ironwork, sculpture, and furniture amassed by Bardini, Florence's first antiquarian and art collector. Then follow the river as far as the Ponte Vecchio and visit the unassuming church of Santa Felicità, set in its own little square. It contains a sublime Deposition painted by Jacopo Carrucci (known

Of the towers and belfries that stand out above the roofs of Florence, two are recognisable at a glance: the bell-tower of the Palazzo Vecchio, seat of the republican government; and the marble lantern of the Duomo (cathedral), which acts as a keystone in blocking the upward thrust of the dome's great stone ribs – another example of Brunelleschi's technical genius.

Facing page:

Baptistery, Campanile, and Duomo: these three monuments, begun in the Middle Ages, were beacons of the quattrocento Renaissance spirit.

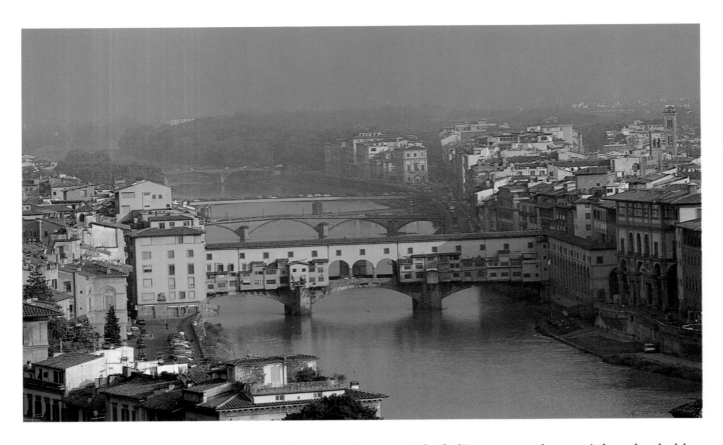

View of the Arno and its bridges. In the foreground is the Ponte Vecchio with its shops (the upper windows are part of Vasari's Corridor, a raised walkway one kilometre (about ½ mile) in length, linking the Uffizi with the Palazzo Pitti).
The second bridge with its three graceful arches was designed in 1567 by Ammanati and rebuilt to his original plan after being blown up in 1944. The third bridge, the Ponte alla Carraia, also rebuilt after the war, is said to have been designed by Giotto.
Facing page:
Florence from the hillside belvedere on the other side of the Arno. The district in the foreground, presided over by the Palazzo Vecchio, is still one of the most pleasant and unspoiled.

as Pontormo). In a swirl of olive-green, salmon-pink and pale-blue draperies, the bearers of Christ's mother-of-pearl body look straight at you, still terrified and wild-eyed.

Florence is a maze of secret, private itineraries, triggering the magic of serendipity. It is always a delight to stumble upon unsuspected masterpieces. For example, in Santa Trinità you may come across Angelo Poliziano who, half way up the steps, stands facing Lorenzo the Magnificent himself, fascinating with his strong nose, sensuous mouth and jutting chin. In the Green Cloister of Santa Maria Novella, you come face to face with Paolo Uccello's terrifying tale of Noah. And you need to keep a sharp eye out to grasp the marvels which adorn façades, squares, and niches: the statues around the outside of Orsanmichele, or the enamelled ceramic medallions of babies by Andrea della Robbia above the arcades of the Ospedale degli Innocenti in the Piazza Annunziata. Florence is an inexhaustible treasure house for those with their wits about them.

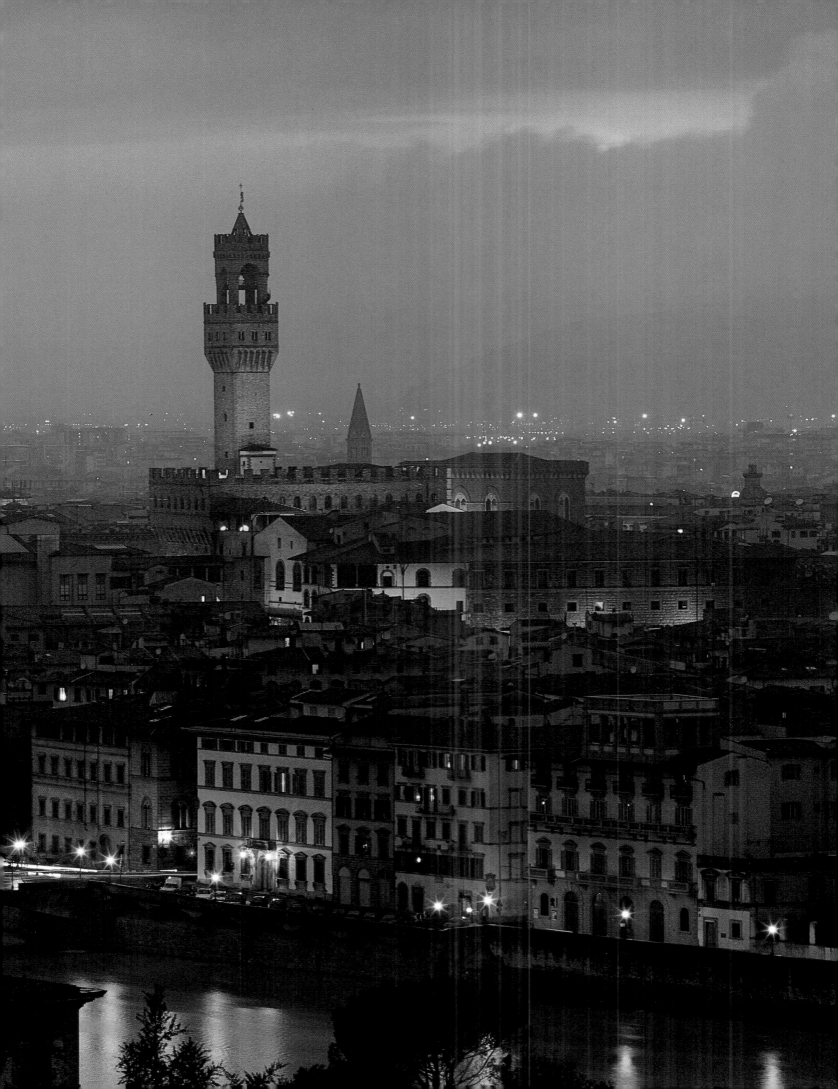

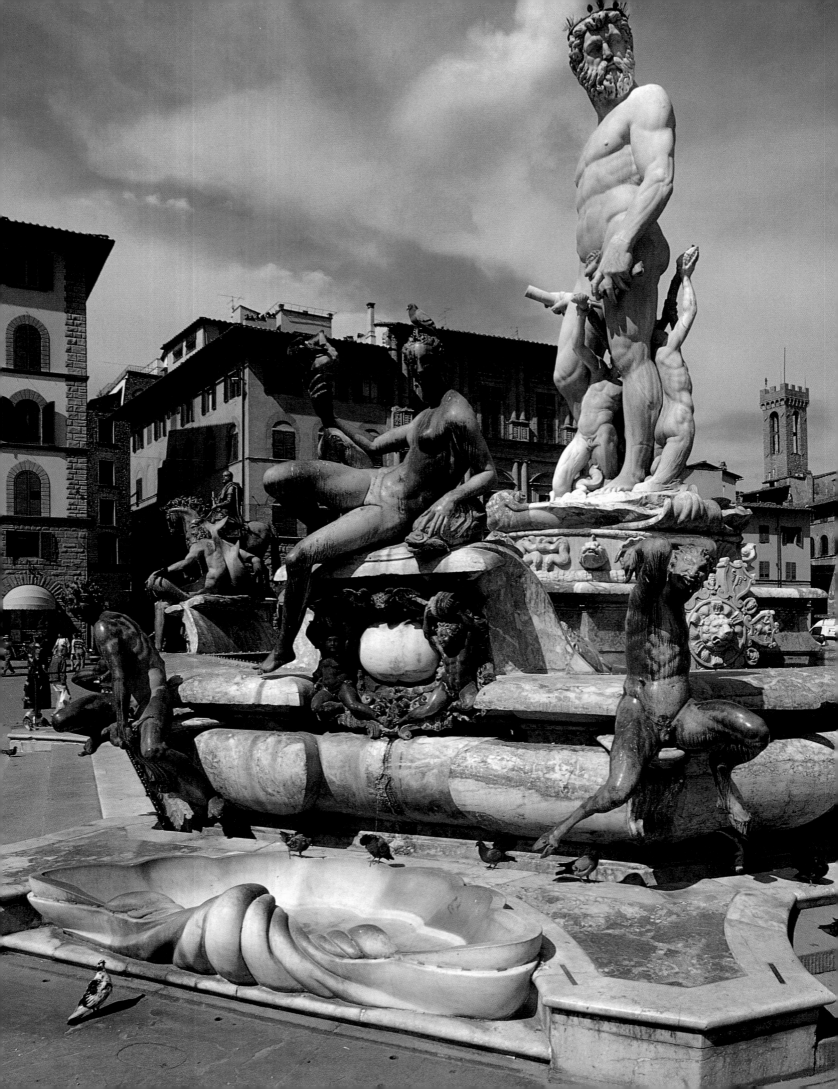

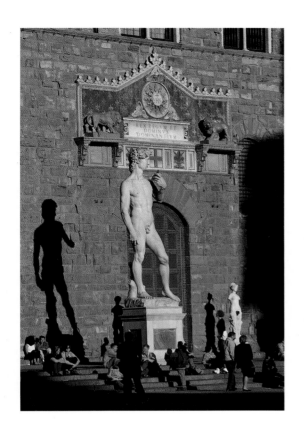

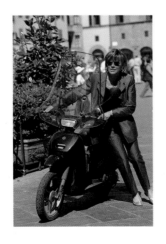

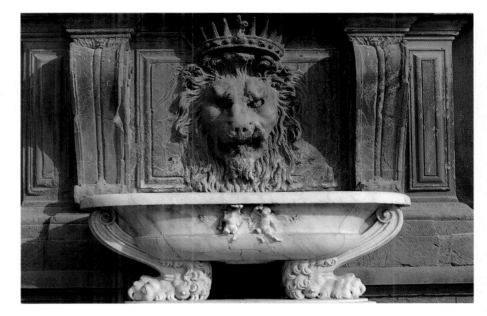

The lion is the emblem of Florence, often represented against a background of lilies. This crowned lion from the Boboli gardens, behind the Palazzo Pitti, is a reminder that Florence was once the capital of a Grand Duchy.
Florence, home of some great couturiers, is also a centre of European fashion. The Florentine women are the city's best ambassadors, even when riding a scooter.
Facing page:
The Neptune fountain in the Piazza della Signoria. "Ammanati, what a fine piece of marble you have ruined", Michelangelo is supposed to have exclaimed on seeing the naked giant. The graceful water nymphs are the work of Giambologna.

> *"A good Chianti is the antechamber*
> *to paradise – if it exists!"*
>
> *Léo Ferré*

CHIANTI COUNTRY
and the Val d'Elsa

Brolio, in the Chianti region, is the symbol of a revival in Italian wine-making. It was here, in the nineteenth century, that Baron Bettino Ricasoli founded the Chianti League. His descendants continue successfully to manage the family estate.

Saturday morning. Market day in the great triangular square at Greve in Chianti, nestling in its valley. You can hardly move for people. The sloping piazza is surrounded by arcaded terraces sheltering restaurants and little gardens. The arcades converge on the apex of the triangle, framing a cream-coloured church and its campanile. The atmosphere is definitely rustic. The men are wearing caps or old felt hats, baggy trousers hanging loose. They take out pocket knives to try the pork products displayed in such profusion on some of the stalls. The bottles of Chianti proffered by the stall-holders are emptied with an alacrity that eloquently testifies to the perfect match between salami, brown bread, and wine. Any good salesman knows that a glass or two stimulates the tastebuds, and that the resulting good humour is likely to loosen the purse strings. But wife tugs at husband's sleeve and breaks the spell: come along now, we've done our shopping!

People come not just to buy provisions, but to chat, meet old friends, and keep up with the latest gossip. Greve market, they will tell you, is the weekly entertainment for miles around, and the

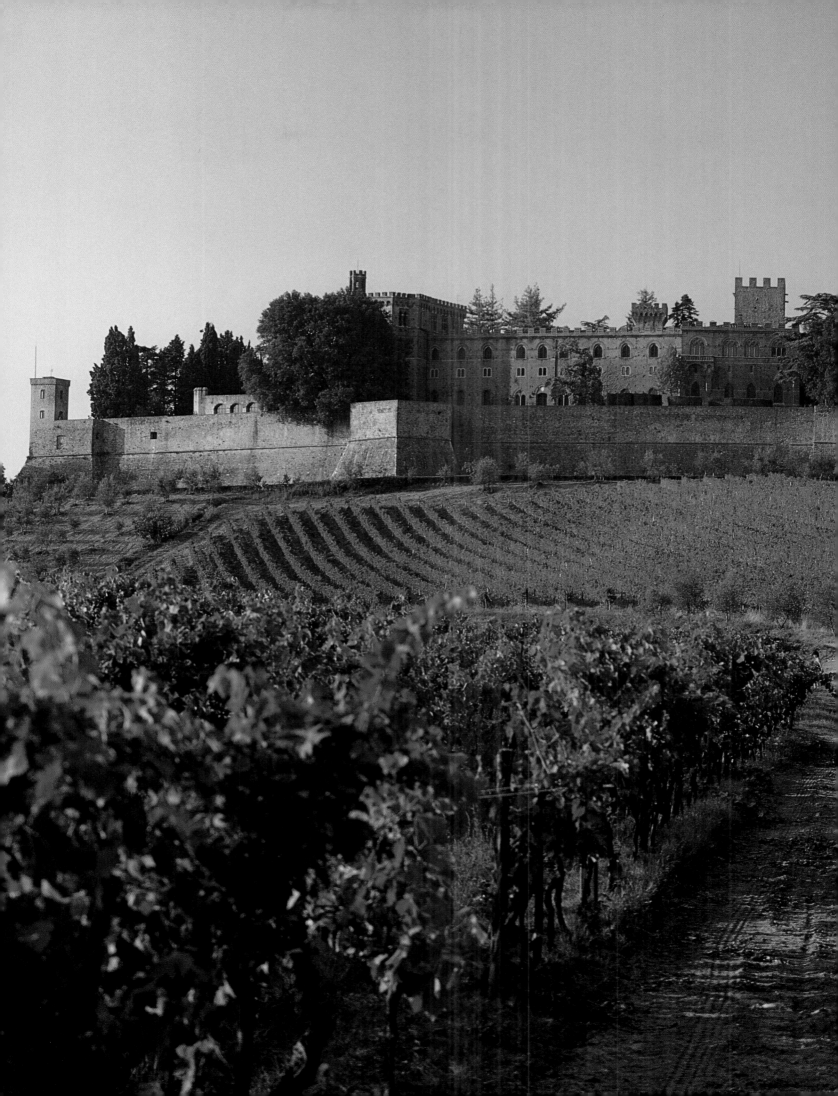

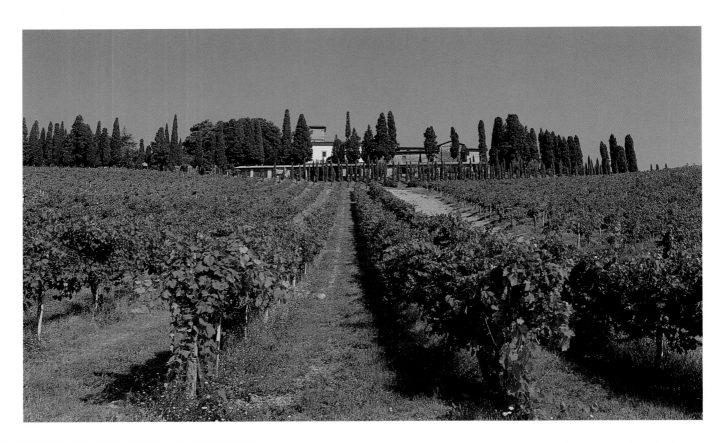

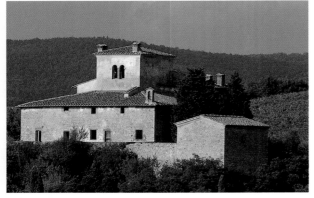

A typical estate in the Chianti region, with cypresses immediately around the house and vineyards beyond. The landscape is hilly and the vegetation varied. In the distance are wooded hillsides, but the sunniest slopes are planted with vines.

children can amuse themselves out of harm's way under the long pedestrian arcades, where the shops are stuffed with bric-à-brac. Greve is only thirty kilometres (18 miles) from Florence by the old road (222), the most scenic route – thirty kilometres of switchback bends, sudden descents, and long hill climbs. On the first stretch, you pass heavenly lemon-coloured villas hidden away among flowers. Then the view opens out. Green hills, with large villages clinging perilously to their slopes, stretch away into the distance. Already there are rows of impeccably pruned vines, with a decorative climbing rose planted at the head of each row. The earth is reddish, stony, planted at intervals with olive groves.

Greve is just a small wine-growing town, more striking than most due to its strangely Alpine atmosphere. It marks the first stage on the Chianti route to Siena, one of the most attractive in Tuscany. Though surrounded by modern highways, much of the Chianti massif is still virgin territory. The villages were well acquainted

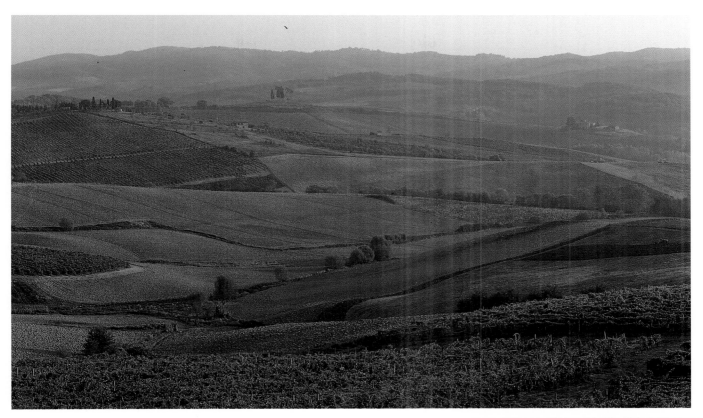

with poverty until the agricultural reforms of the nineteenth century. But they did not really prosper until the *Denominazione di origine controllata* (DOC) appellation was introduced, on French lines, in 1967. Their position was further improved by the 1984 reform, which defined the limits of the Chianti-growing area more accurately and established precise rules regarding grape varieties and the proportions in which they may be used.

Yet wine-making is an ancient tradition of this region. Greve aspires to the title of capital of the Chianti Classico area, but Castellina, in a superb position twenty or so kilometres (12 miles) further on, was the headquarters of the Chianti League in medieval times, as was Radda in the fifteenth century. Their emblem was the *gallo nero*, black cockerel, now the badge of authenticity of Chianti Classico wines.

Friendly rivalry is evident, with every village having some special claim to fame: Tiepolo made his animal sketches at Impruneta,

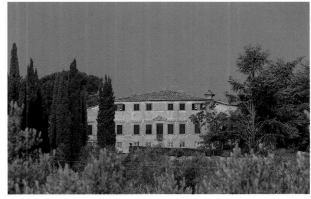

In Tuscany, vineyards tend to alternate with other crops, forming a landscape of soft hues, from lavender blue to fresh green.
Noble residences, too large and expensive for a modern family to run, are gradually falling into decay. In its proportions, this house is reminiscent of Artimino, near Florence, which was designed by Buontalenti.

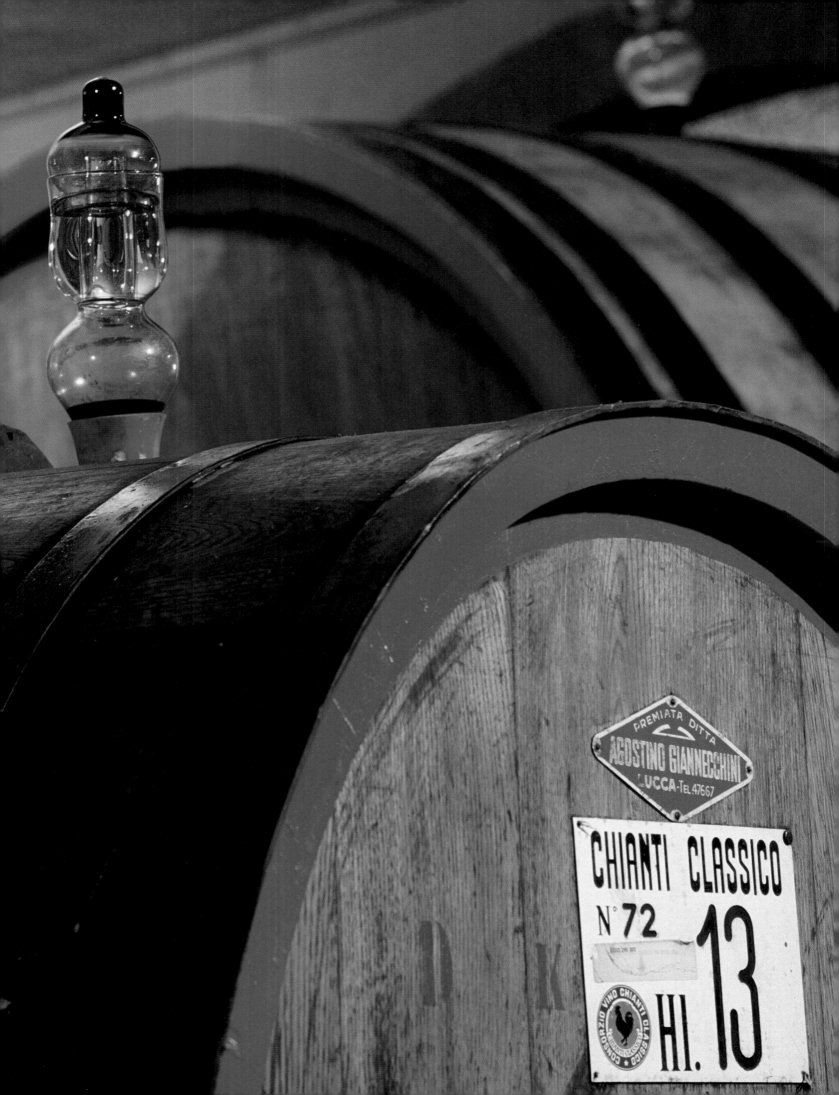

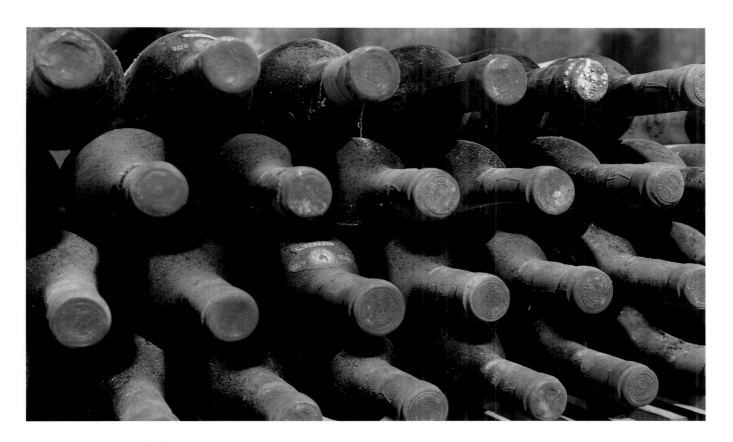

*T*he growing area of Chianti Classico, which can be aged for up to five years,
is strictly controlled. It extends from Greve, Radda, Gaiole and Castellina westwards
into the Val d'Elsa. The 'Classico' appellation has more to do with geographical location
than with the grape varieties employed. The distinctive emblem is a black cockerel.

• Chianti •

The formula for Chianti as we know it dates back to the mid-nineteenth century, when it was imposed by Baron Ricasoli. Red grapes account for 80% of a Chianti wine, used in the following proportions: 50 to 70% of the Sangiovese variety (for colour and bouquet), 10 to 30% Canaiolo Nero (aroma and mellowness). The balance is made up of Malvasia, a white grape which gives acidity and finesse. The name on the label reflects the area of production, not the grape varieties used. The Chianti Classico appellation (12° minimum) is strictly reserved for a small area covering approximately 70,000 hectares (175,000 acres), which embraces Greve, Panzano, Castellina, Radda and Gaiole. Bottles of Classico are easily recognised by the black cockerel symbol on the label. Excellent varieties can be bought directly from producers and from wine merchants in Greve, Castellina, and Panzano.

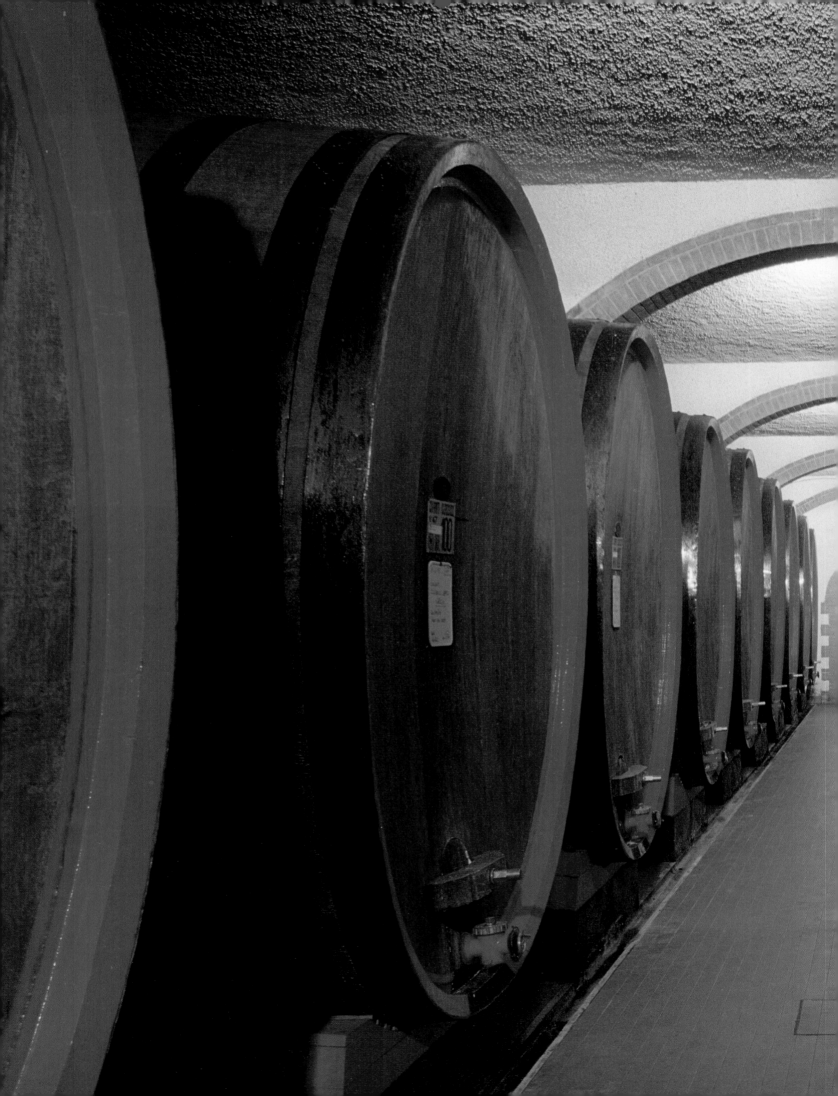

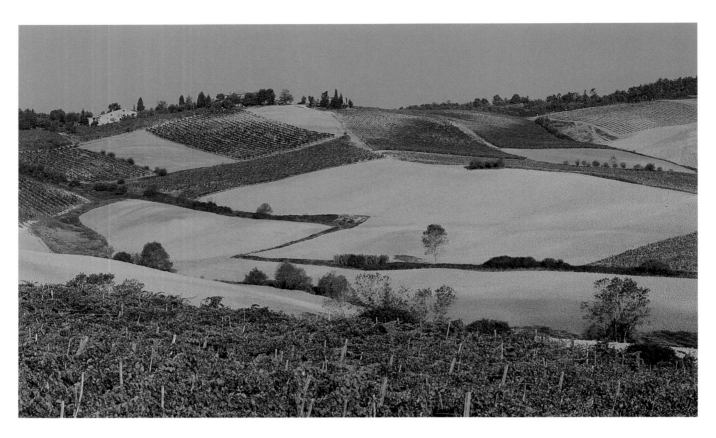

Typical of the countryside north of Siena, with its mixture of wine-growing and cereal production, this landscape is reminiscent of the Lorenzetti brothers' fresco of Good and Bad Government (Palazzo Publico, Siena).
Previous pages:
Signs displayed along the minor roads of the Chianti region tempt visitors to visit wine cellars and – the owners hope – make a purchase. This is the aristocratic estate of San Felice, in the Chianti Classico area.

where there is still a horse and mule market. Montefiorale, with its tower houses, is especially medieval in atmosphere, and Gaiole can boast the nearby fortress of Vertine, long coveted as a military strong point.

However, the location most pregnant with symbolism is undoubtedly the country seat of Brolio, originally built in the thirteenth century, but "heavily restored in the nineteenth century", as the Guide Bleu so coyly puts it – in other words converted into a sub-Elizabethan monstrosity. Here it was that Bettino Ricasoli, the iron baron, began reorganising a wine industry that had got completely out of hand. He restored its prestige by replacing the cheap local Moscadelletto with a richer wine based on the Sangiovese grape variety, which continues to be the essential component of modern Chianti. Still owned by the same family, which "grows" a wine much appreciated in America, it is a magnificent place. Depending on the mood of the

caretakers, you may be able to see the beautiful mosaics in the fifteenth-century chapel of San Jacopo. But even better is the view from the terraced gardens: the eye takes in an endless swelling sea of variegated brown and yellow hills, fading into the distance at the foot of Monte Amiata (1,738 m; 5,702 ft), which rises from the landscape with all the majesty of an Italian Fujiyama.

At table in the charming Antica Trattoria la Torre, opposite the church in Castellina, we are not sure which way to go next. This opulent village, including the Palazzo Ugolini, is perched above the enchanting landscape of the Arbia valley. From morning to evening, the inhabitants are blessed with the view of these vine- and olive-covered hills, whose crests are planted with avenues of cypresses leading to mysterious farmsteads. Let it not be forgotten that twenty million olive trees were destroyed by frost in 1985. A farmer with 8,000 trees yielding 10,000 litres of olive oil saw his production fall to a mere 500 litres. And it will take some years yet to recover from the disaster.

Castellina is a crossroads at which to dream. To the north is Florence, to the south Siena: two superstars of the tourist circuit. To the east lies Radda and the other side of the Chianti massif, the more romantic with its red-earth woodland trails. To the west is Boccaccio's Val d'Elsa; San Gimignano, pictures of whose tower houses have fascinated me since childhood; and the mineral-rich hills of Etruscan Volterra. A grappa, landlord! No, make it two! We'll need them for so difficult a decision.

In the end we went west into the relatively unsung regions of the Val d'Elsa, and certainly did not regret it. At Castelfiorentino, we discovered some stunning frescoes by Benozzo Gozzoli, a far better artist than the critics are willing to concede. At Colle Val

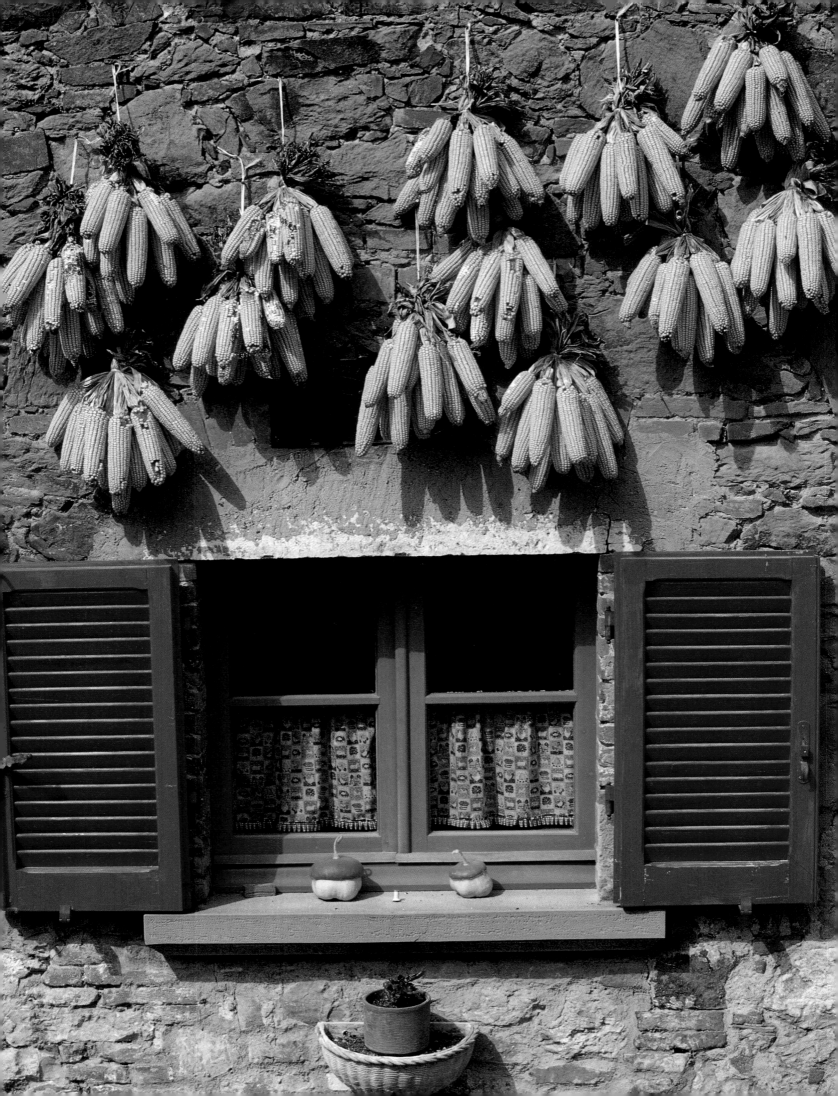

Diversity of crops and colours is a feature of Tuscany's small-scale agriculture. The Sangiovese grape accounts for 70% of a normal Chianti, giving it body and colour.

It does not take much to brighten the most ordinary façade: drying corn cobs which attract the birds, a window set in brown stone, candle-like squashes, and a basket-work flower-pot holder…

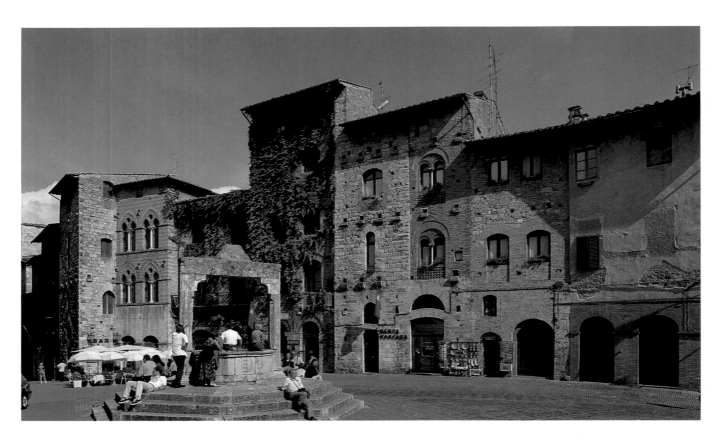

Stage set or reality? The Piazza della Cisterna in San Gimignano. For almost eight centuries this medieval well must have been the scene of bustling activity as the townspeople came to draw water.
Facing page:
Piazza del Duomo in San Gimignano, looking down on the Palazzo Publico. The tower of the 'podestà', the city's presiding magistrate, springs directly from the roof of the building. It had to be taller than those of private citizens, such as the Chigi next door, however wealthy they might be.

d'Elsa, the medieval upper town – ignored, forgotten but so natural – seemed centuries away from our hurried lifestyle. The nearby stronghold of Casole d'Elsa is the only vestige of the defeat inflicted on Siena by the Florentines in 1266 – a defeat from which the vanquished soon recovered, just as Florence had quickly recovered from its discomfiture at Montaperti, outside Siena, six years earlier.

A brief stopover at brick-red Certaldo, home of Boccaccio, who virtually worshipped Dante and was Petrarch's closest friend. Voltaire rightly believed that this prolific prose writer, author of the Decameron, set the pattern for the Italian language. His house, destroyed during the Second World War, has been faithfully rebuilt, but somehow his spirit has departed.

The scenery is magnificent in this region of leap-frogging hills and valleys. In the distance rise the celebrated towers of San Gimignano, which we approach with a degree of suspicion.

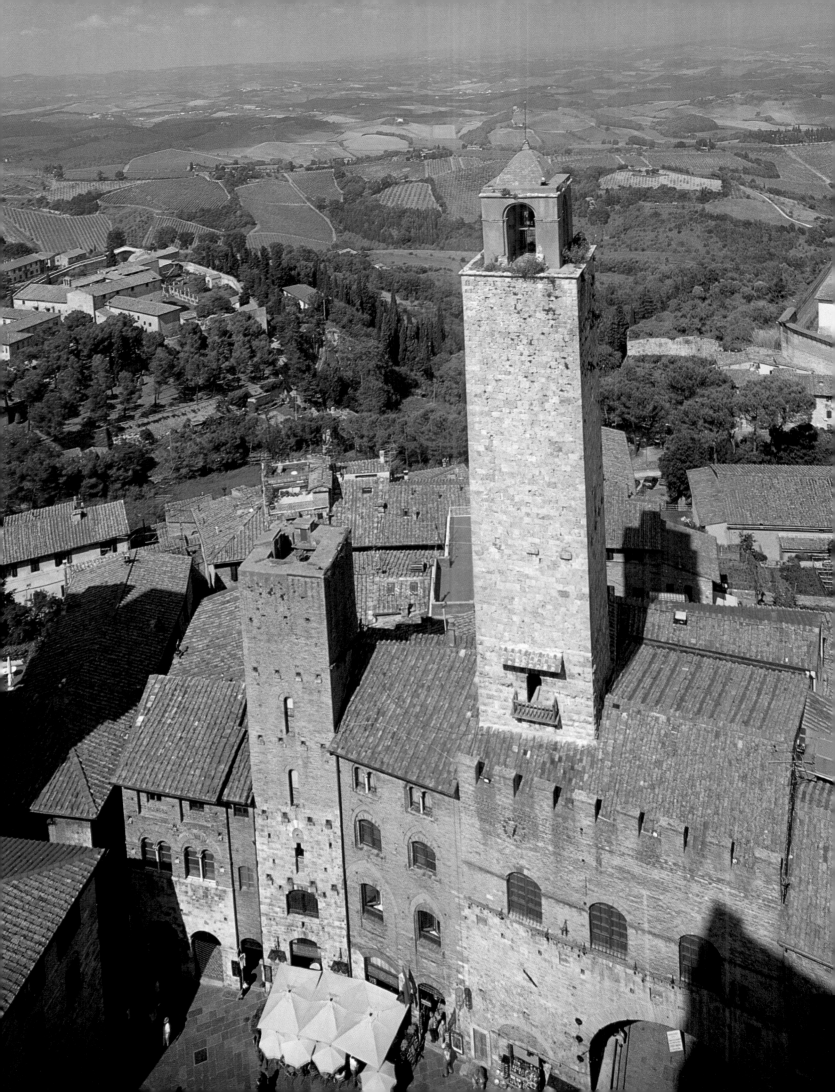

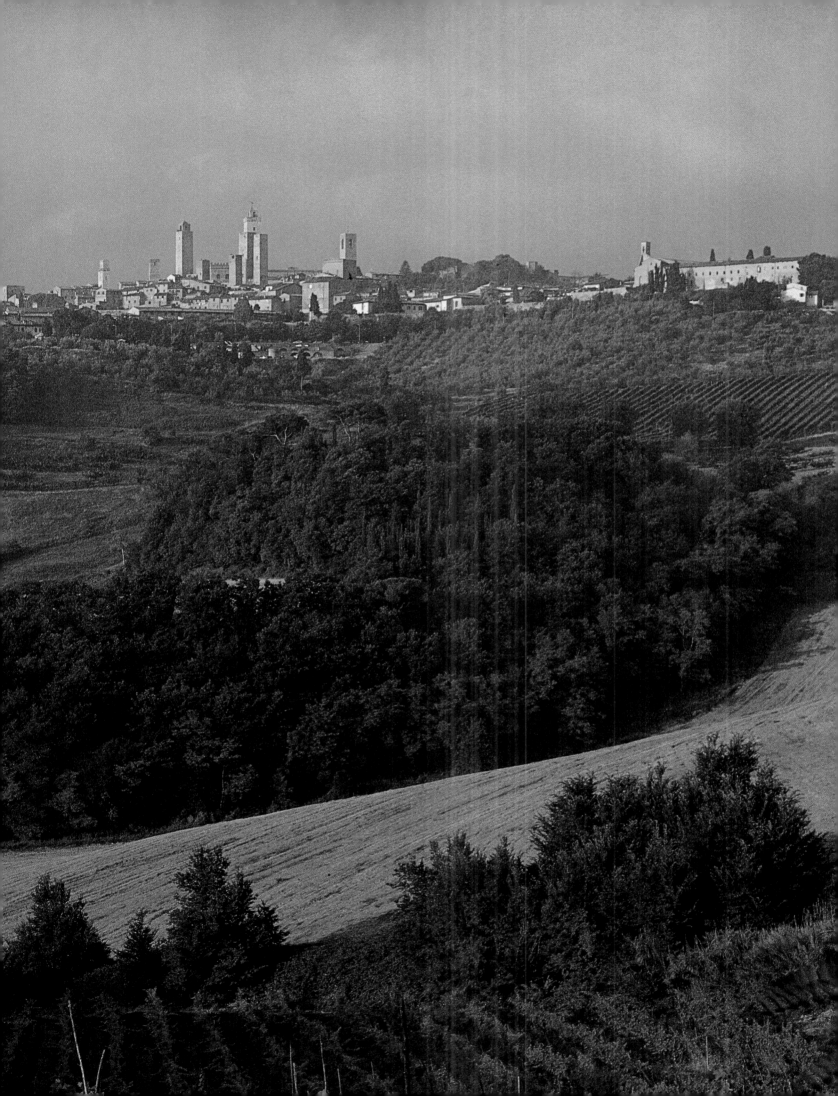

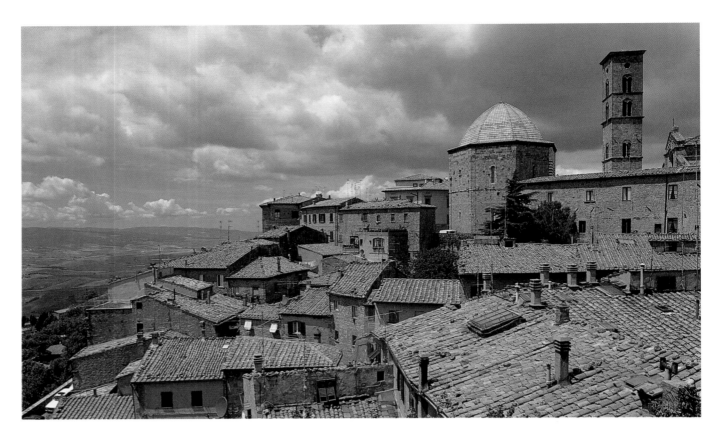

Like a sentinel in the heart of its iron-rich region, Volterra is built over an Etruscan city far more important than the present-day town. It has an austere kind of beauty, and the local authority evidently encourages displays of flowers.

Previous pages:

San Gimignano and its magical countryside. The town once had as many as sixty towers; thirteen remain. This is what a Tuscan town was like in the Middle Ages. Siena and Florence bristled with towers of this kind, built for defence and as status symbols. These precocious Manhattans were eventually razed by new rulers and their stones used to build citadels.

Having spoken so much about them, lauding their charms and beauty, is there not a danger of disappointment? But first let us hear the experience of André Suarès, who found it the most fascinating town in Italy. Arriving at the turn of the century, he noted: "Hardly a foreigner to be seen on this beautiful, languid August afternoon of torrid heat." Happy days…

But let us not be hypocritical. You cannot endorse San Gimignano with three stars in all the tourist guides, then expect to have it all to yourself. The town's golden age lasted a little under fifty years, from 1300 to the terrible plague of 1348, which decimated the entire province. Dante had persuaded the city elders to join Florence in a war against Pisa, Siena, Arezzo, and neighbouring Volterra. The conflict having been settled in Florence's favour, San Gimignano's reward was the loss of its independence and a gradual tightening of the Florentine noose. The four centuries that followed were a time of decadence, and

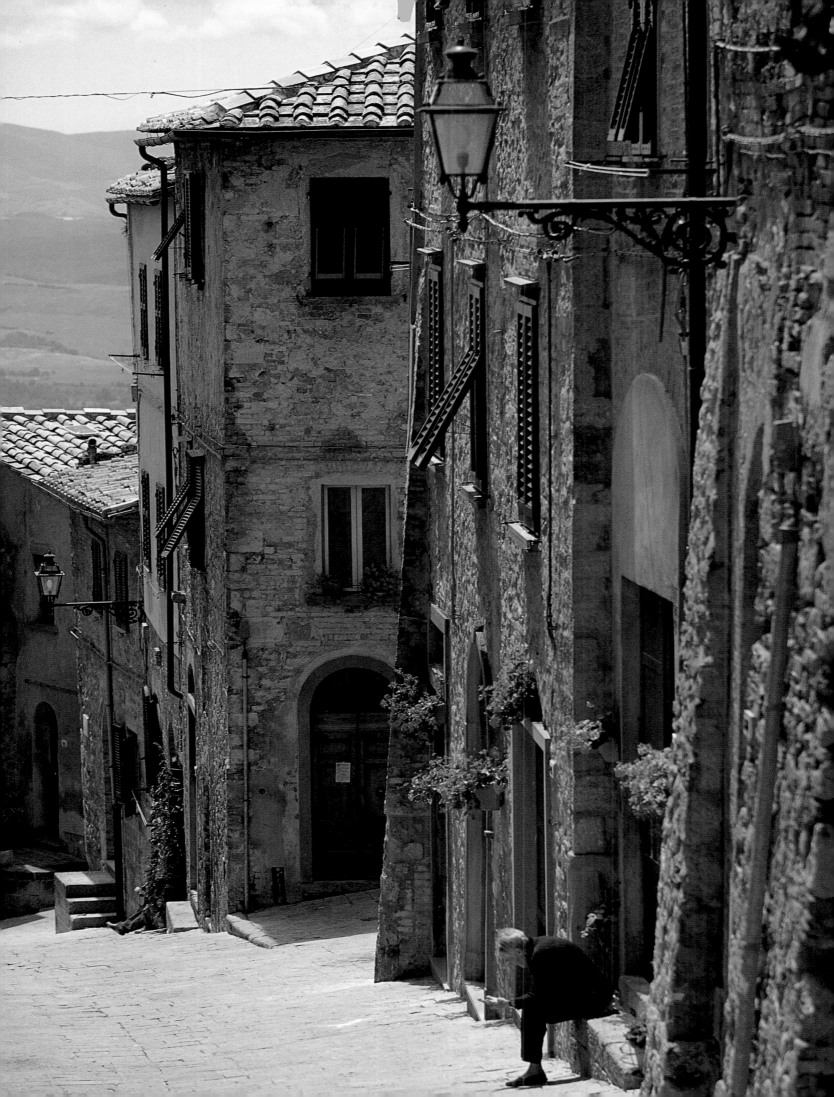

the proud towers erected during the town's heyday – used as grain store, stronghold, and status symbol – gradually collapsed. Of the original sixty, only thirteen are left.

Generally, though, the signs of San Gimignano's medieval prosperity remain. What we see today is a perfectly authentic urban jewel, gradually restored since the 1960s under the auspices of UNESCO. There is plenty to see, but this is not a guide book. Our favourites are the down-to-earth Last Judgement in the Duomo; in the Museo Civico, the fresco of a young couple bathing and going to bed; and the story of Saint Augustine, delightfully depicted by Benozzo Gozzoli – again – in the church of Sant'Agostino.

Then there is a succession of three squares – Piazza delle Erbe, Piazza del Duomo, and Piazza della Cisterna – which together form an amazing architectural setting. To really enjoy the town, come in the late autumn and spend at least one night. The

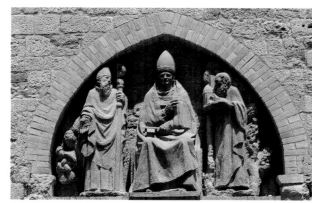

Volterra's cathedral is moving in its simplicity and purity of style. These close-ups show the delicacy of the white and dark-coloured marble inlays, the art of marrying volcanic rocks, and the care lavished on even the least visible parts of the building.
Peter, the first bishop of Rome.

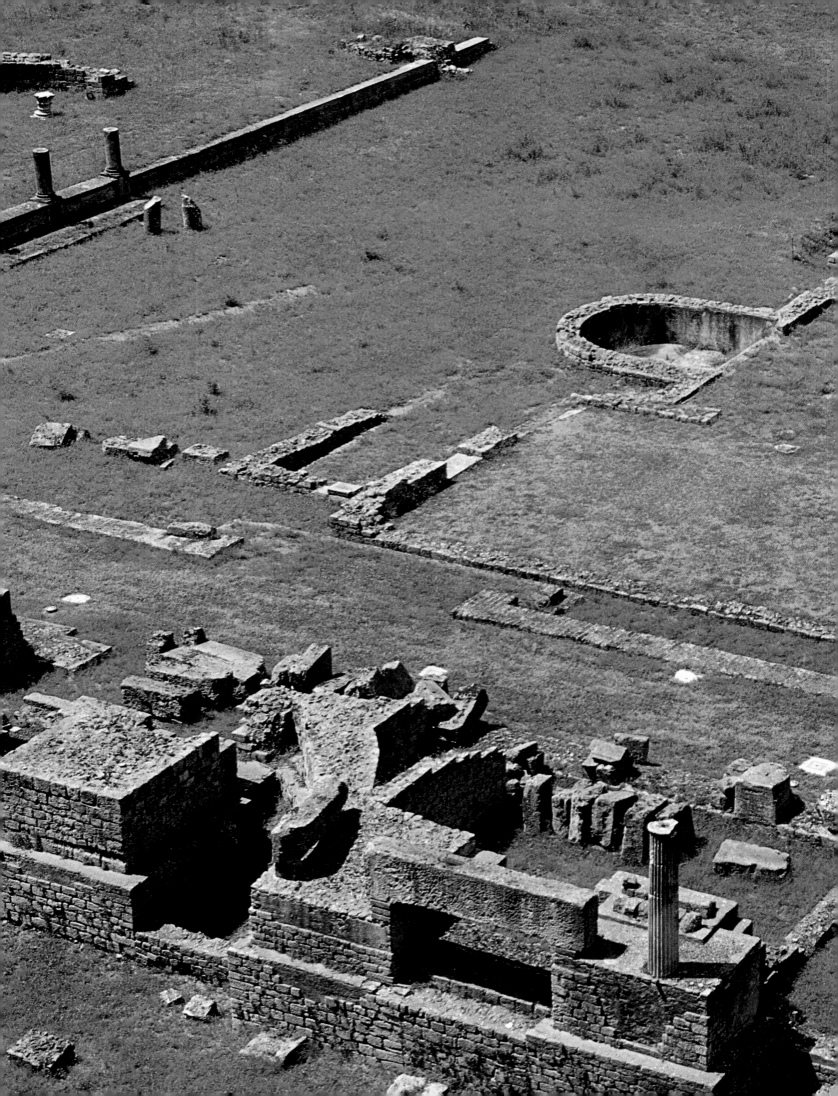

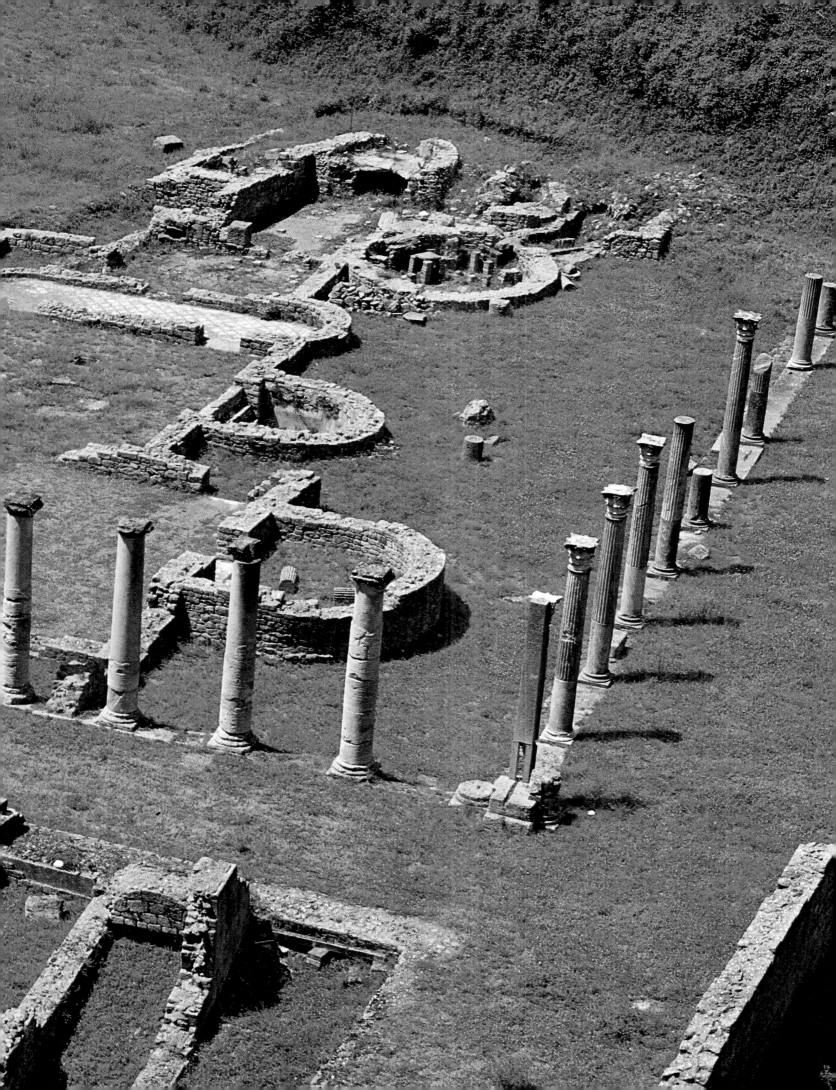

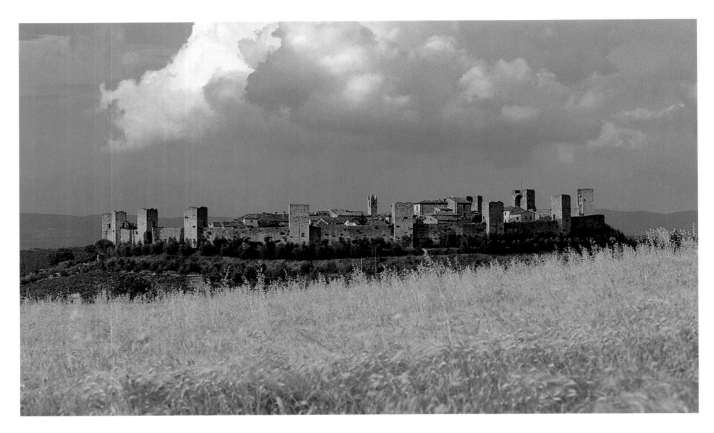

*B*etween Siena and San Gimignano is the hill village of Monteriggioni, one of the few to have retained its complete circle of ramparts and defensive towers. From this truly charming village there is a breath-taking view of the Tuscan countryside and its vineyards. Monteriggioni's own wines are entitled to the Chianti Classico emblem.
Previous pages:
Volterra has an outdoor archaeological museum featuring Etruscan and Roman remains. Here we see vestiges of the Roman theatre and baths, recently restored.

coaches and day-trippers are long gone. The young and less young sit chatting on the broad steps of public buildings or sing in the evening around the well, whose stone parapet is grooved by the taut ropes let down to draw water. Like the wheelmarks under the porticos, or the worn sunken steps, they bear their testimony to the daily life of long ago. You can almost hear the chatter of generations of children, girls, men, and women who, since 1237, have left their humble signature on this well.

Let us admit it: it is for convenience sake that we have tacked Volterra on to the Val d'Elsa, whose pastel-coloured hills are some of the most sensual in Tuscany. Thirty or so kilometres (19 miles) further on, we are in a different world. The landscape is of volcanic origin (the boiling underground water at Larderello is used to generate electricity) and deposits of lead, copper, and tin were long exploited by the Etruscans, for whom Volterra was a major city. It had Cyclopean ramparts, as you can still see from

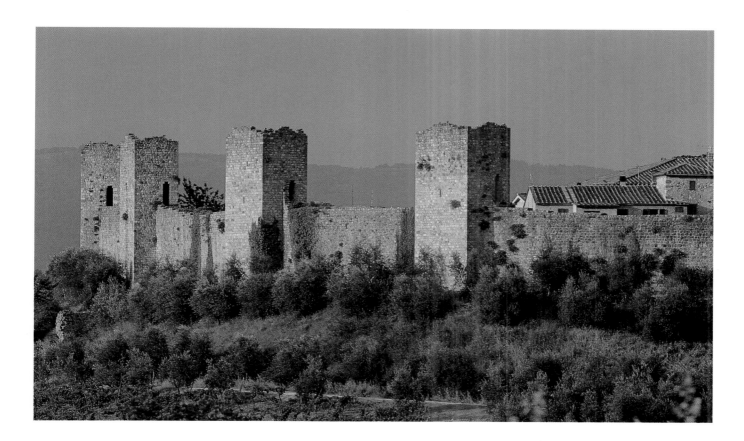

vestiges in the vicinity of the Balze (cliffs) or the All'Arco gate. And Etruscan tomb sculpture, worked in alabaster, is perhaps the outstanding feature of this little town, whose austere, monumental beauty can be somewhat oppressive. The atmosphere is less intimidating in the outdoor archaeological museum, laid out as a public garden, beside which a charming cart track leads through orchards and vegetable gardens.

The order in which its dozens of funerary urns (Etruscans were cremated) are displayed is a mystery known only to the curators of the Museo Guaranacci. They range from common-or-garden ones that anyone could afford to unique items commissioned by noble families. Some are marvels of delicate craftsmanship and vivacity. Then it is startling to discover elongated statuettes that might well have been presented to the museum by Giacometti. In fact they are Hellenistic artefacts unearthed in central Italy. Confusing, eh?

"For those involved in governing the city,

the main problem is one of beauty"

The aldermen of Siena

SIENA
and the call of the South

Graceful architecture: the cupola of Siena's cathedral looks as if it is about to rise into the air like a hot-air balloon, and the campanile owes its soaring lightness to the increasing number of columns and size of the openings at each level – a technique commonly adopted by medieval and Renaissance builders.

In the 1820s, according to the historian Taine, it took two days to travel from Siena to Florence, a distance of seventy kilometres (44 miles), and those adventurous spirits who took the risk made their wills before setting out. He concluded: "Siena is like a medieval Pompeii."

But what volcanic eruption had buried the city? None, of course. Its preservation was simply due to decadence, decadence accumulating day by day over the centuries, that had dried up its commerce, emptied its bank accounts, forced the more ambitious to emigrate, and allowed arrogant and incapable tyrants to hold power. For at least three centuries, until tourism transformed the situation, Siena had preserved the magnificence of its setting, but had been quietly bleeding to death.

And it is true that in the last forty years so-called mass tourism has brought the city to life. There had always been the occasional handful of distinguished art lovers to sustain one or two hotels in genteel decrepitude. All of them, with more or less talent, wrote of the splendour of this jewel-like medieval fossil. But nowadays,

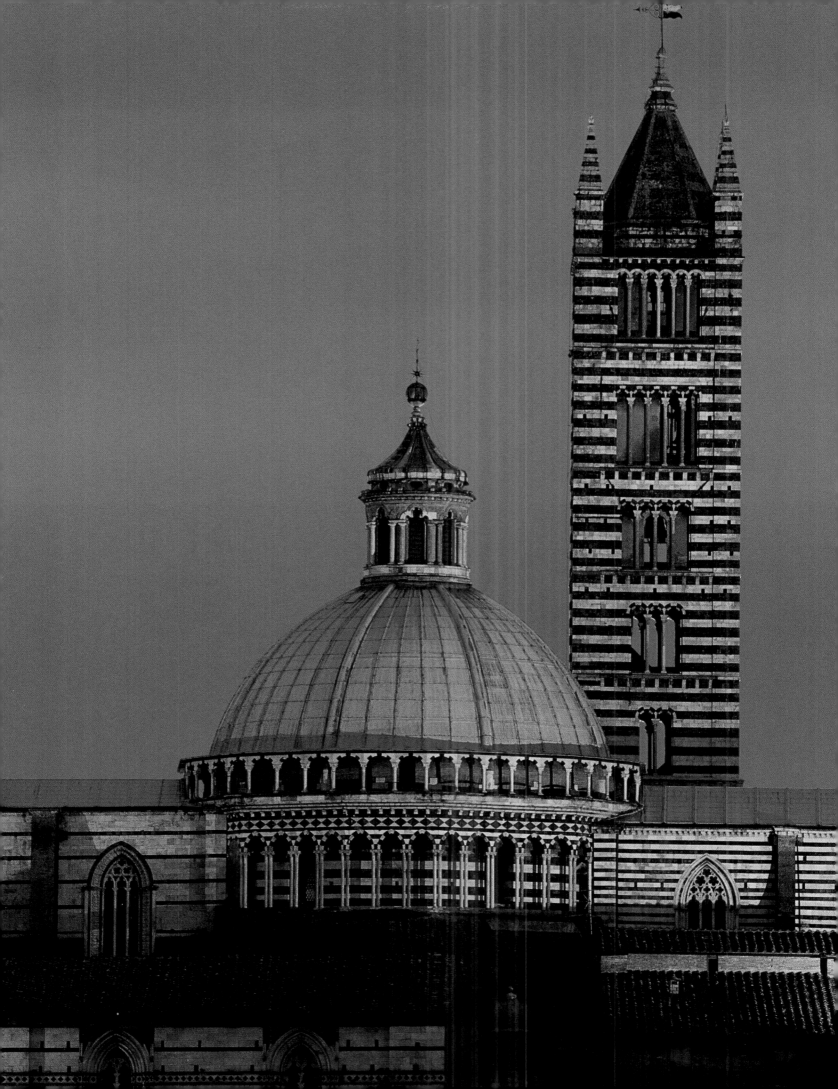

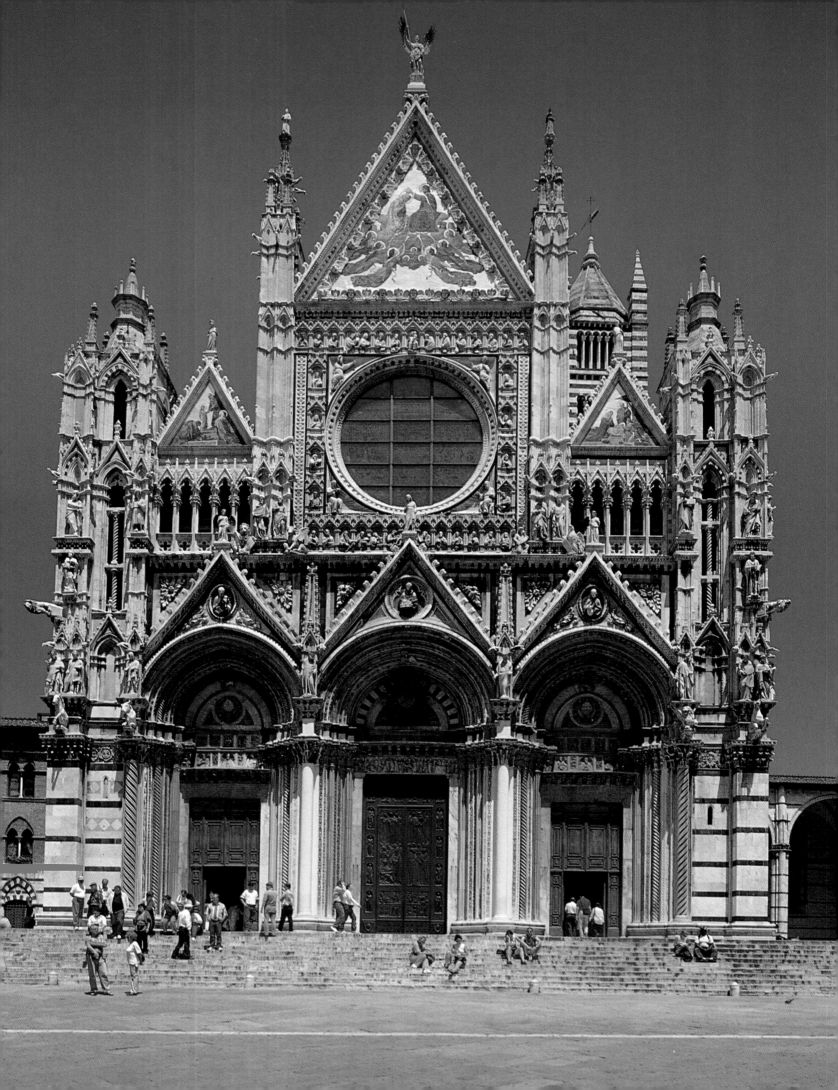

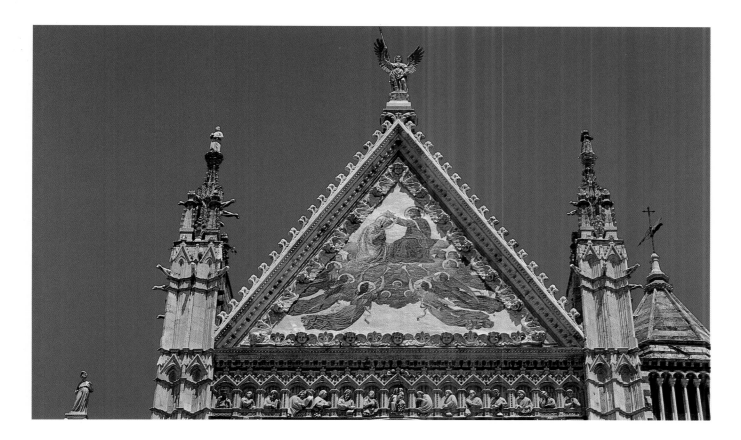

for seven or eight months of the year, everything revolves around the crowds of visitors who walk in procession from the Campo to the cathedral and back again. "Let them keep coming," was our worldly-wise waiter's comment. "It's good for business!"

Very true. Everyone is entitled to a wonder or two, and Siena is one of the great wonders of the world. We spoke earlier of San Gimignano, as if it had fallen by magic out of the Middle Ages into the twentieth century. But Siena has played a far more distinguished role in history, and its cultural heritage reflects the fact.

Before Florence, it established the first international banks and covered Europe with its textile warehouses. Its silver florin and bills of exchange inspired universal confidence. It raked in money from the whole of Christendom on behalf of the popes and, along with a very nice rate of commission, was granted the privilege of excommunicating bad payers – in other words consigning them to hell. For hundreds of years, Siena enjoyed the world's respect

The cathedral façade is one of the most "French" in Tuscany, and also one of the most composite, having been under construction from the thirteenth century (lower part) to the nineteenth (mosaic of the Coronation of the Virgin). The statues date from periods in between.

The masterly sculptures carved for the doorways of the cathedral by Giovanni Pisano at the end of the thirteenth century can be seen in the Cathedral Museum, next door.

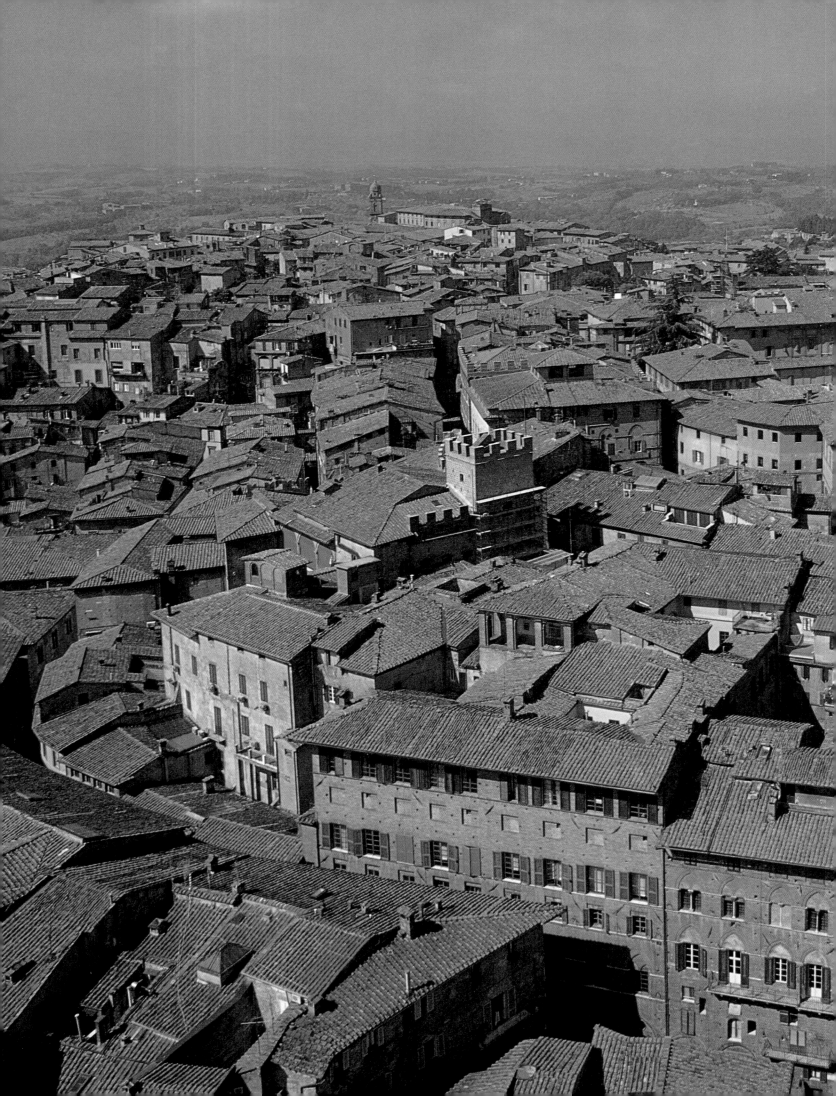

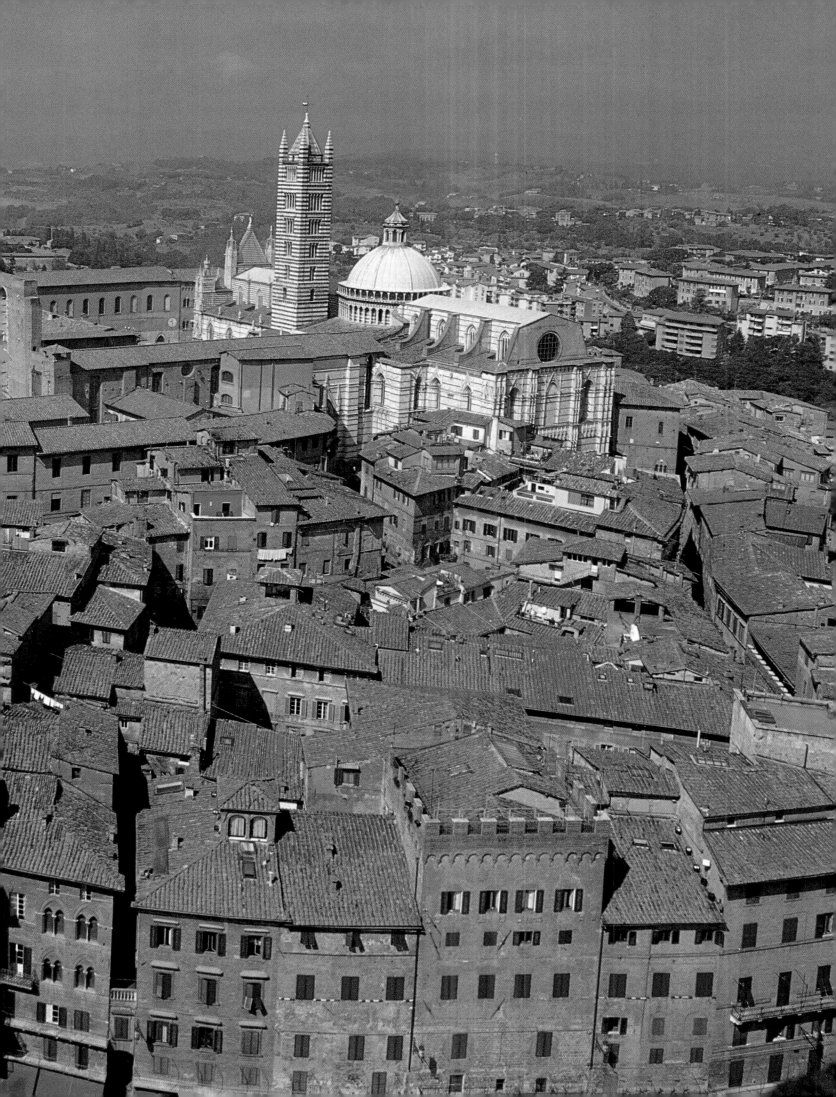

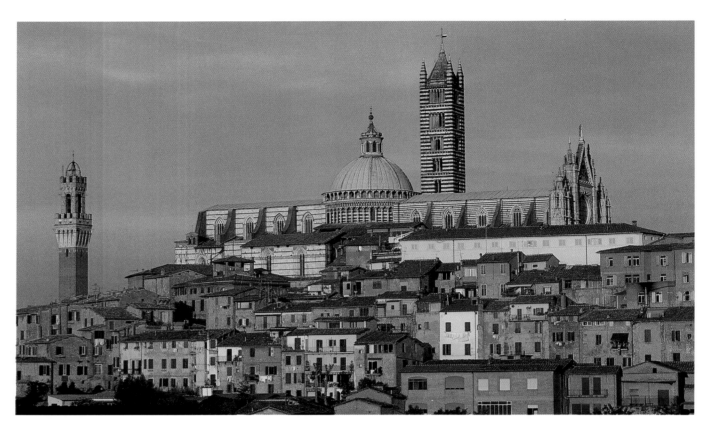

Harmonious shades of brown lead upwards to the Duomo, built on Siena's highest hill. To the left is the Torre della Mangia, lording it over the Campo below.

Facing page:

From the banded-marble campanile, there is a fabulous view over the Sienese countryside.

Previous pages:

A stunning view over Siena's patchwork of roofs. It is easy to make out the ground plan of the aborted cathedral extension: the new nave was to encompass the area stretching from the cupola to the high brick wall to its left, pierced with two pointed arches. The existing cathedral would have become the transept of the vast new edifice.

and was admired for its Gothic art. Its artists, sculptors, architects and painters – Giovanni Pisano, the Lorenzetti brothers, Simone Martini, Domenico Beccafumi, and Francesco di Giorgio, to name but a few – were in constant demand.

The events and changes of sides leading up to the city's final defeat in 1555 by Charles V, its former ally, are too complicated to go into here. In any case, this battle, which ended the long and heroic defence led by the French general Monluc, put a brutal end to any further grandiose aspirations. In the next fifteen years, the population of Siena fell from 100,000 to just 8,000. Decadence has set in with a vengeance.

Every time we return to Siena, this pedestrianised urban museum fills us with mixed feelings: joy on rediscovering an environment so unspoiled, and melancholy at its despondent provincialism. There is still something rather rustic about it, with its uneven lanes laid out like minor country roads, following the humps and

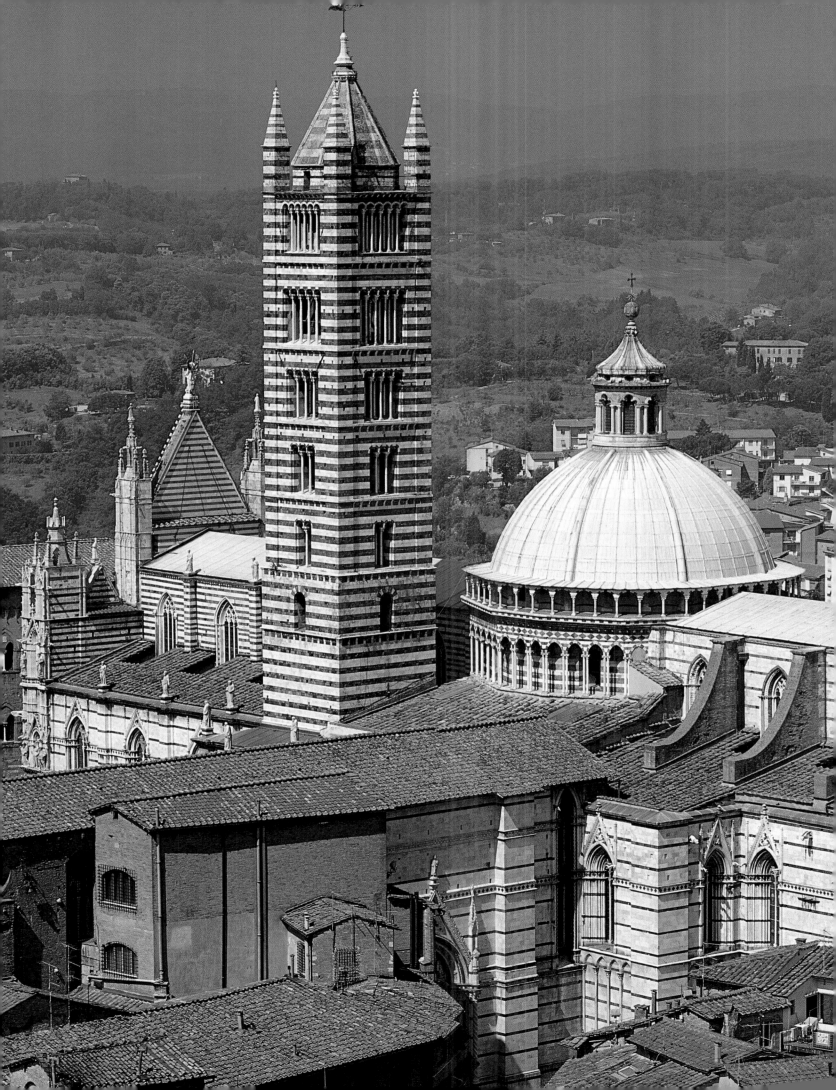

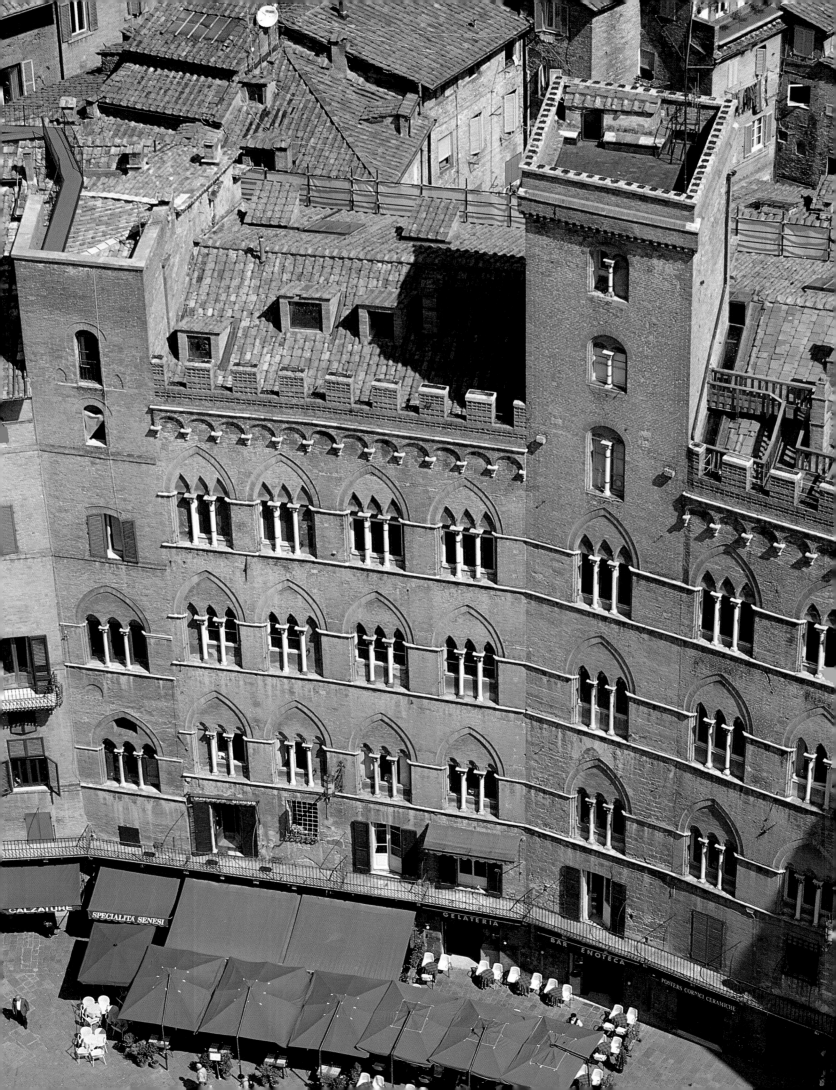

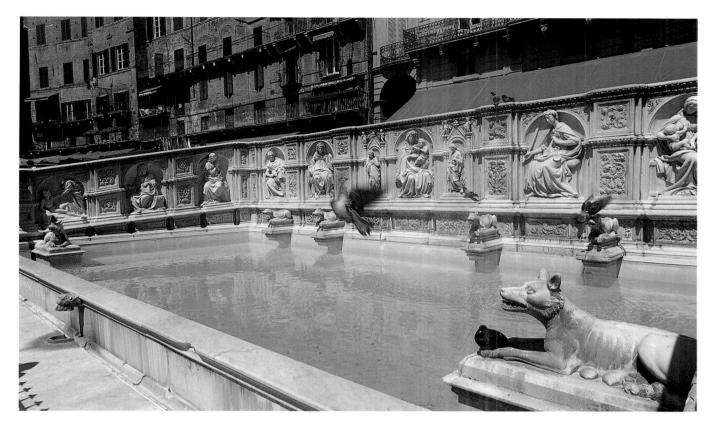

hollows of the terrain. In the shelter of its walls and from the summits of its hills and flights of steps, it seems always to be watching over the countryside. The populace eat pasta and tripe, gesticulate as they play cards in the wine bars, and honourably earn a living by a host of unexceptionable little schemes. The patricians are affable, and movingly old-fashioned in their manners. In the evening, the members of this little society congregate in dark suits on the Via Banchi di Sopra, around the Piazza Tolomei – named after a banking dynasty dating back to the twelfth century – and discuss the prospects of the various *contrade* (districts) in the Palio, run on 2 July and 16 August each year, days consecrated to the Blessed Virgin. When summer is over, the talk turns to the circumstances of victory and defeat. Each of the seventeen districts is still at heart a village, a sort of extended family, a clan, with its precepts, traditions, and age-old hostilities. The districts have their own distinctive symbols: you

The Fonte Gaia, beloved of the pigeons in the Piazza del Campo, is a rather stiff replica (nineteenth century) of Jacopo della Quercia's original work, the marble of which had been eaten away over the years. Part of the original can still be seen on the terrace of the Museo Civico.
Facing page:
View down on part of the Campo and the Palazzo Sansedoni (thirteenth century), which once had a much taller tower. Note the quirky stairs and passageways over the roofs.

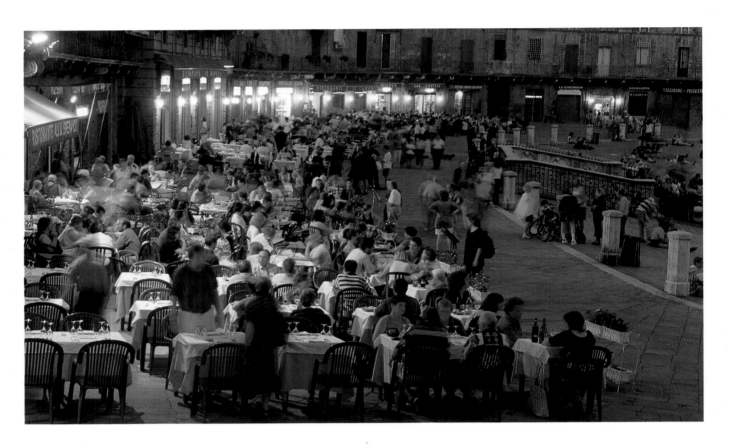

The Campo on a summer's evening. It is not so much the quality of the food that attracts people as the magic and mystery of this unique environment, like a vast brick-paved sea shell.
Facing page:
Siena's Palazzo Publico, at the lower end of the Campo, has been the seat of government since the thirteenth century. In the areas open to the public (Museo Civico), you can admire some of Italy's finest frescoes, and some of the first to depict secular themes. The 100-metre (328-ft) bell tower, known as the Torre della Mangia, was symbolic of the freedoms of the city-state and therefore the end of the feudal era. The rest of the Campo is ordered around this building and its great tower.

are born She-wolf, Ram, Dragon, Unicorn, Goose, Snail… From the cradle to the grave, charitable organisations and local associations are there to lend support in times of rejoicing and distress. Naturally, each *contrada* has its church and its Palio museum. For at least three hundred years, this event has followed the same rules and is the subject of year-round preparations, negotiations, and plotting. Some districts are allies and others enemies, which can lead to problems when members of rival *contrade* want to marry. The Palio epitomises the way each individual is rooted, in a way perhaps unique in Italy, in the soil of his own *contrada*. Guido Piovene speaks of it, quite rightly, as "symbolic warfare".

It all boils down to a fiercely contested race between ten horses, some of them drawn by lot three days earlier (yes, purely a matter of chance!), representing the pride of ten different districts. On the appointed day, each horse is blessed by the priest of its own

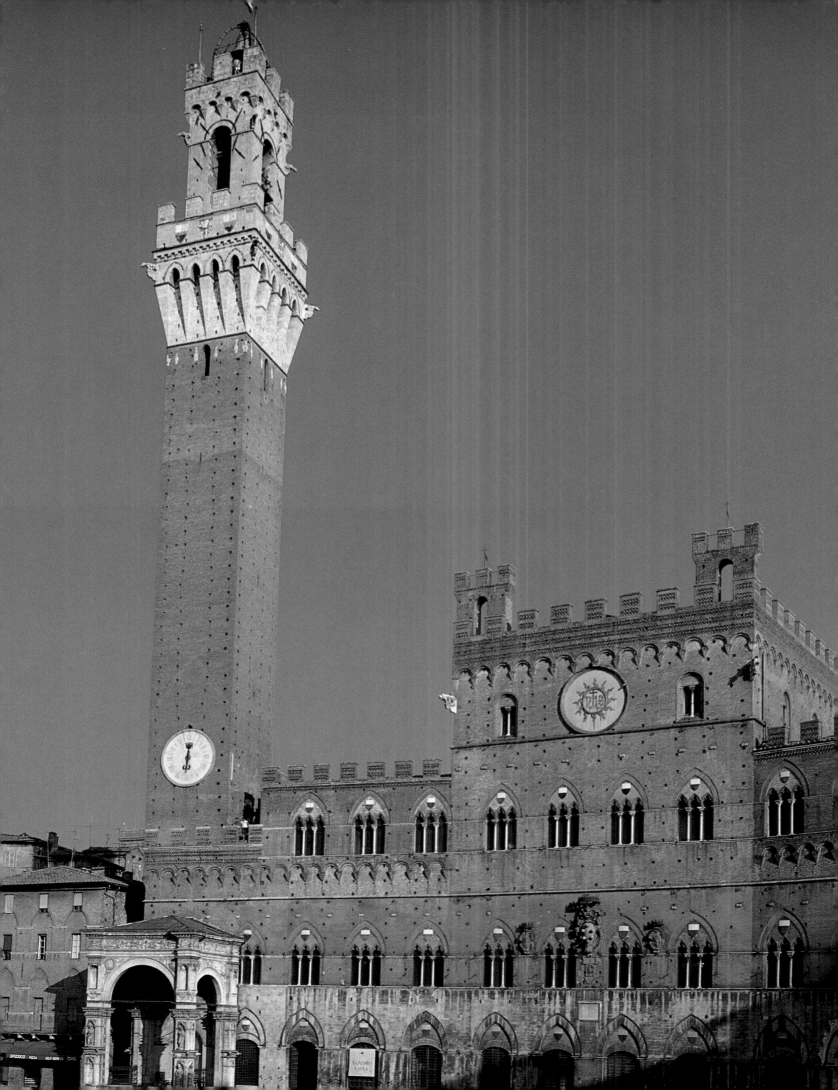

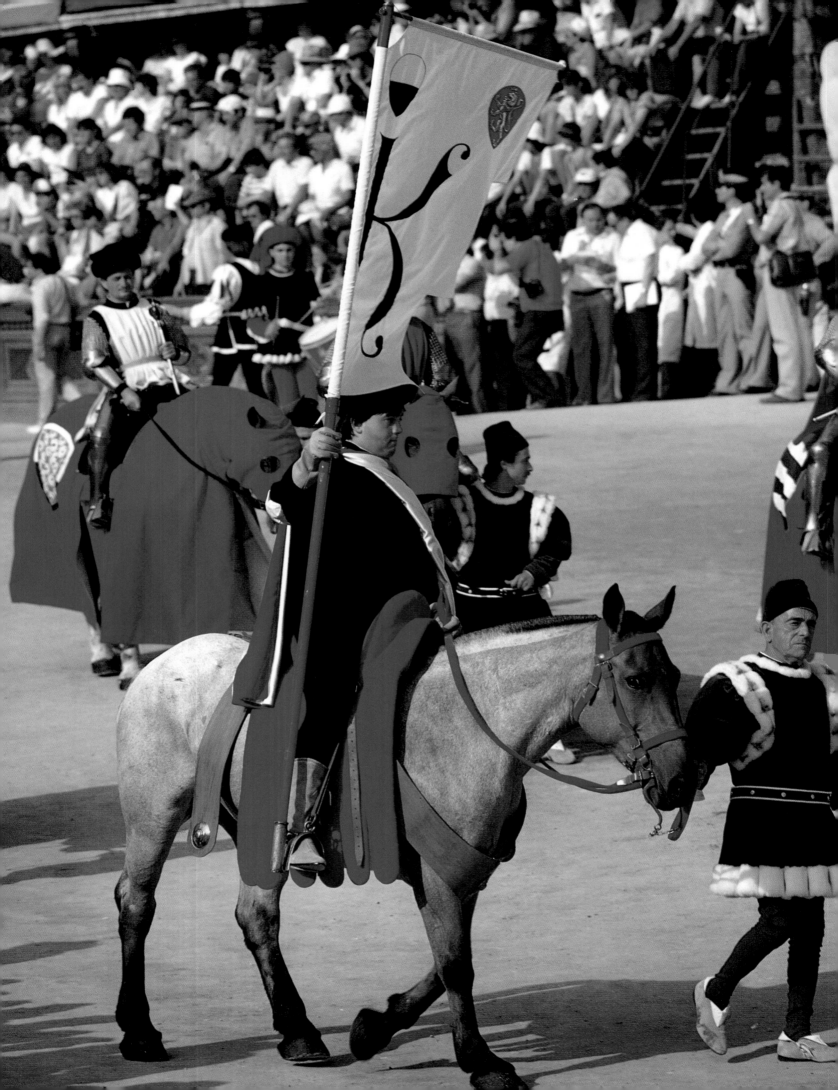

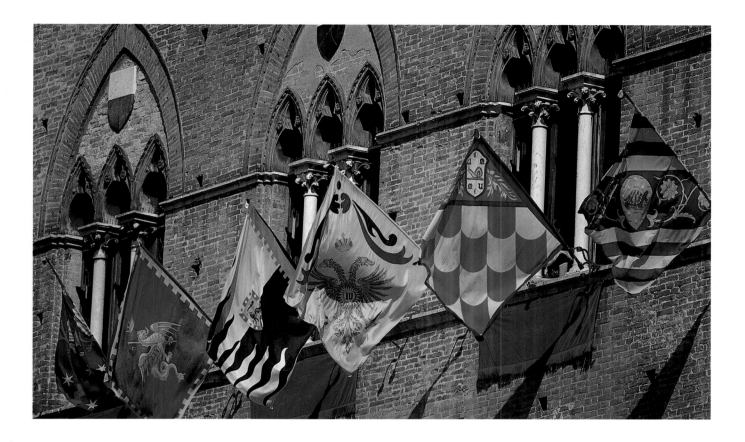

The standard-bearer of the Pantera (Panther) district makes his way into the Campo, where vast crowds are gathered. The balconies of the surrounding buildings and the mullioned windows of the Palazzo Publico are decorated with banners.

• The Palio •

Siena has seventeen 'contrade' (districts), but only ten take part in the Palio each year. Seven participate on a rota basis, and three are chosen by lot. The race itself consists of just three laps of the Campo, and the jockeys, who ride bareback, are versed in every possible dirty trick. But these few minutes of supreme excitement are the culmination of months of hard work and negotiations. Subtle alliances are woven between the traditionally antagonistic 'contrade', reflecting rivalries that have persisted into modern times. If a boy marries a girl from a rival 'contrada', the families may try to arrange a temporary separation in the run-up to the Palio.

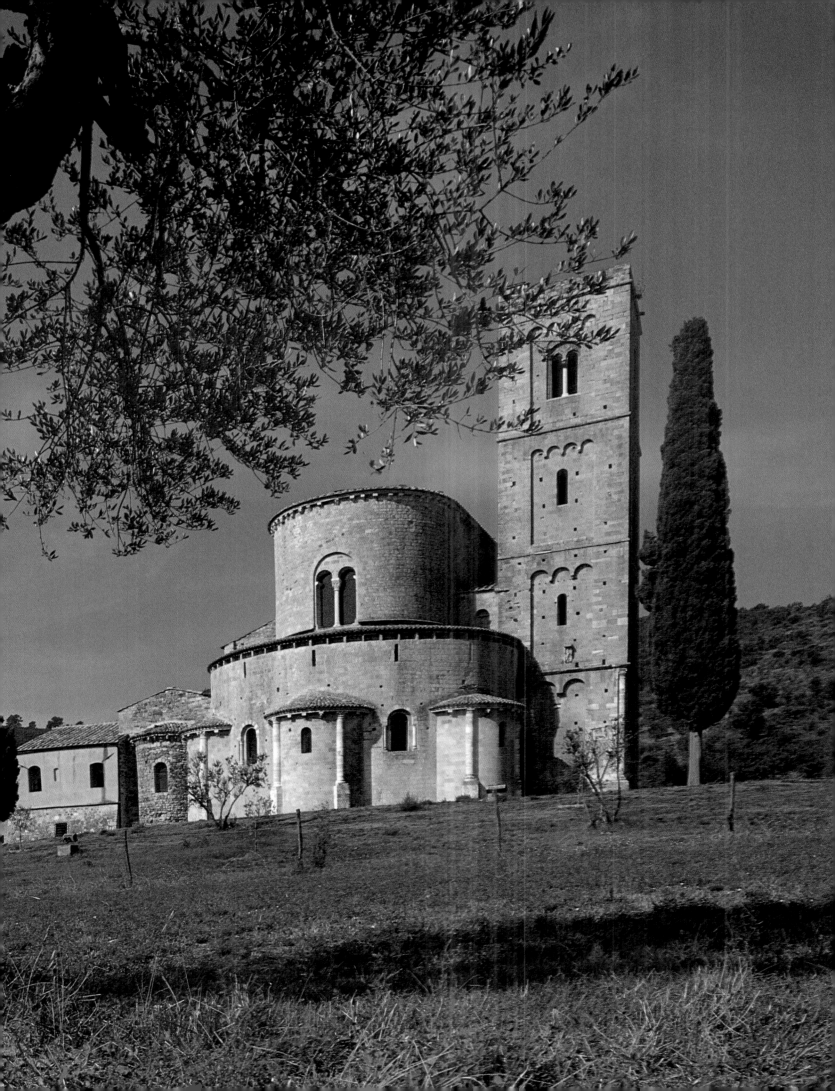

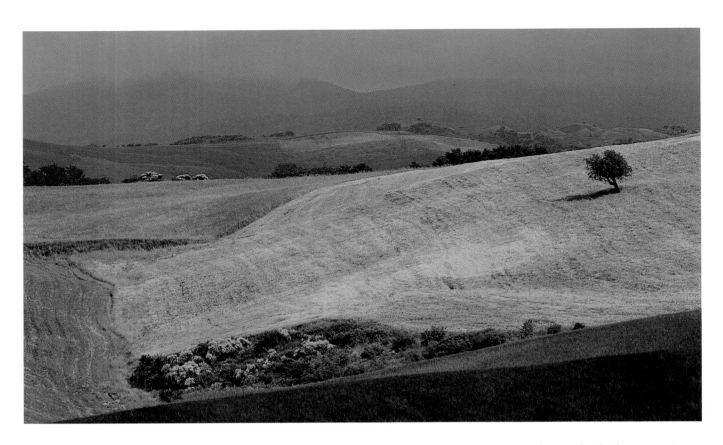

Soft shades of green and clumps of broom, a lone tree bent over by the wind, gentle valleys, and sunken roads: an austere beauty, composed of next to nothing, yet unforgettable.
Facing page:
A burnt-Siena landscape planted with a line of giant candles: the very essence of Tuscany.
Previous pages:
Ten kilometres (6 miles) from Montalcino "hidden in the depth of the wilderness in a tree-girt hollow", the abbey of Sant'Antimo is in the purest Romanesque style – as grandiose and austere as the abbey of Fontenay in France. The traditional services are celebrated by a handful of Augustinian monks.

contrada, then led in great pomp to the cathedral to receive a blessing, with all the others, from the bishop. Dressed in brightly coloured medieval costume, the ten contingents of flag-throwers, mace-bearers, gonfaloniers, valets and captains, drummers and trumpeters process to the Campo, where the atmosphere is electric and the crowds shout encouragement. We will gloss over the varied manoeuvres which may delay the start for hours, raising the excitement to fever pitch. The race is lost and won in just three laps of the track, a few minutes during which no holds are barred. Later in the evening, the winning horse will be led to the place of honour at an enormous candle-lit banquet, with tables set out in the street.

But let us take stock of our surroundings. Even the most tortuous alleys always bring you back to one or another of the dark stairways leading down between high walls into the dazzling light of the Campo, which meets you like a slap in the face. An

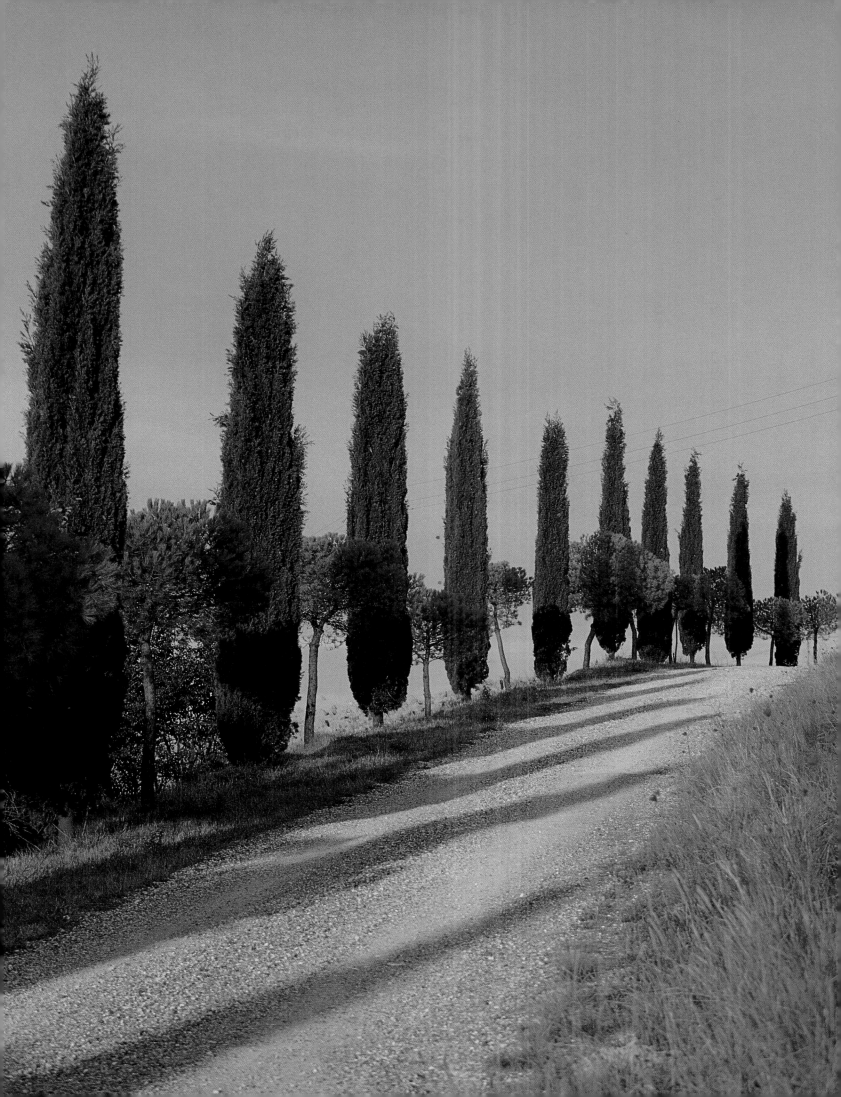

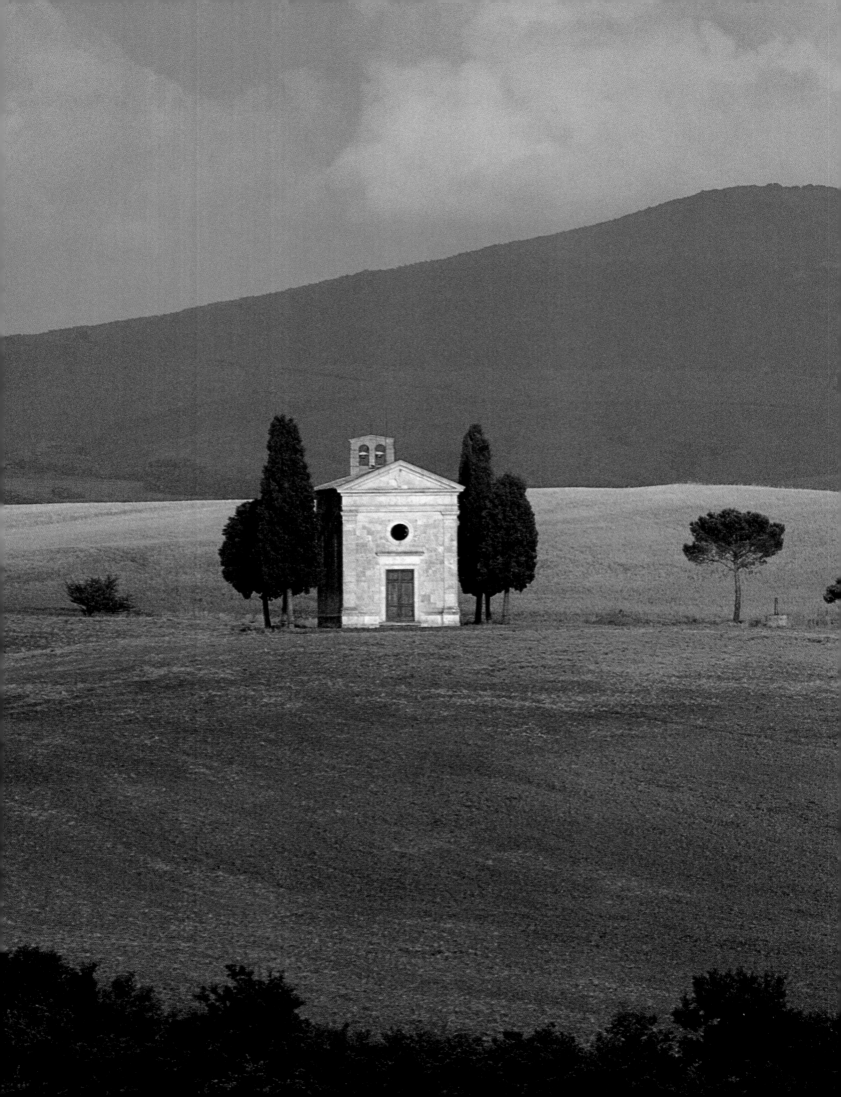

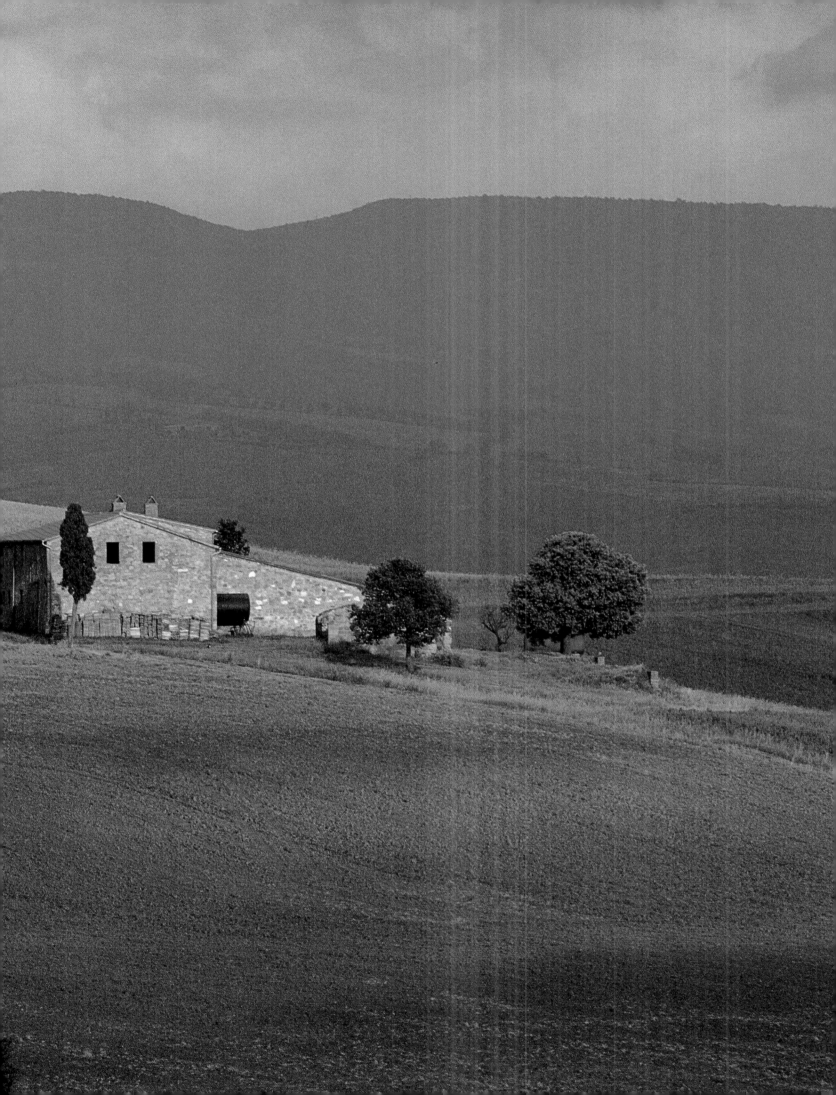

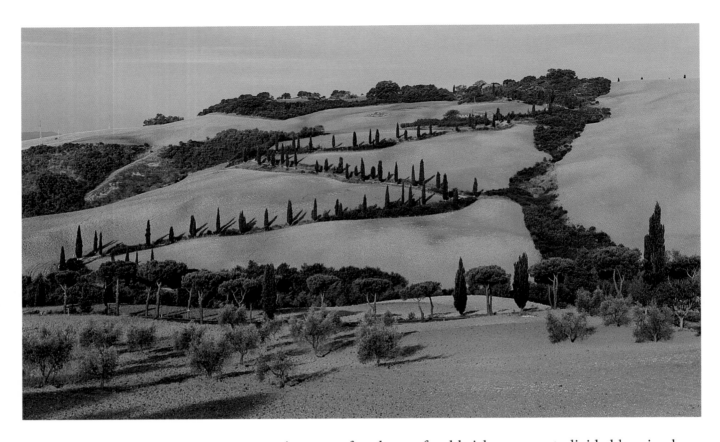

It could be a landscape painted centuries ago by a Sienese artist. The countryside has changed so little.
Previous pages:
Hour by hour the light works its magic on ploughed fields, house, chapel and hills, creating a series of ephemeral pictures.

immense fan shape of red brick pavement, divided by nine long spokes of white marble, the square rises shell-like to the semi-circle of old-rose palazzi to your right and left. You may have seen it a hundred times in photographs, but your first encounter with the reality leaves a lasting impression. For Siena's Campo is the magical combination of a sloping piece of waste ground once deeply scored by rainwater, and the human genius that made this unpromising feature into one of the world's most dazzling achievements in town planning.

It takes just a few minutes, by a series of tunnels, arches, and steps, to reach the black-and-white striped cathedral, which dominates the city from its promontory. In the days of the city's prosperity, the proud Sienese dreamed of making this the greatest temple in Christendom. They intended that the present nave – vast as it is – should be merely the transept of a far greater building. Common sense and the plague put a stop to this over-ambitious project, of

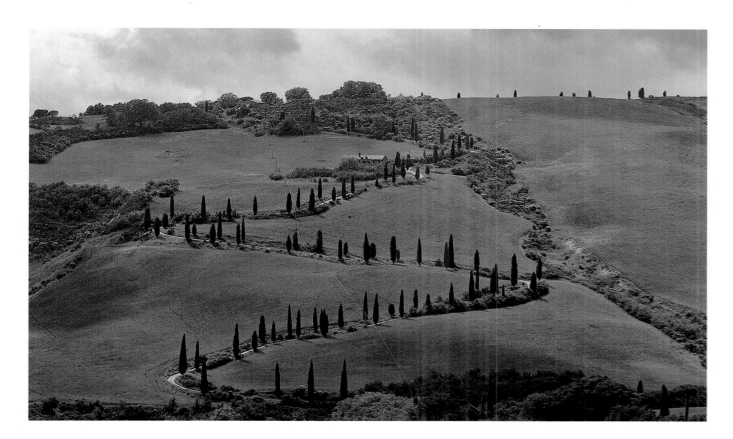

which some unfinished sections of wall are still visible. The extraordinary marble flooring of Siena's Duomo, illustrating Bible stories and the advent of Christianity, is itself a unique achievement. Giovanni Pisano's statues for the façade of the cathedral are now in the nearby museum, together with Duccio's gold-backed Maestà, which in its time (1311) was carried in triumph through the city.

All around are mysterious lanes hemmed in by tall buildings. It is always a delight to wander at a venture, here exploring a church, there a cloister or the open courtyard of a palazzo. But do not waste your time visiting the house of Saint Catherine, which has been turned into a sugary oratory. If you are interested in this young woman and her ecstatic spiritual experiences, try the church of San Domenico, a formidable brick fortress where at the age of fifteen Catherine became a nun. The only true likeness of her, painted by her friend Vanni, can be seen in the Capella delle Volte.

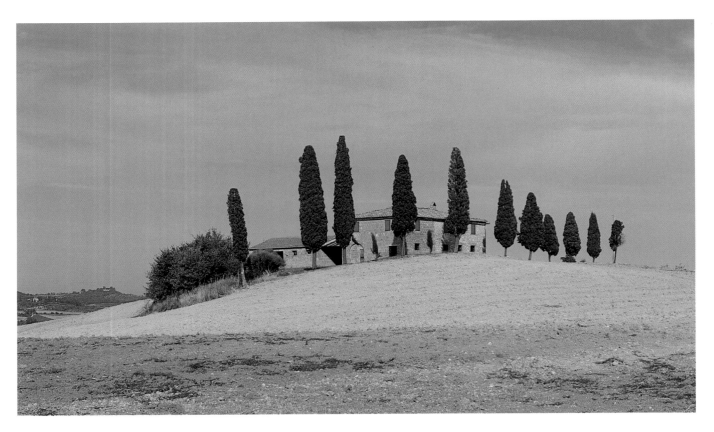

There they stand: cypresses, useless but reassuring, like silent giants guarding the farm.
Facing page:
Hills, ravines, copses, and golden fields stretch away into the distance, forming a setting for the occasional isolated farm. South of Siena begins a Tuscany austere and magnificent, its soil like homespun cloth. The summer is shadeless and burning hot; the unrestrained winter wind biting cold.

The painters represented in Siena's Pinacoteca or the exquisite museums of the surrounding villages often depicted the countryside they knew so well. If in the Museo Civico – the daring building at the foot of the Piazza del Campo – you have admired the magnificent fresco of Good and Bad Government, you will find similar landscapes as you travel the minor roads south of Siena: the same hills, often arid and ravaged, crowned with a single line of cypresses; the same burnished farms nestling in a hollow; the same stark clay ridges, crumpled like crêpe paper; the same dirt tracks stretching away among distant olive groves.

This is the quintessential Tuscany, with little towns perched sentry-like on hilltops and the predominant gold and red of ripe cereals and bare earth. A good example is the abbey of Monte Oliveto Maggiore, where one is torn between the frescoes of the life of Saint Benedict by Signorelli and Sodoma and, if the season is right, the white truffles they serve on the leafy terrace.

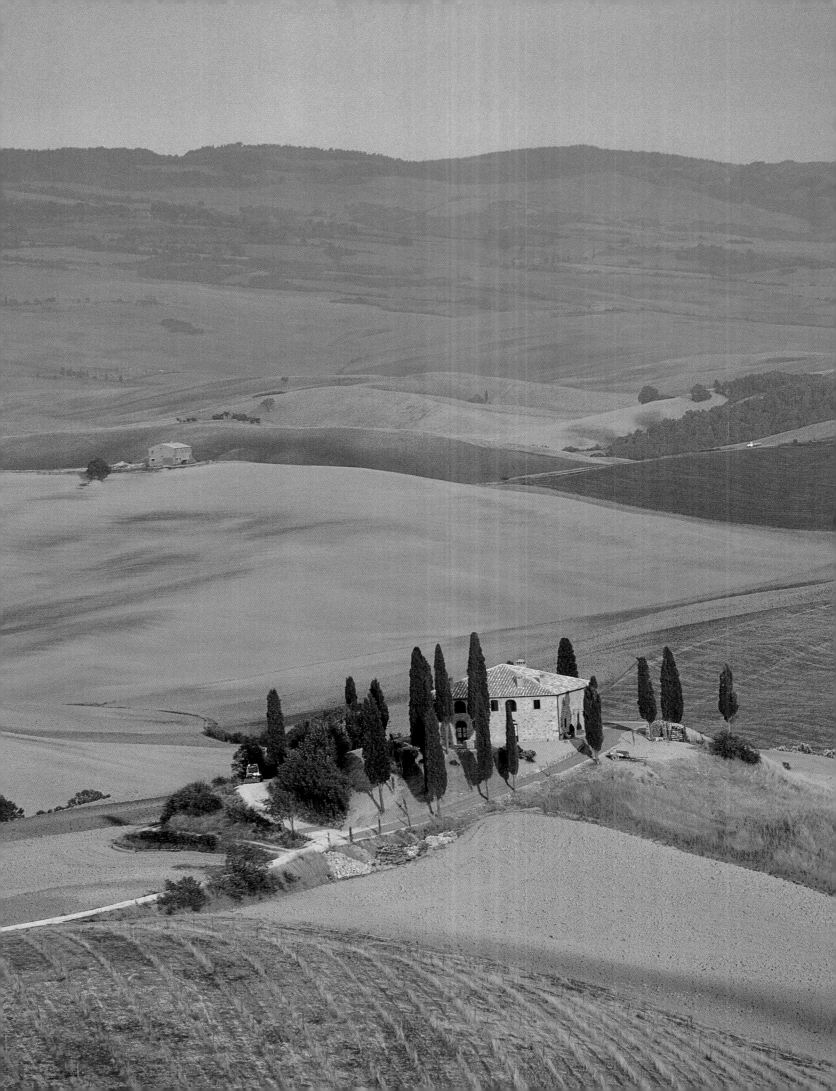

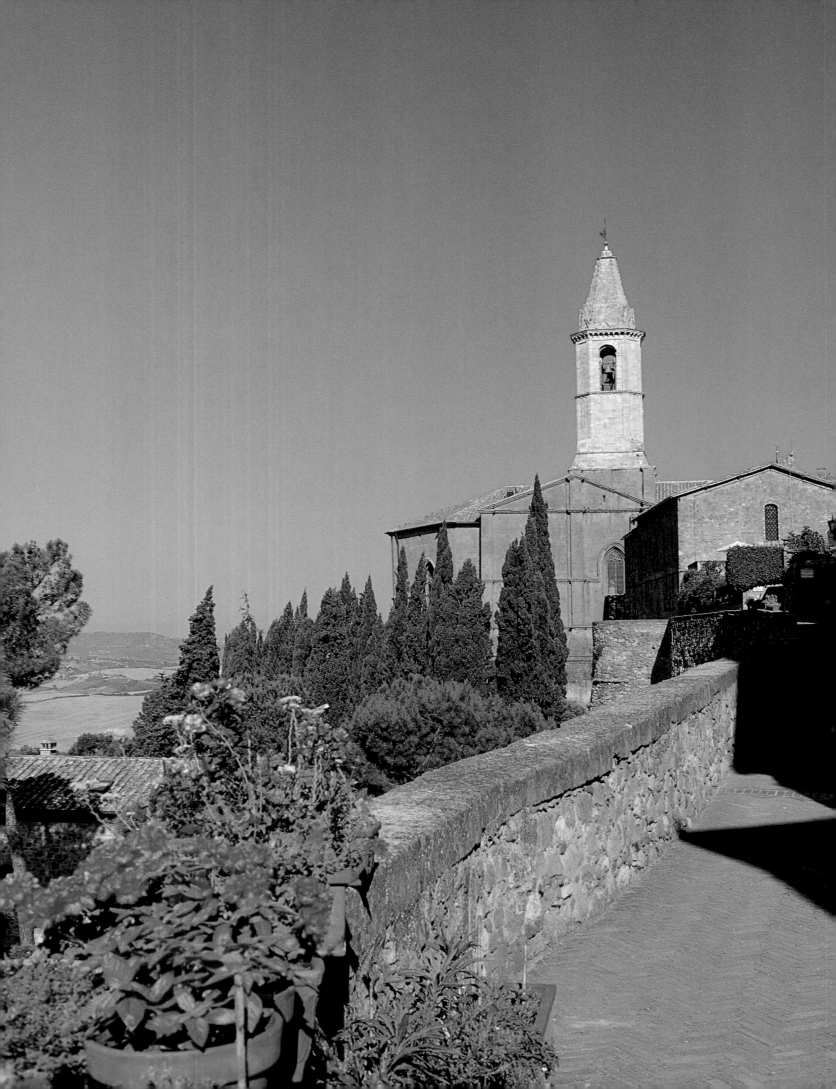

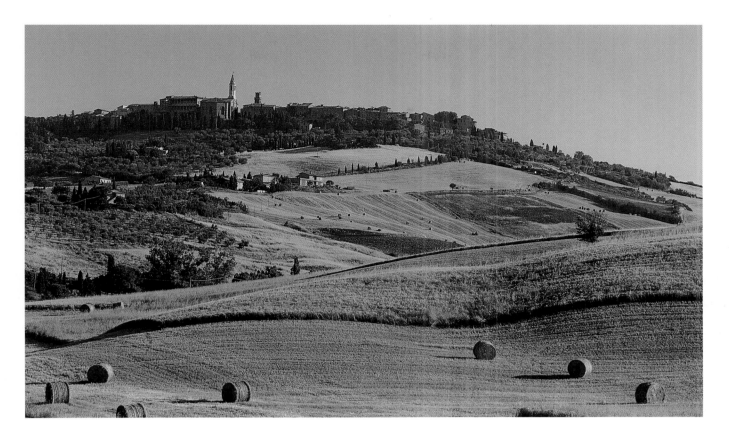

This part of Tuscany is intoxicating. Even in mid-August, it is not crowded. This is a good time to enjoy the graceful silhouette and airy stairways of the abbey of Saint Galgano, caressed by the clouds. Or go and admire the incredible view, straight as a die, from the Villa Cetinale to Cardinal Chigi's Hermitage, which stands at the summit of an exhausting flight of steps cut through a wood of oak trees. It is said that the Cardinal climbed it every day, in expiation for having murdered a rival in love.

Convoluted as a snail shell, Montalcino is the Lilliputian capital of the divine Brunello, a wine that can be left to age in the cask for twenty years or more. In the tiny Piazza del Popolo, where a cracked bell sounds the hours from its campanile, the Belle Époque will serve you wine by the glass at marble counters surrounded by red velvet benches, together with a plate of ham, salami, and other pork delicacies. Overshadowing everything stands the colossal fortress that gave sanctuary to Monluc and his

The harvest is over, the straw baled. All day, tractor and harvester have toiled in this dream-like landscape, with the spire of Pienza's cathedral in the background.

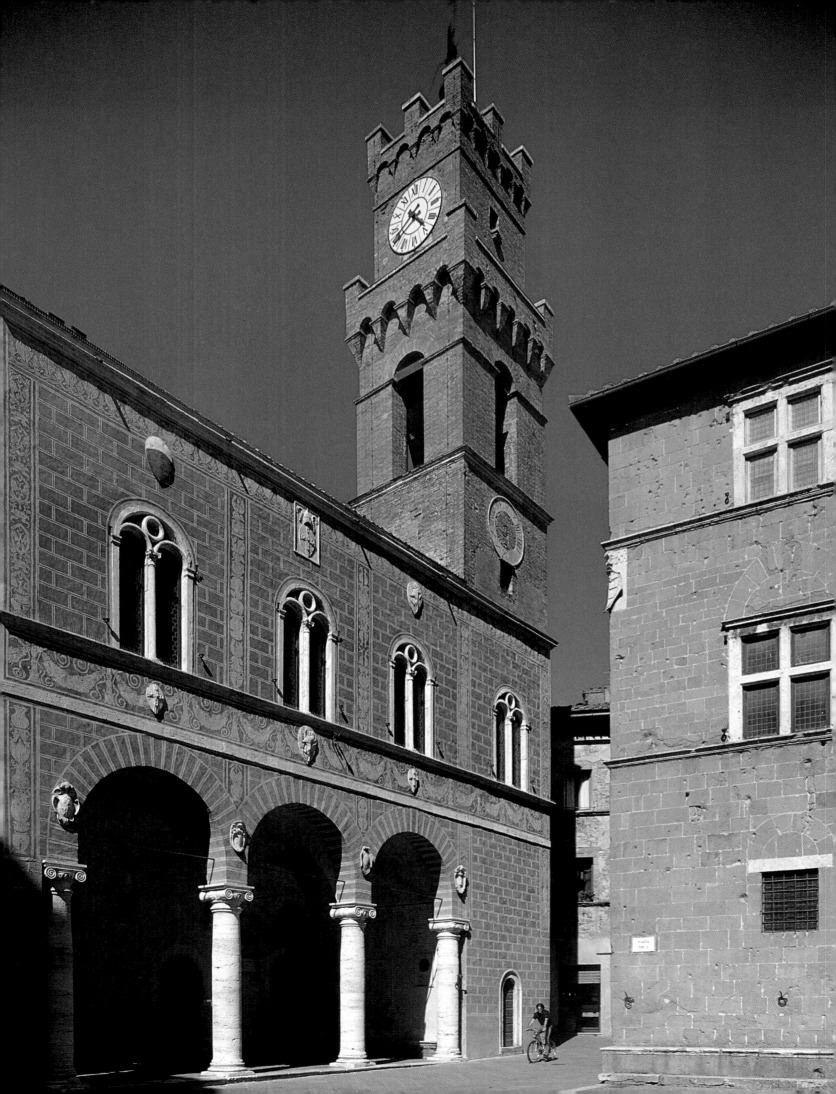

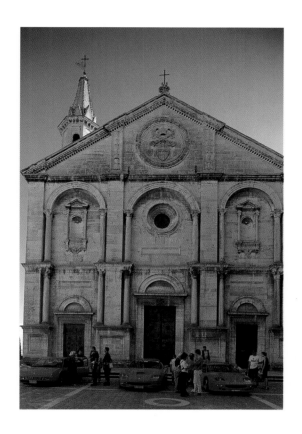

An arresting story. The child of an exiled noble family was born here in 1404, in an out-of-the-way village then known as Cordignano. He became pope, as Pius II, and decided to transform the village into Pi…enza: an ideal Renaissance town with a cathedral and fine houses, designed and built by the best architects of the period. Today there is a wedding.
Energetic, sharp-witted and sceptical, young Tuscan women no longer give in to machismo.

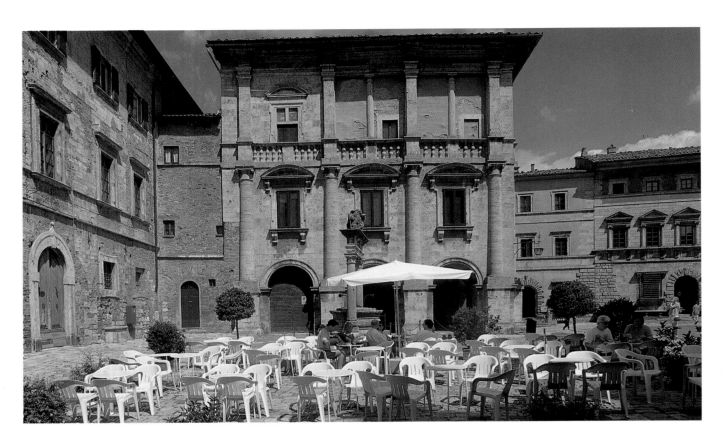

Montepulciano, an aristocratic old town, haughty and beautiful.
Opposite:
At its foot stands a marvel: the church of San Biagio, by Sangallo the Elder, inaugurated with great pomp by Pope Clement VII (a natural son of Lorenzo the Magnificent) in 1529. The balanced proportions of the interior come close to perfection.

fellow refugees after the fall of Siena, watching over the vines creeping up the flanks of the hill.

Town follows village, and each has at least one curiosity, like the Romanesque church of San Quirico d'Orcia, whose marble turns a warm honey colour in the rays of the setting sun. Nearby Pienza is a breathtaking sight for the unsuspecting visitor; though no more than a village it was planned by Bernardo Rossellino, Alberti's favourite pupil, with false perspectives to form a perfect Renaissance townscape. Its history is, to say the least, unusual. In 1404, Aeneas Piccolomini was born here to a patrician family from Siena, who had been exiled to this, then, ordinary village. At the age of forty, Aeneas, having sown his wild oats, repented of his sins and embarked on a religious career, rapidly rising to the papal throne as Pius II. His fairy-tale life was later depicted with zestful enthusiasm by Pinturicchio on the walls of the Piccolomini library in Siena cathedral.

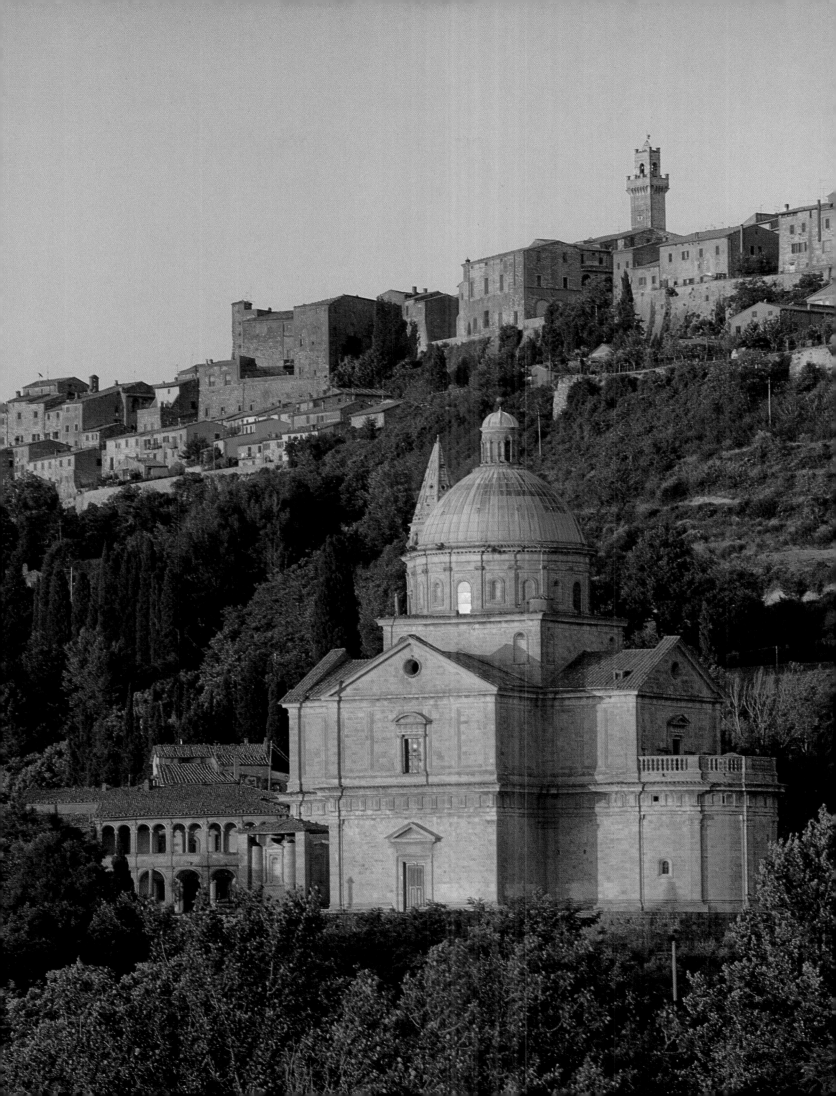

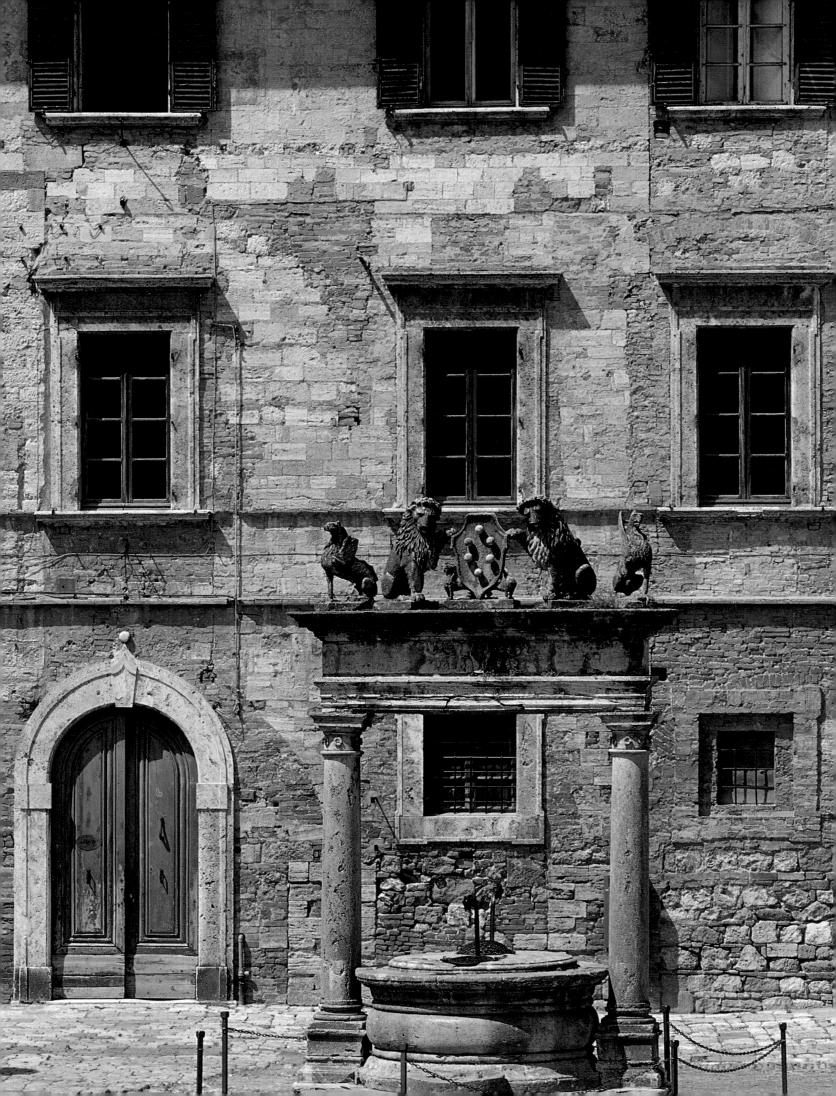

From here, we really ought to push on to the delightful town of Chiusi, an ancient Etruscan stronghold which looks out over an admirable landscape of olive groves, vineyards and wheat fields. But often we get no further than Montepulciano, clinging to its hillside, which acts as a magnet on its occasional visitors, holding them under its spell for a day or two. Its tortuous, steeply sloping streets – eventually wending their way to the aristocratically dignified Piazza Grande – are lined with *palazzi* of a class and elegance that take one by surprise in so out-of-the-way a place. From the ramparts, the eye travels in every direction over a sea of hills, and all around are the vineyards which produce Vino Nobile, one of the great Italian vintages. Eastward shimmers the distant mirror of Lake Trasimene. One's dream of Tuscany could hardly be better summed up than here.

Montepulciano, a powerful affirmation of Renaissance pride. The style is vigorous and beautiful, without frills, its severity barely relieved by potted shrubs. But in this masterly austerity, we already detect hints of Mannerism and the Baroque.
The paw of the Florentine lion supports the Medici coat of arms: a way of marking its territory.

121

"Arezzo and Cortona:

 still Tuscany and already Umbria.

Genius twice over"

<div align="right">

Berenson

</div>

AREZZO
and the borders of Umbria

Arezzo's Giostra del Saracino (a medieval tilting match) is announced in all four quarters of the city on the morning of the great day.

Arezzo is all on a slope. It begins with the modern town, at the foot of the hill, and ages with altitude. It already has wrinkles by the time you reach the Via Garibaldi, and withdraws into its Renaissance and medieval shell as you climb towards the Duomo at its summit. The nearby citadel dominates the countryside for miles around.

It is a strange place, as if all its life had drained down to the nether regions, rebuilt without much inspiration after the war. After six o'clock in the evening, the delightful upper town is given over to the cats which hold court on the stairways, under Vasari's arcades or on the vast expanse of the Passaggio del Prato, which commands extensive views. Imperilling the occasional pedestrian, street urchins come charging down the alleyways on skate-boards, pulling up at the last moment in Piazza Grande or elsewhere. Every fifteen minutes or so, an adult appears to issue an unconvincing final warning…

The hours slip away, marked by clear, musical notes from the campanile. Finally, it is time for the locals to gather for an aperitif

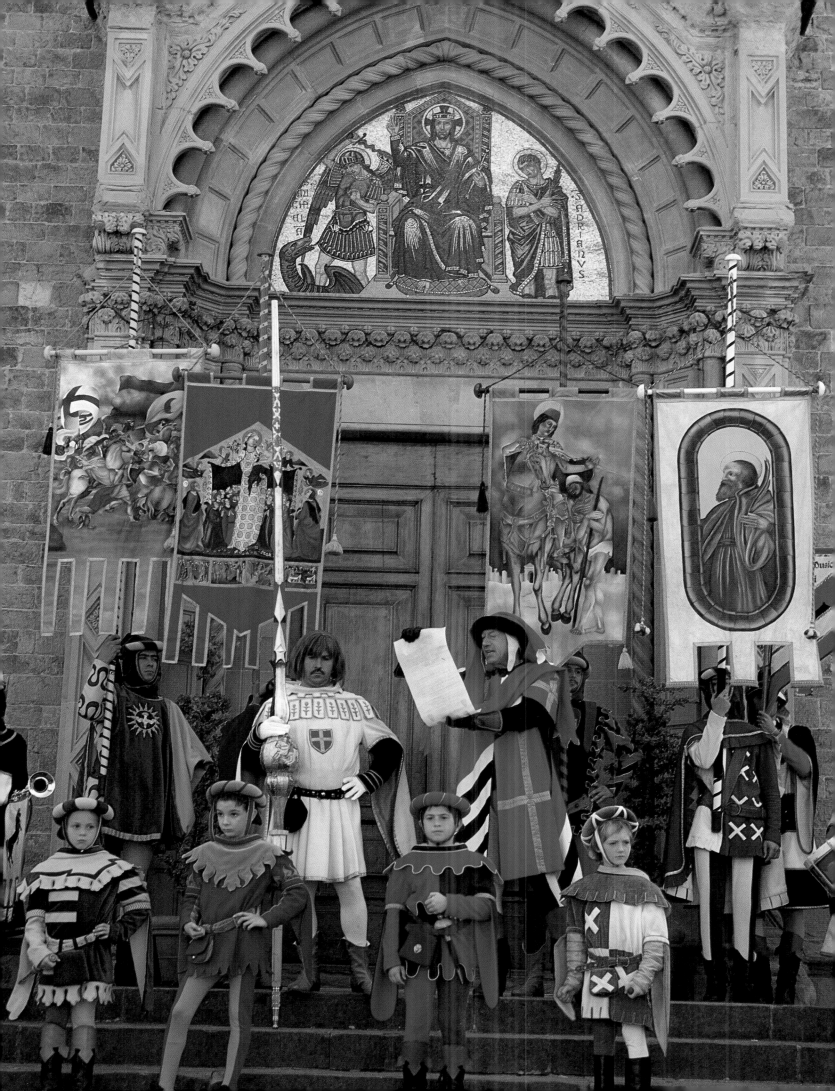

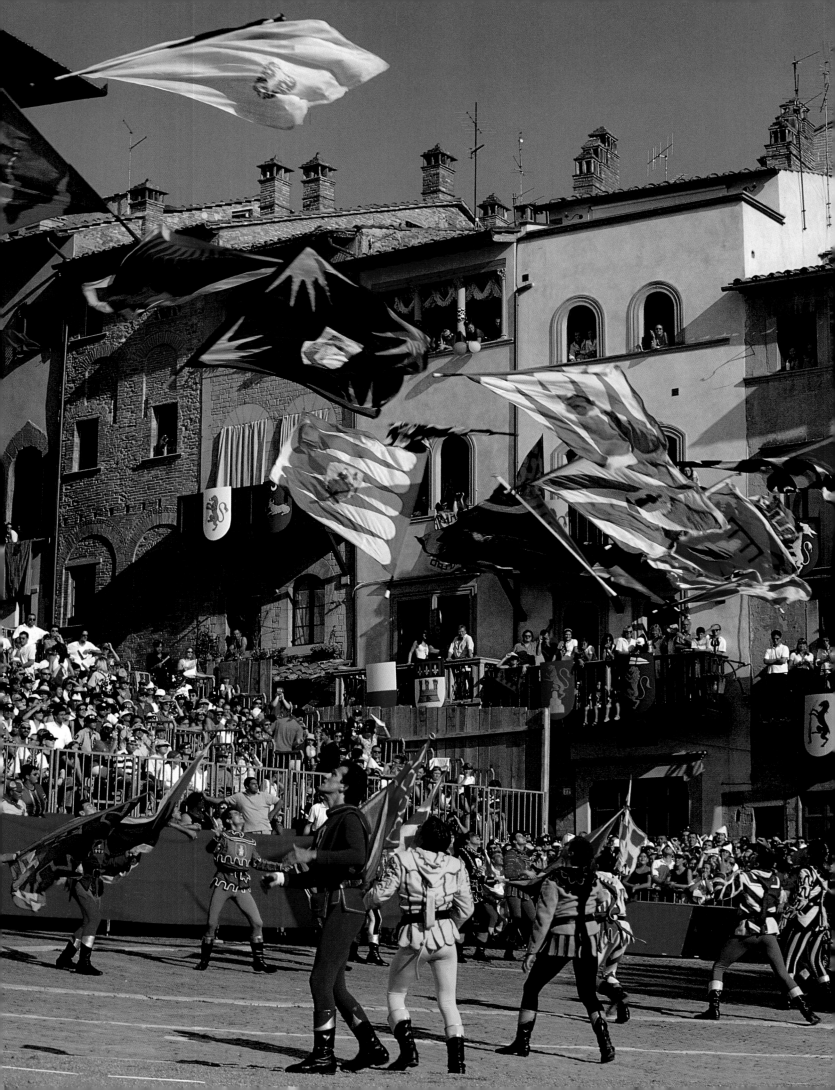

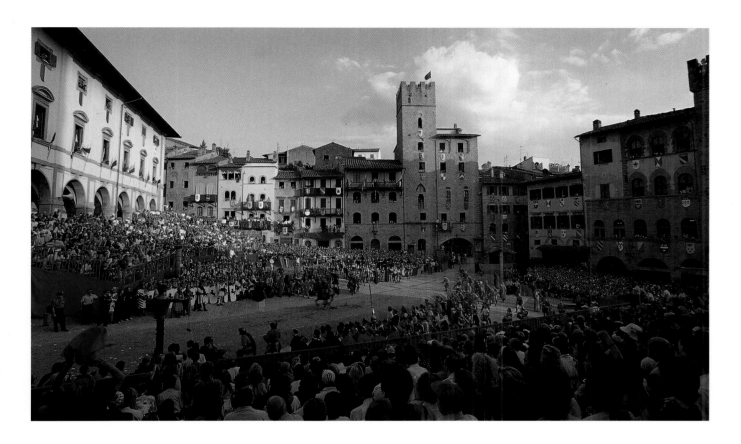

The riders charge from the bottom of Piazza Grande to tilt at the Saracen's shield.
Facing page: The flag throwers have practised for months.
Re-enactments of medieval games often begin with a spectacular parade of this kind.

• The Giostra del Saracino •

This medieval tilting match takes place twice a year: on the last Sunday in June and again on the last Sunday in September, though the general festivities begin on the Saturday evening. Long forgotten, the tournament was revived in 1931, based as closely as possible on the rules observed in the seventeenth century. It is a competition between the town's four quarters, each of which has its own colours: Porta Crucifera, red and green; Porta del Foro, yellow and crimson; Porta Sant'Andrea, white and green; Porta Santo Spirito, yellow and blue. The actual tilting is against a quintain: a figure mounted on a pivot which swings round when struck. A Golden Lance is awarded to the horseman who, in the judges' opinion, has displayed a winning combination of strength and skill. The costumes now worn by the hundreds of participants were entirely redesigned in 1992.

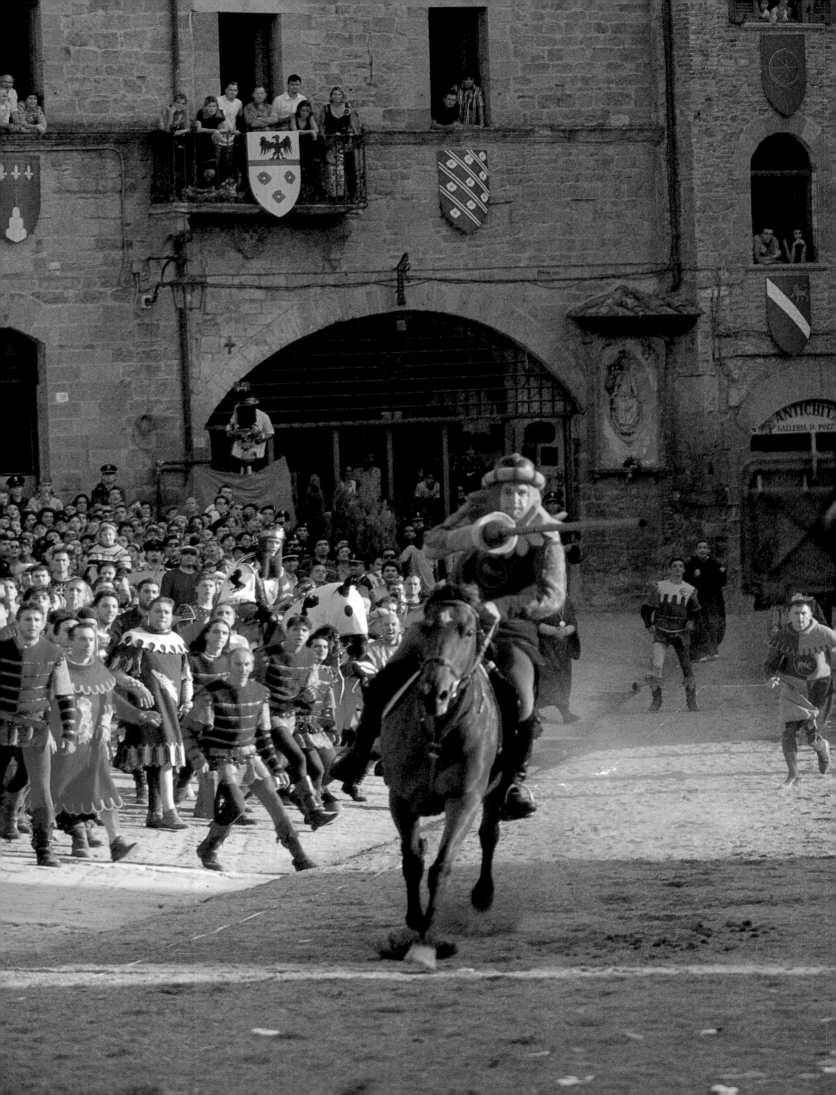

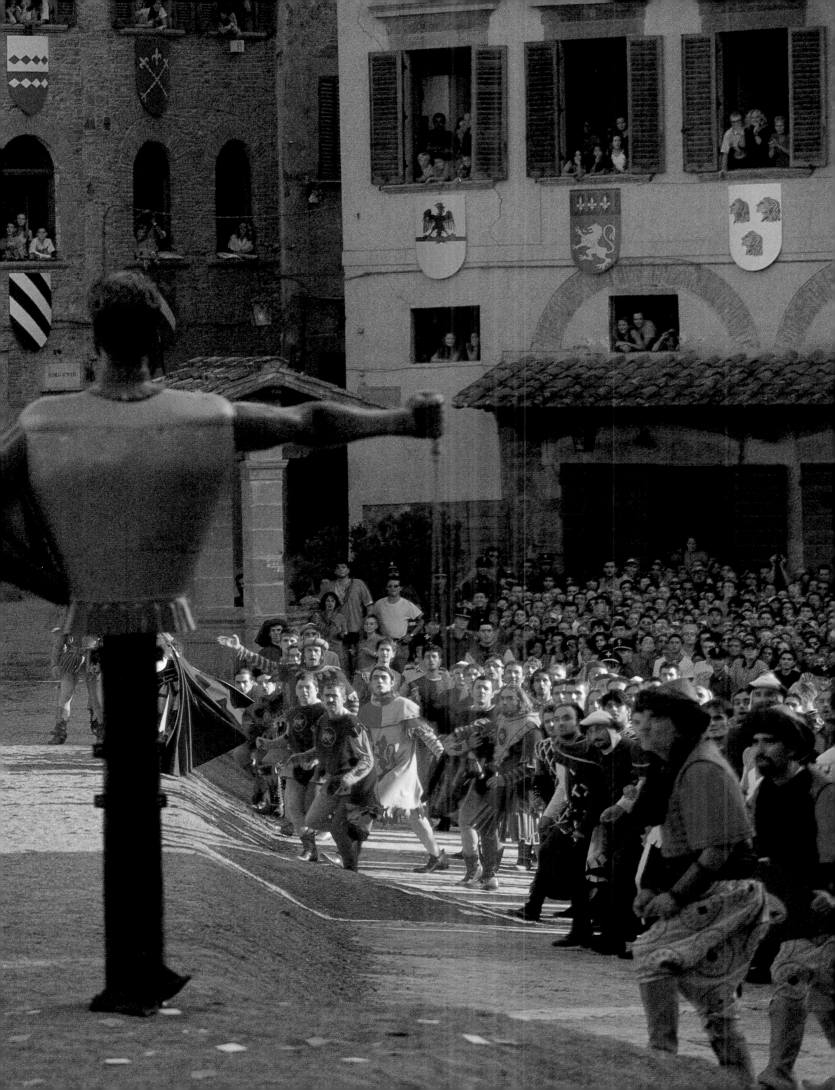

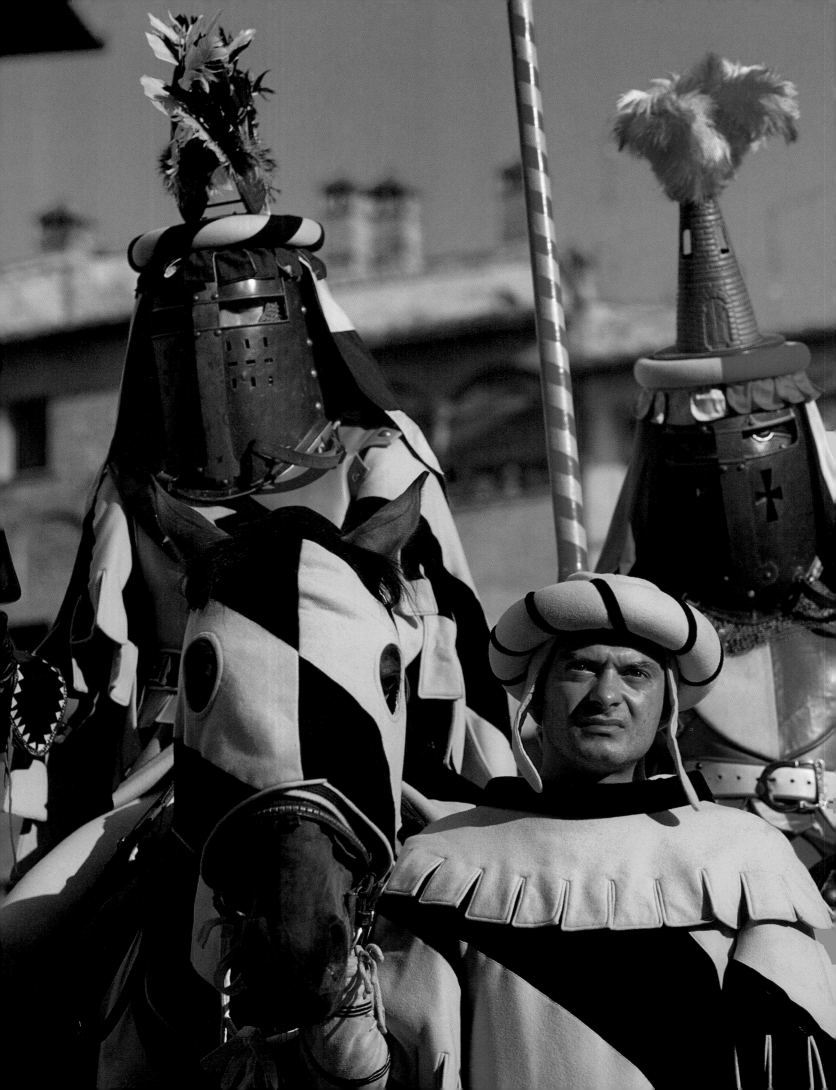

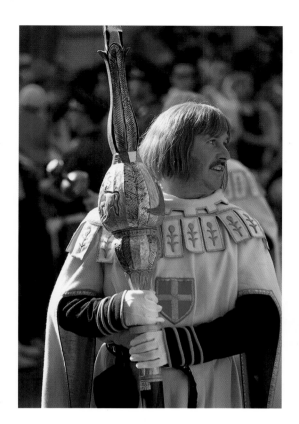

*A*rezzo's medieval tournament is said to date back to a victory over the Saracens, who were trying to invade the north of Italy. The costumes were entirely redesigned in 1992. Picking the winner is a difficult business.

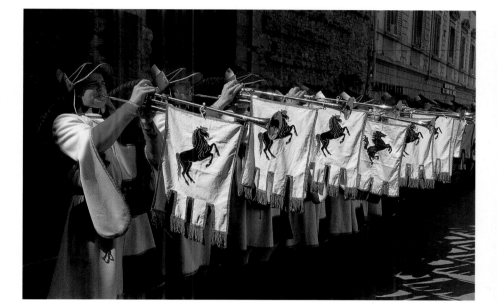

or a game of cards in Piazza Grande, a delight at any hour of the day or night. Not that the buildings are anything exceptional, though the many-apertured campanile, the heavily emblazoned court house, and the Palazzo della Fraternità dei Laici are choice examples of Romanesque through to Renaissance. But apart from Vasari's immense and precisely proportioned Palazzo delle Loge, everything here is a joyful jumble: the ground which slopes so steeply it seems to be running away; houses tall and thin, short and squat, some with open galleries on the top floor, others with balconies haphazardly tacked on.

The first weekend in every month, the square and surrounding streets form an appropriate setting for the Fiera Antiquaria,

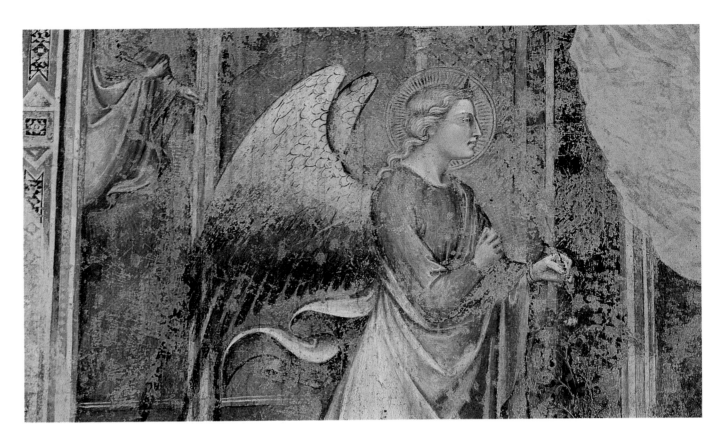

Painter, architect, Renaissance art historian and a great admirer of Michelangelo, Giorgio Vasari (1511–1574) had a house built in Arezzo (his native town) and decorated it himself. His depictions of the classical myths are rather heavy-handed, but he painted some charming trompe-l'oeil, like this figure reading by a window. You can visit the house and garden, which are quite charming.
One of the Angels of the Annunciation, and Jesus with the Doctors of the Law.

attended by antiques dealers and second-hand merchants from far and wide. They offer a mixture of furniture, ceramics, porcelain, paintings, and sculptures, often of surprisingly good quality. You would think that the great Italian families, or the nouveaux riches, never stopped selling, bartering and stock-piling their wealth.

Northern Europeans are often surprised by the Italians' fondness for medieval games: *calcio* (an early version of football) in Florence, regattas at Pisa, jousting at Pistoia, to name but a few. Though it cannot claim the dramatic intensity of the Palio in Siena, the Arezzo's Giostra del Saracino is a colourful local festival, no doubt rooted in memories of the crusades.

A cheerful event, including a procession in medieval costume through the town, the Giostra involves over 300 people and culminates in a contest between eight horsemen (two from each quarter) on the Piazza Grande. With their lances, they tilt at the

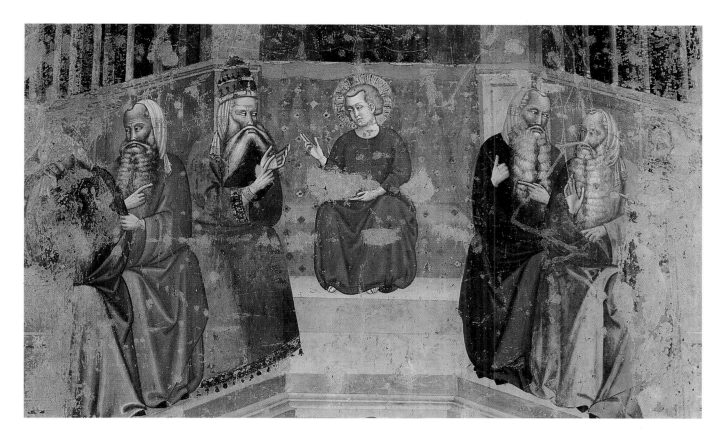

shield of a wooden figure (the Saracen) set up on a pivot. Armed
with a flail weighted with lead shot and leather, the Saracen may
swing round with force, disarming, striking, or even throwing
them from the saddle.

The festival itself begins the evening before, with banquets held
out of doors by torch light. The following morning, a Sunday, the
good people of Arezzo are awakened at seven o'clock by the firing
of a cannon from the fortress. A second shot, fired at eleven, is the
signal for the announcement of the tournament to be read out at
different places around the town. The herald is of course
accompanied by numerous standard bearers and musicians.

At two o'clock exactly, a third cannon shot signals the start of the
various processions from their respective districts. Making their
way through the dense crowds to a musical accompaniment, they
converge on the cathedral to receive the bishop's blessing. Then
the full cortège, consisting of captains and jousters, horsemen,

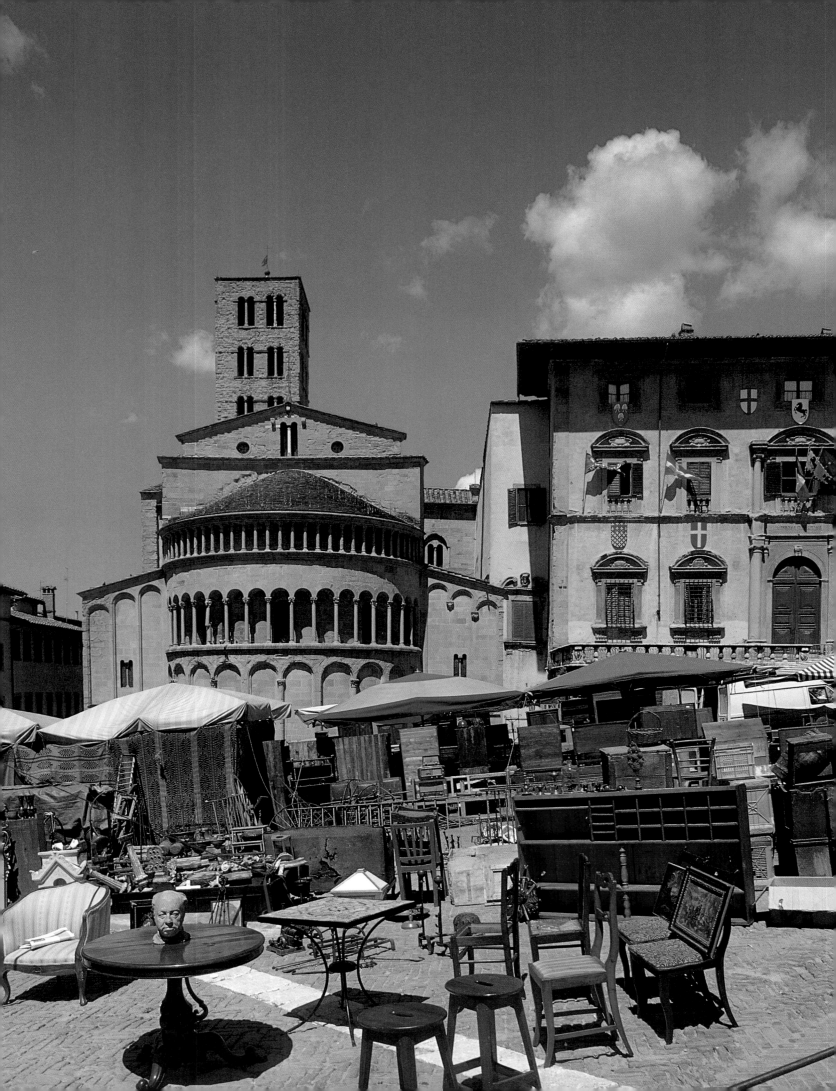

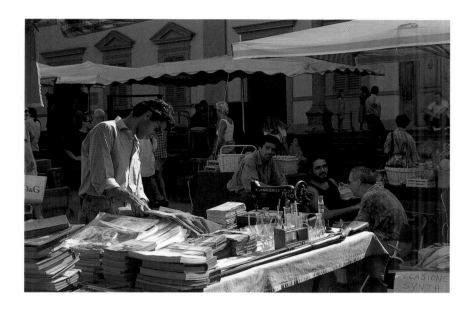

On the first weekend of every month, an antiques fair (Fiera Antiquaria) is held in Arezzo's Piazza Grande and surrounding streets. It attracts antiques dealers, booksellers, art dealers and second-hand merchants from all over Italy. Whatever the quality of the goods, the setting is truly magnificent: a sight to savour, even if you are immune to the collecting bug…

Cortona is the sort of hill town that hugs a projection in the mountainside, hence the way the streets divide on either side of the town hall. The squares of the lower town are very lively: every building and 'palazzo' seems to have a boutique or workshop at street level. The market is also held here.

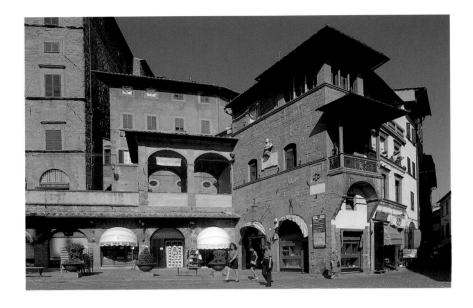

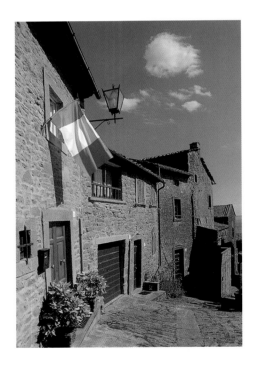

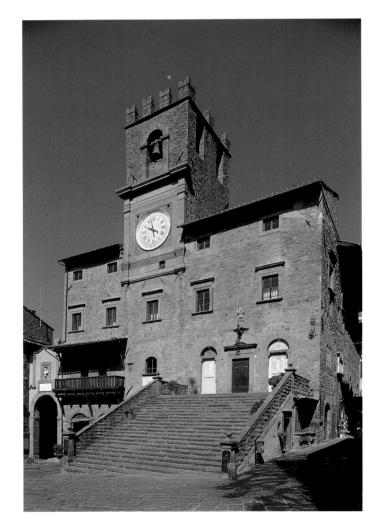

Facing page:
Santa Maria delle Grazie, a fine Renaissance church built by the Sienese Giorgio Martini below Cortona. In the background is Lake Trasimene.

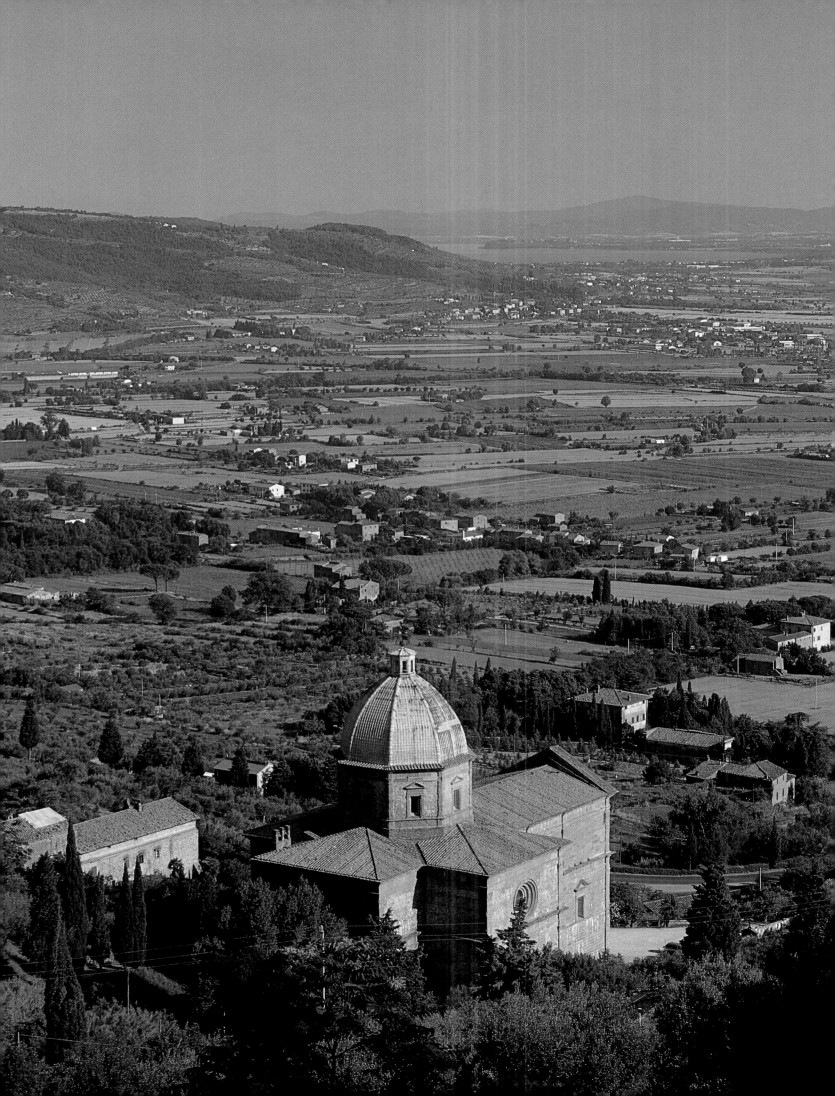

mace bearers, foot soldiers, crossbowmen, and of course a brass band playing marches, arrives in Piazza Grande, which is jam packed. Fortunes are paid to hire a vantage point from which to view the spectacle. Carpets, tapestries, and flags are hung from the balconies. Jugglers throw and catch their multicoloured flags in an aerial ballet, and the tournament itself begins.

Apart from this colourful spectacle, Arezzo attracts visitors all the year round. They come to the church of San Francesco to admire one of Italy's greatest masterpieces: Piero della Francesca's frescoes of the Legend of the Holy Cross. Restoration of this major Renaissance work will be completed in 1999, after years of painstaking work that has prevented the taking of photographs in recent times. The cycle, which should re-emerge in all its freshness, was begun in 1452. It consists of ten or so superb scenes, depicting how the tree bearing the forbidden fruit in the Garden of Eden, having become the cross of Christ, was rediscovered and enabled the Emperor Constantine, after his conversion, to ensure the triumph of Christianity. Before his "rediscovery" in the twentieth century, Piero della Francesca had been admired by only a handful of his art-loving contemporaries. He was born at Sansepolcro, a small town about forty kilometres (25 miles) north of Arezzo. It is a sleepy place (despite the fact that Buitoni pasta is manufactured there), and its tastefully renovated art gallery houses some interesting pictures. But it is in the chapel at the nearby cemetery of Montarchi that you can see one of Piero's most famous and arresting works: pointing at her unbuttoned dress, the Virgin indicates that she is with child.

A *bistecca alla fiorentina* is not just any old steak, and the restaurant owner who includes this dish on his menu has to show

it due respect. As well as being cooked correctly – ten or twelve minutes on the grill, lightly dressed with olive oil, salt added at the last moment – the succulent red meat must come from cattle of the Chianina breed, raised exclusively in the Val di Chiana, a long valley of rich pasture land, once a malarial marsh, which stretches from Arezzo to south of Cortona.

On the morning we were there, the valley resembled a great white desert seen from the terrace of our charming little hotel at the top of the hill in Cortona. It was a delightful village-like setting: tiny gardens planted with single palm trees, small squares shaded by elm trees, alleys paved with large slabs falling steeply away towards the Piazza Garibaldi. By a rare combination of circumstances (though the Tuscan winter can be bitter), it had snowed then iced over. The few cars that had ventured forth were now stuck in awkward positions. Cortona – an angular jewel, its sloping facets incised with endless stairways – was deserted.

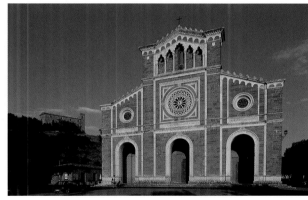

An evocative open-air cemetery, planted with cypresses and enclosed with funerary chapels. Apart from its veneration by pilgrims, the only virtue of Santa Margherita is its location above Cortona; the culmination of the town's splendid alleys, flights of steps and stony pathways.
Following pages:
Castel Porciano, near Stia, one of the finest sites in the Casentino range to the north of Arezzo. The Guidi family, who owned several castles in the region, welcomed Dante after his exile from Florence.

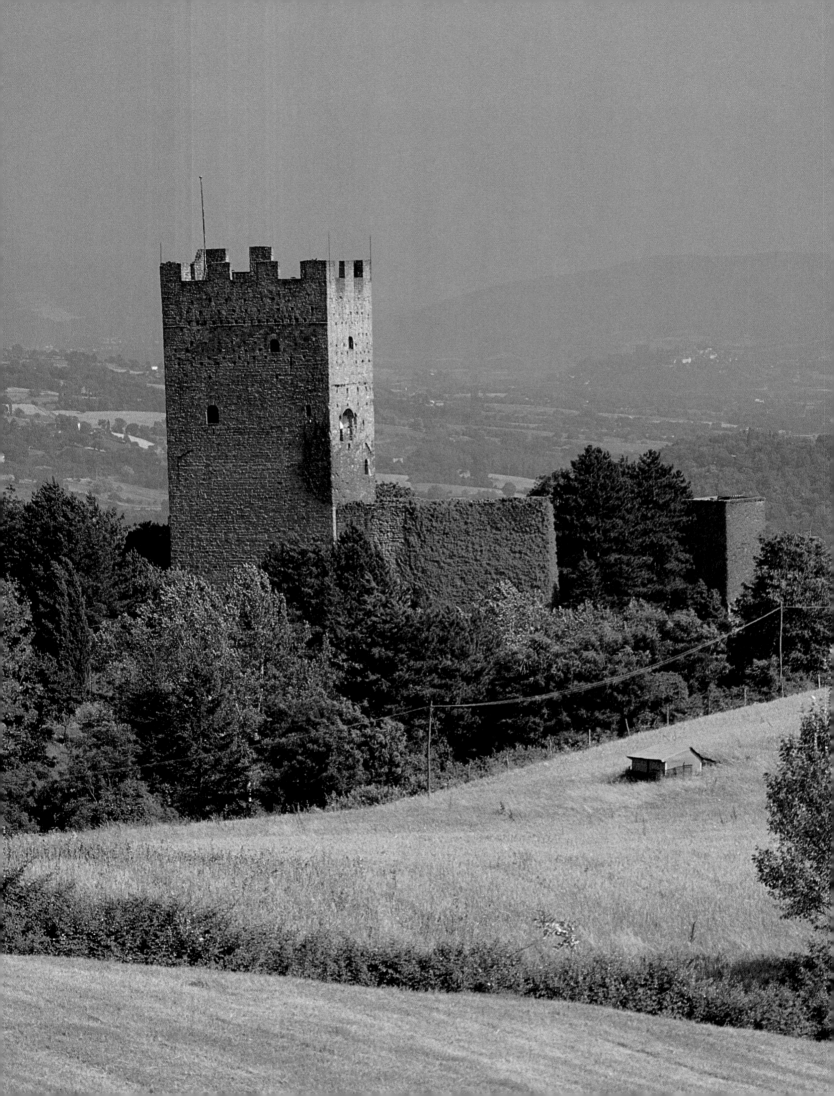

It was here at La Verna that Saint Francis received the stigmata on 14 September 1224. The Angel Chapel is part of a convent built in the nineteenth century.
Facing page:
Sixty kilometres (38 miles) north of Arezzo, near where the River Arno has its source, Poppi was once the "capital" of the Casentino region. Headquarters of the Guidi family, the Castello Pretorio (open to visitors) is built around a courtyard embellished with coats of arms.

By eleven o'clock, all had been restored to order. The town was again its normal grey; its unruly alleys the province of puffing *mamme*. No town is harder on the lungs, but then no town is more mysterious, nor offers such amazing views, whatever the season.

A guide book is superfluous. From Santa Margherita, take the roughly paved pathway bordered with yews, negotiate several flights of steps, follow alleyways lined with craftsmen's workshops, and finally you will come to the main shopping streets, where even the smallest boutique occupies the ground floor of a palace. All roads lead to the Piazza della Repubblica. Connected to it is the Piazza Signorelli (Luca Signorelli was born here; you can see his famous Descent from the Cross in the diocesan museum), which is packed with people for the Saturday market: a setting and a way of life that have scarcely changed for a thousand years…

"The Maremma keeps reminding me of the American West (…) the similarity is under the skin of the place: a loneliness, an eye on the stranger"

Frances Mayes

THE MAREMMA,
Tuscany's last wilderness

The area inland from the Tyrrhenian coast, between the Piombino peninsula and Lake Burano (to the south of Orbetello), was once a region of unhealthy marshland, infested by mosquitoes and roamed by wild boar, buffalo, half-wild horses, and cattle with lyre-shaped horns. Cattle herders ('butteri') – skilled horsemen like the 'gardians' of the Camargue – can still be seen in the Maremma nature reserve.

Poppi lives in an unpretentious house above Vetulonia. Three bay trees in pots and a few flowers transform his terrace into a fragrant garden. His memories go back to the beginning of the century, when he was a herdsman, like his father and brothers: "We lived in the marshlands of the Ombrone. I worked on horseback, driving the cattle with my goad. Sometimes I was in the saddle all day. It was alive with mosquitoes, and people died young. I am the only survivor." Poppi gets up and points to the plain with its grid of fields stretching away as far as Grosseto: "It was a muddy waste. You rode along and suddenly you were in the water. It was inhospitable country. We hunted wild boar, deer, even water buffalo… But you caught every illness going. Only poor people like us stayed. And look now: it's like America."

It is true. As far as the eye can see, the land, drained by order of Mussolini, is laid out in a pattern of rectangular fields. This new bread-basket was already a fertile plain in the time of the Etruscans. The canals they had dug so long before were restored to working order. Vetulonia, where Poppi lives, was one of the twelve

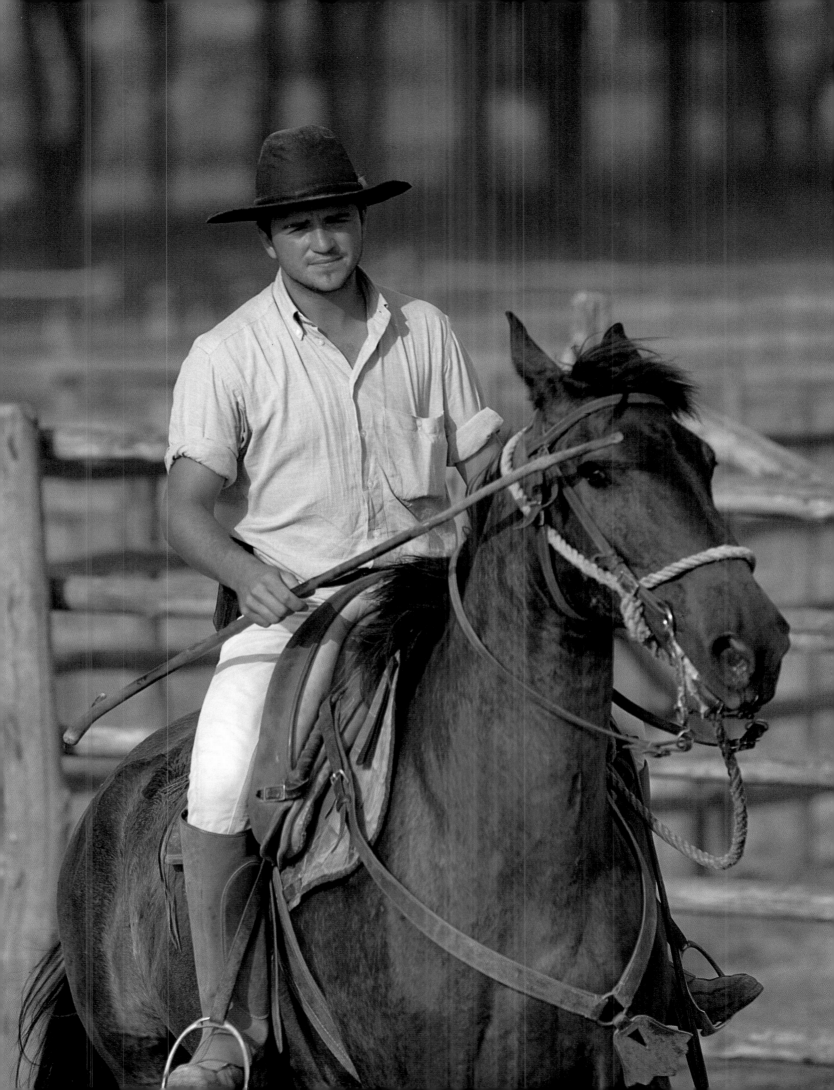

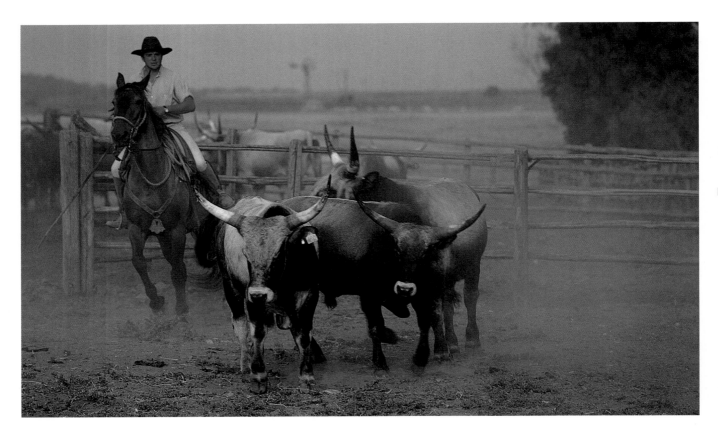

A 'buttero' at work. The cows of the Maremma are renowned for the quality of their milk. In the olden days, herds of 600 cattle were not uncommon. The tradition is still alive in the region of Lake Burano and around the mouth of the Ombrone, where the Uccelina mountains sweep down to the sea.

Facing page:

Almost half of the Maremma nature reserve is still in private hands. The local farmers have adopted organic methods, which is now the cause of their success.

Rambling and pony-trekking are the way to see this still unspoilt area, a mixture of salt scrub, marshland and wooded hills.

cities of the Etruscan Confederation. It now stands twenty kilometres (12 miles) inland on a slight rise, and yet it was a port trading with the eastern Mediterranean. Before it was drained, the plain was quite a deep lake connected to the sea by a canal accessible to shipping…

What then is the Maremma? Its borders are somewhat fuzzy. It extends from the Populonia peninsula and Piombino, opposite Elba, to the scrubby country around Lake Burano, south of the Argentario peninsula. But that only accounts for the coastline. It says nothing of the prevailing climate, the region's fauna and flora. Nothing of its Etruscan past, nor of the ancient festivals which still survive in modified form.

Climate: malarial. Fauna: wild boar, roe deer, water buffalo, foxes, half-wild horses, and Maremma cattle – good milk producers – not to mention waterfowl. Flora: beech and chestnut inland, pine and holm oak along the coast, and the ever-present maquis of

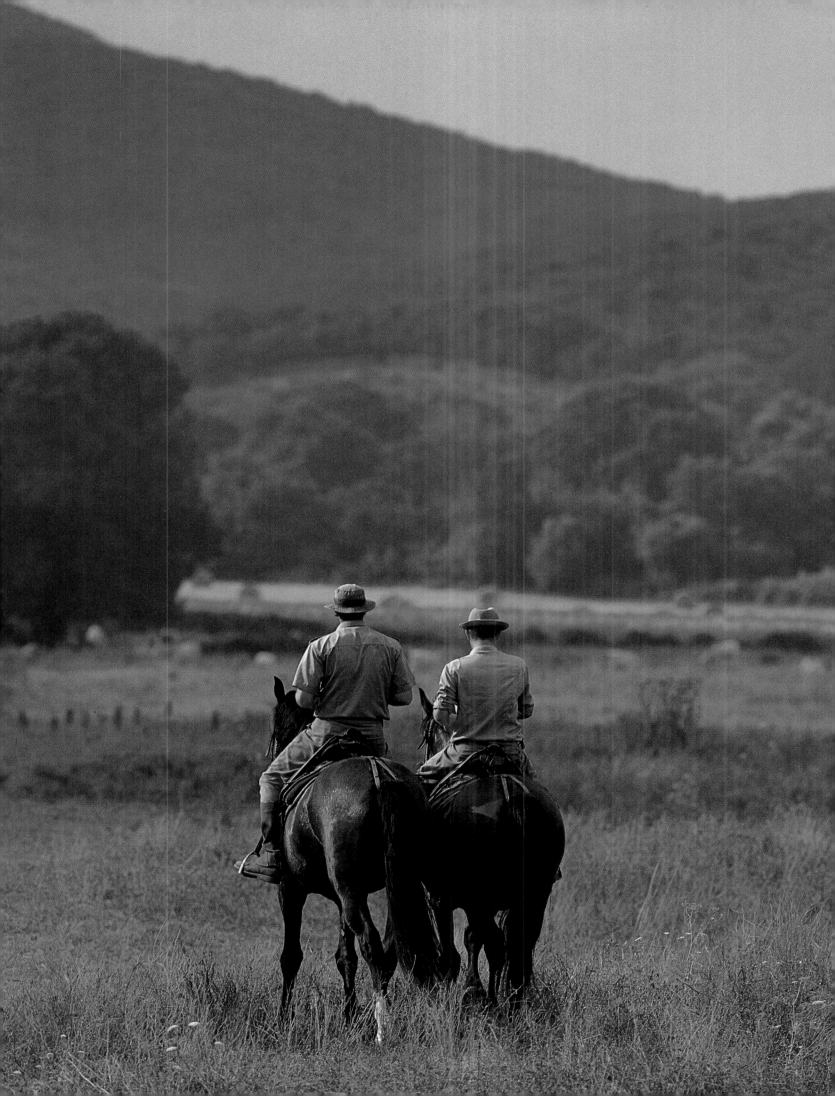

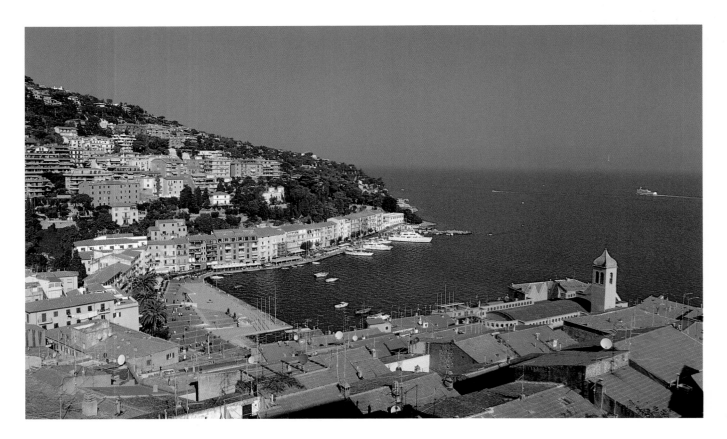

*The Argentario promontory was
once an island. Nowadays it is
popular with the wealthy, who like
to spend their holidays at Porto
Santo Stefano, and with yachtsmen.
A small-scale fishing industry holds
its own, thanks to local demand and
tourism. The fishermen here are
pictured in the charming little
harbour of Port'Ercole.*

saltbush which produces a bitter-tasting honey. Festivals: rodeos
during which *butteri* (cowboys) and their horses twist and turn to
slip on – or avoid – a halter held out on the end of a hazel pole,
magic wand of the skilful rider; so skilful – they say – that the
butteri used to make fun of Buffalo Bill.

The Maremma nature reserve, established in 1975 on the stretch
of coast between Marina di Albarese and the protected headland
at Talamone, gives a good idea of what the area was like in times
gone by – marshland, dunes, pine woods, all in a rocky,
tumbledown landscape covered in dense scrub. A few old
Genoese towers standing guard, and the ivy-covered ruins of the
San Rabano abbey. It is here that you will encounter the last of the
butteri, counterparts of the *gardians* of the Camargue, driving
their herds of sharp-horned cattle.

Further to the north are some peculiarly Italian seaside resorts,
with rows of beach huts, vending booths and parasols leaving a

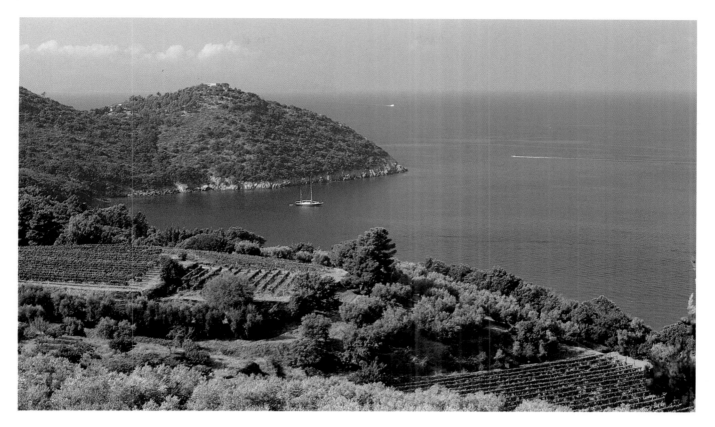

few strips of sand where bronzed Italian men can chat up the girls. Out of season, it is a pleasure to stroll along at the foot of the cliffs on the beaches and wild inlets of Punta Ala, Castiglione and other seaside settlements.

Not until you venture into the chaotic hinterland do you really understand the nature of the Maremma. It is a harsh land where water has always been a problem, even in Etruscan times. A land laid bare, sometimes flayed to the bone, often emaciated and depopulated, apart from the vineyards that produce a pungent, highly coloured, very drinkable wine. A desert, European style, which that great revolution in thought – the humanism of the Renaissance – never reached.

Coming from Siena and leaving Monte Amiata to its splendid isolation, you penetrate a silent world where it is rare for a foreigner to venture. There is never a straight stretch on these mountain roads with their old castles and remote villages, where

*F*ollowing pages:
Cream-coloured houses on the hillside, busy streets, and a bustling harbour: Porto Santo Stefano is the rendezvous of wealthy Italians from the north and from Rome, who own fabulous villas with stupendous views over the sea.

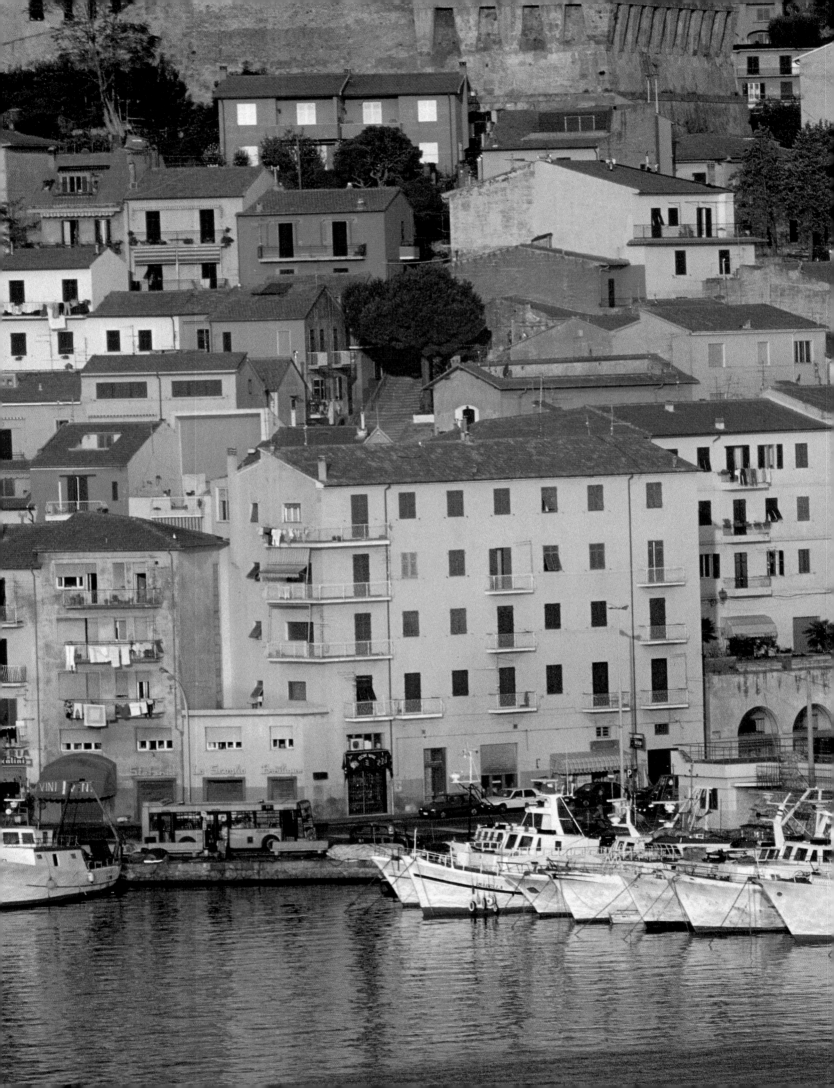

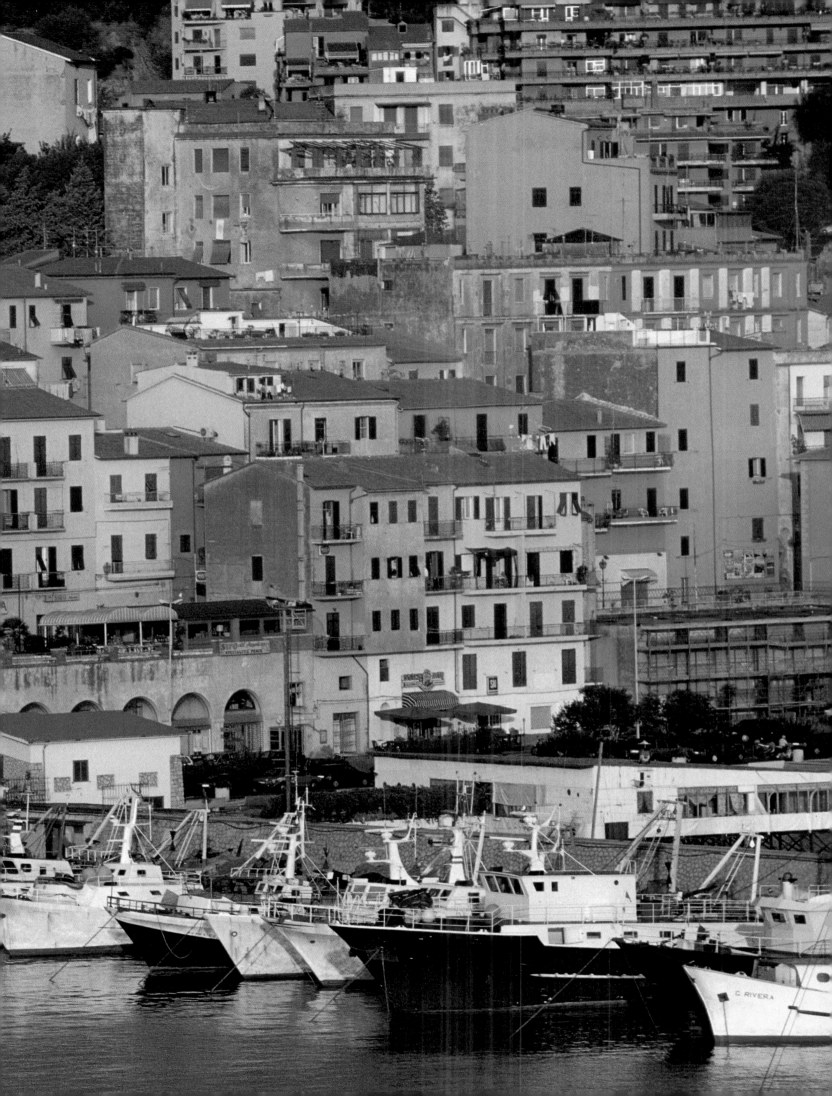

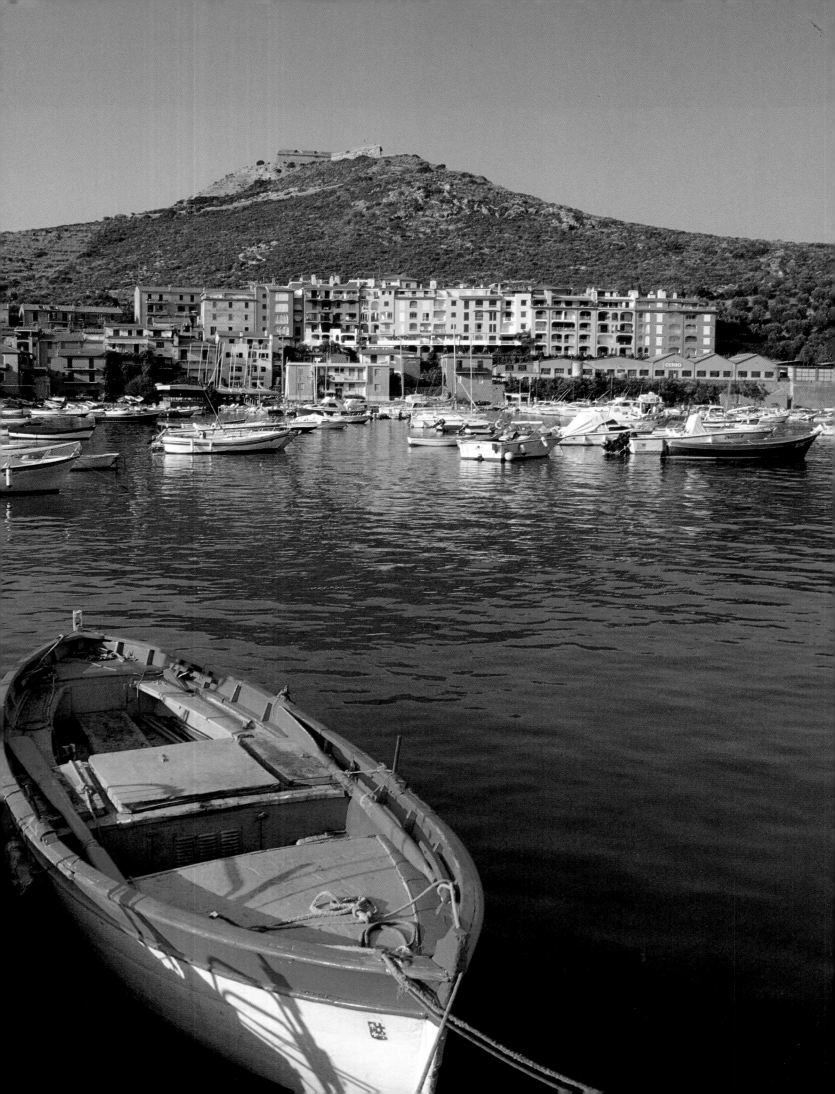

TOLLS ON ITALIAN MOTORWAYS ("Autostrada")

(Tolls in Italian Lire)

	Route	km	I	II	III	IV	V
A1	**Milano - Napoli**						
	Milano S. - Bologna (A14)	203	17,000	17,500	21,500	34,000	40,500
	Bologna (A14) - Firenze N.	85	9,000	9,500	11,500	18,000	22,000
	Firenze S. - Roma N.	273	20,500	21,000	26,000	41,000	49,000
	Roma S. - Napoli N.	198	16,500	16,500	20,500	32,500	39,000
	Milano S. - Napoli N.	759	64,000	65,500	80,500	127,000	152,000
A3	**Napoli - Reggio Calabria**						
	Napoli - Pompei - Salerno	50	1,600	2,000	3,500	4,500	5,000
	Salerno - Reggio Calabria	442	-	-	-	-	-
A4	**Torino - Trieste**						
	Torino - Milano Ghisolfa	122	10,000	10,500	13,000	20,500	24,500
	Milano E. - Brescia W.	77	7,500	7,500	9,000	14,500	17,500
	Brescia E. - Verona S.	55	4,500	4,500	5,500	9,000	11,000
	Verona E. - Padova W.	89	6,000	6,000	7,500	12,000	14,000
	Padova E. - Venezia (Mestre)	20	3,000	3,000	3,500	5,500	7,000
	Milano E. - Venezia (Mestre)	241	21,500	22,000	27,000	43,000	51,500
	Venezia E. - Trieste Lisert	122	10,000	10,500	12,500	20,000	24,000
A5	**Torino - Monte Bianco**						
	Torino N. - Aosta	108	18,500	20,000	27,000	42,500	49,000
	Santhia - Aosta	87	16,000	17,500	23,500	37,000	42,000
	Aosta - Morgex	31	3,500	4,500	6,000	9,500	11,500
A6	**Torino - Savona**						
	Torino - Savona	127	13,500	14,000	19,000	29,500	34,500
A7	**Milano - Genova**						
	Milano W. - Tortona	59	6,000	6,500	8,000	12,500	14,500
	Milano W. - Genova W.	128	12,500	13,000	15,500	25,000	30,000
A8/9	**Milano - Laghi**						
	Milano - Gallarate	31	3,400	3,600	4,000	7,000	8,000
	Milano - Sesto Calede	47	3,600	3,800	4,500	7,500	8,500
	Milano - Como	40	4,200	4,300	5,000	8,500	10,000

		km	I	II	III	IV	V
A10	**Genova - Ventimiglia**						
	Genova airport - Savona Vado	46	4,000	4,500	5,500	8,500	10,000
	Savano Vado - Ventimiglia	113	20,000	24,000	38,500	50,000	57,500
A11	**Firenze - Pisa Nord**						
	Firenze - Montecatini	44	3,000	3,500	4,000	6,500	7,500
	Firenze - Pisa N.	82	6,500	7,000	8,500	13,000	16,000
A12	**Genova - Cecina**						
	Genova E. - La Spezia	96	12,500	13,000	17,000	27,000	31,500
	Genova E. - Viareggio Camaiore	137	16,000	16,500	21,500	34,500	40,000
	La Spezia - Risignano M.	110	15,000	15,500	21,000	33,000	38,500
	Genova E. - Rosignano M.	206	25,500	26,000	34,500	55,000	64,000
	Roma - Civitavecchia						
	Roma W. - S.S.1 Aurelia (Civ'ia)	66	5,000	5,000	7,000	11,000	13,000
A13	**Bologna - Padova**						
	Bologna - Ferrara S.	34	3,000	3,500	4,000	6,500	7,500
	Ferrara N. - Padova S.	83	5,000	5,500	6,500	10,500	12,500
	Bologna - Padova	117	9,500	10,000	12,000	19,000	23,000
A14	**Bologna - Taranto**						
	Bologna S. L. - Ravenna	75	6,000	6,000	7,500	11,500	14,000
	Bologna S. L. - Ancona N.	211	16,000	165,000	20,000	32,000	38,000
	Ancona S. - Pescara N.	175	11,000	11,000	13,500	21,500	26,000
	Pescara S. - Bari N.	295	23,500	24,500	30,000	358,000	69,500
	Pescara S. - Taranto N.	378	29,000	30,000	36,500	58,000	69,500
	Bologna S.L. - Taranto N.	759	60,000	61,500	75,500	119,500	143,000
A15	**Parma - La Spezia**						
	Parma W. - La Spezia	101	13,500	13,500	18,500	29,000	34,000
A16	**Napoli - Canosa**						
	Napoli E. - Bari N. (A14)	179	22,000	22,500	27,500	43,500	52,500
A18	**Messina - Catania**						
	Messina - Catania	93	5,000	6,000	9,500	13,000	15,000
A19	**Palermo - Catania**						
	Palermo - Catania	176	-	-	-	-	-

		km	I	II	III	IV	V
A20	**Messina - Palermo**						
	Messina N. - Furiano	101	10,000	10,500	12,000	19,500	23,500
	Cefalu - Buonfornello	28	1,400	1,500	7,500	12,000	14,500
A21	**Torino - Piacenza - Brescia**						
	Villanova d'Asti - Allessandria W.	73	6,500	6,500	8,000	12,500	15,000
	Allessandria E. - Piacenza	77	7,500	8,000	9,500	15,000	18,000
	Villanova d'Asti - Piacenza	173	14,500	15,000	18,500	29,500	35,000
	La Villa - Brescia	72	6,000	6,000	7,500	12,000	14,500
A22	**Brennero - Modena**						
	Brennero - Trento C.	138	13,500	14,000	17,000	27,000	32,500
	Trento C. - Verona N.	92	8,000	8,500	10,000	16,000	19,500
	Verona S. - Mantova S.	28	3,000	3,000	4,000	6,000	7,000
	Brennero - Modena N.	317	29,000	30,000	36,500	58,000	69,500
A23	**Udine - Tarvisio**						
	Udine N. - Tarvisio	102	8,500	8,500	10,500	17,000	20,500
A24	**Roma - L'Aquila - Teramo**						
	Roma E. - L'Aquila W.	116	8,500	8,500	10,000	16,500	20,000
	Roma E. - Teramo	73	12,500	13,000	14,500	24,500	29,500
A25	**Torano - Pescara**						
	Roma E. - Pescara Villanova	186	14,500	15,000	17,500	28,500	34,500
A26	**Genova Voltri - Gravellona Toce**						
	Genova - Alessandria S.	68	6,000	6,500	7,500	12,000	14,500
	Genova - Vercelli W.	124	10,000	10,500	13,000	20,500	24,500
	Genova - Arona	187	14,500	15,000	18,500	29,000	35,000
A27	**Mestre - Belluno**						
	Mestre N - Fadalto Lago di S. Croce	60	6,500	6,500	8,000	12,500	15,000
A28	**Portogruaro - Pordenone**						
	Portogruaro -Pordenone	21	-	-	-	-	-
A29	**Palermo - Mazara del Vallo**						
	Palermo - Mazara del Vallo	254	-	-	-	-	-

		km	I	II	III	IV	V
A30	**Caserta - Salerno**						
	Caserta N. (A1) - Salerno	55	5,000	5,000	6,500	10,000	12,000
A31	**Vicenza Piovene Rocchette**						
	Vicenza N. - Piovene Rocchette	36	2,500	2,500	3,000	5,000	5,500
A32	**Torino - Bardonecchia**						
	Salbertrand - Bruere	60	14,700	17,200	27,200	36,000	42,000

Tolls are applied as follows:

Category I	motorcycles, cars with a height measured at the front axle of less than 1.30 m
Category II	3-wheeled vehicles and vehicles with a height at the front axle exceeding 1.30 m
Category III	motor vehicles (with or without trailer) with 3 axles
Category IV	motor vehicles (with or without trailer) with 4 axles
Category V	motor vehicles (with or without trailer) with 5 axles

Some motorways are better known under the following names:

A1	Del Sole	A14	Adriatica
A4	Est Serenissima	A15	Della Cisa
A5	Valdostana	A16	Dei due Mari
A6	Torino - Mare	A21	Dei Vini
A8, A9	Dei Lagi	A22	Dei Brennero
A10	Dei Fioro	A26	Dei Trafori
A11	Firenze - Ma	A27	D'Alemagna
A12	Azzura	A31	Valdastico

cont....

Toll payment:

Tolls can be paid with lire, foreign currency, credit card or by magnetic card (see below).

Major credit cards are accepted on the following motorways:

> A4......Venice - Trieste A28.......Portogruaro - Pordone
> A22....Modena - Brennaro A32.......Torino - Bardonecchia

Motorists may pay tolls with a VIACARD on the majority of motorways (except A18 and A20). The card can be used for any vehicle and is available in two amounts: 50,000 lire and 90,000 lire. Motorists can obtain then from motorway toll booths and service areas, certain banks, tourist offices and tobacconists. When leaving a motorway on which the VIACARD is accepted, the card and the entry ticket is handed to the attendant who will deduct the amount due. At motorway exits with automatic barriers, the VIACARD should be inserted into the machine. The card is valid until the credit expires. Credit Cards are NOT accepted for payment of the VIACARD.

The 'Adriacard' can be used on motorways to the Adriatic:

> A4.......Venice - Trieste A27......Mestre - Belluno
> A23.....Udine - Tarviso A32......Portogruaro - Pordenone

This card (in values of 20,000 lire, 50,000 lire and 90,000 lire) is available from main service stations on these motorways and local Automobile Club Italia (ACI) offices.

Every effort is made to ensure the accuracy of information contained in this leaflet, however, the RAC cannot be held responsible for any errrors or omissions. Contents are believed to be correct at time of printing but toll charges may alter after this time.

Prepared by Touring Information and Research Unit, RAC, PO Box 700, Bristol BS99 1RB.

RAC/TIR/August 1998

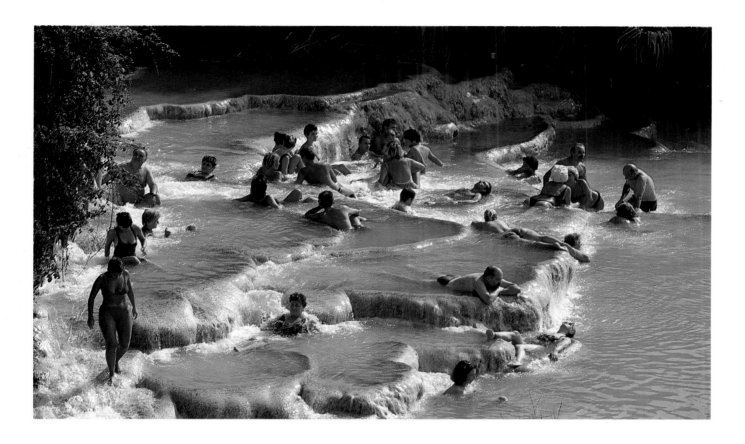

*L*ight blue water tumbling into Saturnia's petrified pools.
You can relax for hours in the tepid water.
It is supposed to be excellent for respiratory ailments.

• Saturnia •

Said to have been founded by the god Saturn, the little town of Saturnia is surrounded by well-preserved Etruscan tombs. But it is also famous for its thermal springs. The sulphurous waters of the Cascate di Gorello come welling up at 37°C and flow down into petrified outdoor pools where you can bathe free of charge. The place is crowded on Sundays and during the holiday season. But in the fresh early morning air, you can relax all on your own in the golden light. The water is light blue and virtually odourless, as the sulphur content is not high. The strong current provides a pleasant massage. The Maremma, with its volcanic rocks, has other thermal springs, but these are undoubtedly the most pleasant – and excellent for the respiratory system.

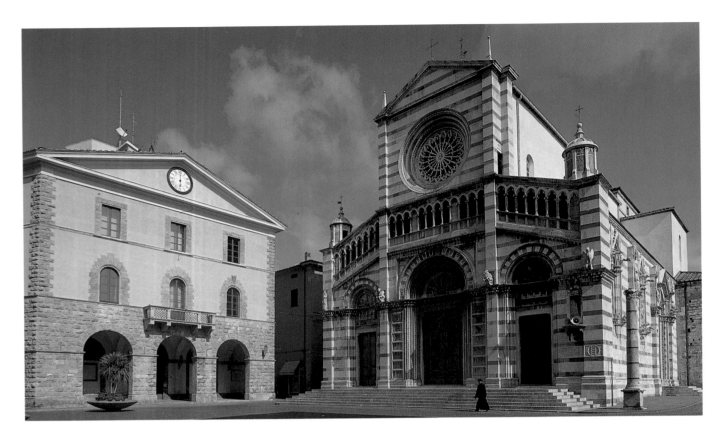

Set in a vast plain, Grosseto has benefited enormously from land reclamation schemes. Though badly damaged by air raids during the last war, the busy modern town still has an old district with an unusual cathedral, clad in red and white marble. The façade has some charming details.

poverty is a daily reality. That is the foreigner's loss. He will never taste the local vegetable broth, to which they add an egg just before it is ready. He will never enjoy a real *zuppa di fagioli* (white bean soup), nor the local game, nor wild boar seasoned with apples or blackberries. The heartlands of the Maremma have jealously guarded these recipes which appear on menus all over Tuscany, but in adulterated form. If you want to try the real ancestral cuisine, it is here, to these unpretentious village restaurants, that you must come.

The road winds between soft tufa cliffs clad in chestnut trees. The Etruscans lived here, and here you will see their tombs: grotto temples, their entrances adorned with capitals and sculpted friezes. Up there on its hill, Sovana looks as if it is about to crumble away. The ghost village which in the eleventh century gave birth to the monk Hildebrand, later Pope Gregory VII, has just one street, prettily paved with pink bricks. It leads to a little square graced by

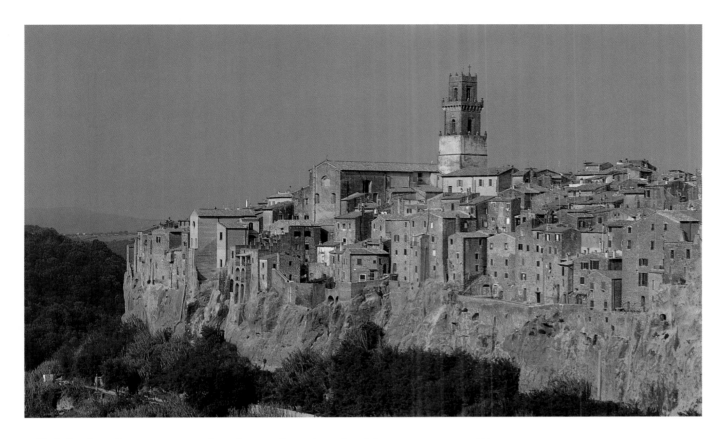

a slightly tipsy Romanesque church, another church with a stone-canopied altar and, opposite, a loggia sheltering the modest little Etruscan museum.

Huddled around the fortress of the Orsini family, the little medieval town of Sorano, also of Etruscan origin, seems even more deserted. No chance of the wealthy British, Germans or Italians coming and restoring any of these ageless buildings: the motorways are at least an hour away.

But the highlight is Pitigliano, planted on its rock like Stylites on his column. How long can it stand? The vineyards round about yield a white, slightly stony wine, pleasant to drink at the cafés of this enchanting – and very busy – little centre, modelled from the tufa on which it stands. In the evening, the "mountain" is all lit up, and this out-of-the-way little town with so strong a character is suddenly revealed as one of the most beguiling places in Tuscany.

Pitigliano seems carved out of the tufa of its cliff. It is one of the most amazing hilltop towns, appearing to balance in unstable equilibrium on a dizzy plateau.
Following pages:
The solitary and still wild Maremma shoreline, backed by hills and virgin woodland. A coast where past and present are reconciled, now that the mosquitoes have gone.

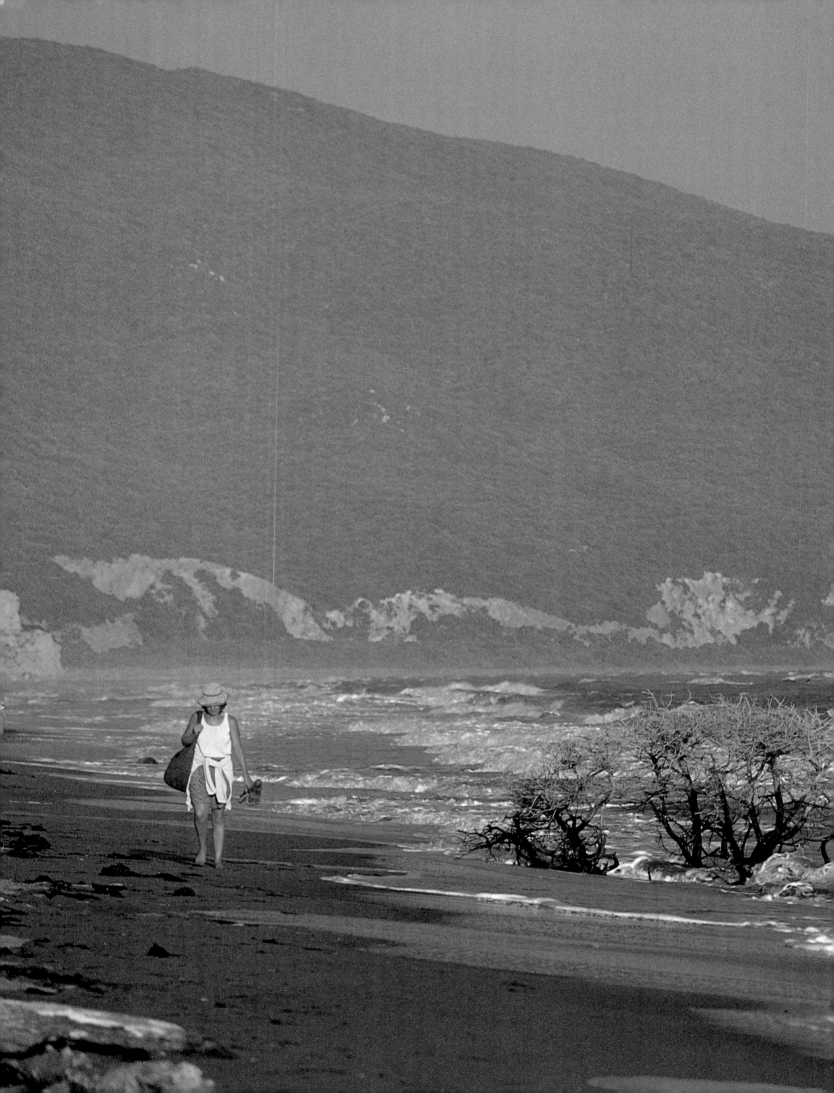

USEFUL INFORMATION

TOURIST INFORMATION IN THE UK: Your first source of information should be the Italian State Tourist Office, 1 Princes Street, London W1R 80Y, tel. 0171 408 1254, fax 0171 493 6695.

TOURIST INFORMATION IN TUSCANY: Regione Toscana Turismo e Comercio, Via di Novoli 26, 50100 Florence, tel. 0039 055 4383680. There are also tourist information offices in all larger towns.

ENTRY FORMALITIES: A valid passport is all you will need. Citizens of most European Union countries will require only an identity card.

CUSTOMS REGULATIONS: With the exception of tobacco and alcohol, there are no restrictions on the import and export of goods for personal use within the EU. There is no limit on tax-paid items purchased in Italy.

ITALIAN EMBASSY AND CONSULATE IN THE UK: Italian Embassy, 14 Three Kings Yard, London W1Y, tel. 0171 312 2200. Italian Consulate General, 38 Eaton Place, London SW1X 8AN, tel. 0171 235 9371.

BRITISH CONSULATE IN TUSCANY: Lungarno Corsini 2, Florence, tel. 0039 055 284133.

MONEY: The unit of currency is the Italian Lira (LIT). There are approx. 2,800 Lire to the Pound Sterling (March 1999). It is often better to change money in Italy itself rather than in the UK. It is also possible to obtain cash from automatic tellers. The usual credit cards are accepted almost everywhere.

GETTING TO TUSCANY: By plane: Florence airport is served by all major European cities, with direct daily flights from London. There are also daily flights to Pisa airport from London. There are express train connections from Pisa airport to Pisa and Florence main train stations. By rail: continental train connections to Florence and to the other major towns in Tuscany are good. Once in Italy, it is worth getting a *biglietto turistico libera circolacione*, which will give you unlimited use of the Italian rail network.

THE COUNTRY AND THE PEOPLE

GEOGRAPHY: Tuscany is bordered by the Etruscan Apennines to the north and north-east and by the Alpi Apuane mountains towards the Po plain in the north-west. It extends to the tuff landscape of Latium in the south and is dominated by the massif, including the 1,738 m (5,700 ft) high Monte Amiata, an extinct volcano. With its charming, undulating countryside and striking cypress trees, the Chianti region between Florence and Siena typifies Tuscany. Many rivers and streams wind their way through Tuscany; the Arno flows through Florence, the Ombrone stretches southwards from Siena as far as Grosseto.

AREA: At around 23,000 km² (8,900 sq. miles), Tuscany is slightly larger than Wales.

CAPITAL: Florence, with a population of over 400,000.

FORM OF GOVERNMENT: Tuscany is subdivided into ten provinces and is one of the 20 regions governed by the Italian State. The President of the Republic of Italy is elected for seven years. The Parliament is made up of the House of Deputies and the Senate.

ECONOMY: About a quarter of Tuscany is given over to agriculture, the most important sector of the economy being olive oil and wine production. Crafts and industry also have an important role to play in the Tuscan economy. The ceramics industry and Florentine wickerwork, together with nuclear research in Pisa and the shipyards and refineries of Livorno are some of the most important manufacturing industries. Tourism is also an important source of income, with around 3 million overnight stops being recorded annually for the whole region.

CLIMATE: The climate is mild in spring and autumn. It is very cool in winter, while in summer it is muggy and hot. It generally has more rain than most of the other regions of Italy. For beach holiday makers, summer is the best time to travel, while spring and autumn are better for those wishing to visit cultural places of interest.

LOCAL TIME: Central European Time (CET) – 1 hour ahead of GMT in winter, 2 hours ahead in summer.

POPULATION: 3.6 million inhabitants, dispersed throughout the ten provinces of Tuscany. Most of the population live in the towns.

RELIGION: Roman Catholicism is the religion of over 90% of the Tuscan population.

LANGUAGE: Italian.

TOURIST ATTRACTIONS: The PIAZZA DEI MIRACOLI in PISA is unquestionably one of the world's most beautiful ensembles of sacred buildings and is dominated by the LEANING TOWER, which now has a lean of 2.2 m (7 ft) and which for safety reasons has been closed to the

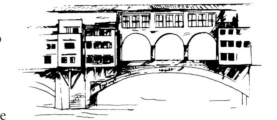

public for several years. Its foundation stone was laid in 1173. The DUOMO, work on which started in 1063, is also impressive. It is noted for its white marble façade, mosaics, and marble and glass inlay, and its bronze main portal by Giambologna. The third building on this square is the BAPTISTERY, which is the largest in the world. The small town of LUCCA is of interest because of its town walls, preserved in their entirety, which provide a pleasant walk right around the town. The central square is the oval PIAZZA DEL MERCATO, which was built in the Middle Ages on the foundation walls of a Roman amphitheatre. Near the town wall is the church of SAN FREDIANO. The upper section of its façade is defined by a Byzantine style gold grounded mosaic showing Christ in the Mandorla. The favourite church of the people of Lucca is SAN MICHELE, which is completely clad in gleaming white Carrara marble and the façade of which is characterised by numerous, individually worked columns. SAN ZENO CATHEDRAL in PISTOIA is one of the oldest churches in Tuscany, with parts of it dating back to the 5th and 6th century. It is famous for the silver altarpiece of St James, which is decorated with 628 figures and which was created by many artists from 1287 onwards into the 15th century. FLORENCE, the capital of Tuscany, has numerous tourist attractions, by far and away the most famous being the SANTA MARIA CATHEDRAL with its huge dome by Brunelleschi (1420–1436) and Giotto's bell-tower, which was begun in 1334. The Basilica, which houses many treasures, has three apses and is the fourth largest church in the world. The octagonal BAPTISTERY with its bronze doors by Andrea Pisano and Lorenzo Ghiberti stands in front of its main façade. The most important squares during the Florentine Renaissance were the PIAZZA DELLA SIGNORIA, where Ammanati's NEPTUNE FOUNTAIN and a copy of Michelangelo's DAVID now stand, and the PALAZZO VECCHIO. A passageway connects the picture and sculpture galleries of the UFFIZI, which in turn is connected by the Corridoio Vasariano covered passageway over the PONTE VECCHIO to the PALAZZO PITTI on the other side of the Arno. Deep in the gentle, rolling hills of Chianti lies the medieval looking little town of SAN GIMIGNANO, whose particular appeal lies in its 72 towers, which still remain intact and which

rise up between houses and narrow alleyways. Perched on the highest point of SIENA is the SANTA MARIA CATHEDRAL, with its façade richly decorated with numerous figures and its interior inlaid marble pavement depicting biblical and allegorical scenes. The pulpit by Nicola Pisano is one of the most important Tuscan works of art. At the heart of the three hills on which Siena was built lies the CAMPO, a shell-shaped square surrounded by Gothic palaces and dominated by the façade of the PALAZZO PUBBLICO with its landmark TORRE DEL MANGIA. Twice a year, this is the scene for the PALIO, a horse race between members of the town's 17 districts. The church of SAN FRANCESCO is situated in the centre of the town of AREZZO and is famous for its fresco cycles by Piero della Francesca which date from the 15th century and are masterpieces of perspective. The GIOSTRA DEL SARACINO, the tournament held each year to re-enact the skirmishes between Arezzo's medieval knights and the Saracen pirates, takes place on the almost trapezium shaped PIAZZA GRANDE. MAREMMA is a rural province on the Tyrrhenian Sea, with GROSSETO at its centre. Here you will find significant Etruscan necropoli and town foundations.

TRANSPORT: Tuscany has a well developed motorway network, which operates on a toll system. An easy way to pay the tolls is with a Viacard, which will be debited with the amount payable. Car hire firms can be found in most towns and at the airports. Bus services within the provinces are good and cheap. The rail network is also well developed and the train can be recommended as a good value and a quick way to travel between the towns of Tuscany.

REGIONAL CUISINE: Tuscan cuisine is famous for its simple but extremely tasty and wholesome dishes. Be sure you try *bistecca alla fiorentina*, a tender Chianina beef steak weighing at least 600 g (1.3 lb). *Trippa alla fiorentina*, or tripe, is another Florentine speciality. *Fagioli all'uccelletto*, which was originally a poor man's meal made from haricot beans and pork sausage in a tomato, sage and garlic sauce, is also very popular with the Tuscans. An important ingredient in such dishes is Tuscan olive oil, which, alongside Umbrian olive oil, is considered to be the best in the world. With their meal, the Tuscans like to drink local wines from Chianti, which will be to everyone's liking.

Although all information was carefully checked at the time of going to press (March 1999), the publisher cannot accept responsibility for its accuracy.